VISUAL ANTHROPOLOGY

VISUAL ANTHROPOLOGY:

Photography as a Research Method

REVISED AND EXPANDED EDITION

John Collier, Jr., and Malcolm Collier

Foreword by Edward T. Hall

University of New Mexico Press
Albuquerque

Library of Congress Cataloging-in-Publication Data

Collier, John, 1913–
 Visual anthropology.

 Bibliography: p.
 Includes index.
 1. Photography in ethnology. 2. Moving-pictures in ethnology.
I. Collier, Malcolm, 1948– . II. Title.
GN347.C64 1986 306'.0208 86-6926
ISBN 0-8263-0898-8
ISBN 0-8263-0899-6 (pbk.)

Second paperbound printing, 1987

CONTENTS

DEDICATION

This writing is dedicated to Alexander H. Leighton for insights and enthusiasm for research into photography's contribution to anthropology

and to: Edward T. Hall for years of stimulation and insights into the silent language of culture and visual anthropology.

Special acknowledgment must also be given to:

The late Roy E. Stryker for bountiful photographic opportunity and for human integrity in photography,

Walter Goldschmidt for his support and editorship of our first research report in *The American Anthropologist,* in 1957, and

George and Louise Spindler for the publication of the first edition of *Visual Anthropology* as part of the series "Studies in Anthropological Method" in 1967.

ACKNOWLEDGMENTS

The roots of this book lie in the Farm Security Administration and the photographic foresight of Roy E. Stryker. The book's scientific basis began with the Sterling County Study under the direction of Alexander H. Leighton and continued through other field research efforts including: the Fruitland Navajo Project with Tom Sasaki and William A. Rose, the Cornell-Peru Project in Vicos under Allan R. Holmberg, the American Indian Urban Adjustment project with James Hirabayashi, and the National Study of American Indian Education with John Connelly and under the direction of Robert J. Havighurst and Estelle Fuchs. A special thanks to the staffs and fieldworkers of these projects, particularly Ray and Carol Barnhardt, Luis Kemnitzer, Gordon Krutz, William Mcgill, Richard Moore, Frank Norrick, Daniel Swett, Robert N. Rapaport, Seymour Parker, Marc-Adelard Tremblay.

The book draws on independent research projects funded by the National Institute of Education, the Wenner-Gren Foundation, the Spencer Foundation, the John Simon Guggenheim Memorial Foundation, the Foundation for the Study of Man, the American Philosophical Society, and the Spencer Foundation. These projects were aided by a number of individuals, of particular importance are Cam and Anita Pfeiffer, George K. Woo, Marilyn Laatsch, Pat Ferrero, and Stephen Wallace.

We are indebted to colleagues who have enriched this book, many of whom have generously allowed us to use their work as examples. These include: John Adair, Scott Andrews, Lorenzo Avila, Peter Bella, Paul Byers, Rafael Cake, Alyce Cathey, Bernard S. Cohn,

George Collier, Paul Ekman, Celeste Greco, Byron Harvey, William Heick, Dwight Heath, John and Patricia Hitchcock, Heidi Larsen, Russell Lee, Michael Mahar, Margaret Mead, Steve Mitchell, Gunvor Nelson, Morris Opler, David Peri, Pat Rosa, Arthur Rotman, Ron and Don Rundstrom, Bernard Siegal, Hubert Smith, Naomi Togashi, Robert Wharton, Sol Worth, and Peter Yaple.

The content and organization of this book reflects years of teaching and the many students whose work and questions have assisted in defining methods and concepts. Particular respect is paid to the memory of Adan Treganza for his imagination and foresight in laying the foundation for this teaching experience.

In its two editions this book has drawn on the editorial skill and critical reading of: John and Casey Adair, Mary E. T. Collier, Tink Pervier, John and Patricia Hitchcock, Edward T. Hall, and George and Louise Spindler for the first edition; and Mary E. T. Collier, Irene Dea Collier, Allison Jablanko, and Heidi Larsen for the second edition, with the clerical assistance of Alice Lee. Elizabeth Hadas and Dana Asbury carried out the final editing for the University of New Mexico Press, to whom we give a final thanks for their interest in supporting the publication of the second edition.

FOREWORD

Visual Anthropology is an updated, much expanded and clarified revision of the original version published in 1967. What the two Colliers, John and Malcolm, have produced is a manual on the two interlocked processes of observation: how to get information *on* film and how to get information *off* film. There are chapters covering virtually every aspect of filmic research, including the more difficult and abstruse epistemological issues of filmic studies which are constantly being raised by the practitioners of this field. However, there is more to this volume than method and epistemology. An important milestone in John Collier's distingushed career—he began as a photographer for the great Roy Stryker of the Farm Security Administration, then worked for Standard Oil in Latin America, Alexander Leighton in Nova Scotia, and the Holmberg's Vicos study in Peru, and in his New Mexico homeland as well as with his talented son Malcolm in Alaska with the Eskimo—this book treats the subject on a deeper, much more basic level than one is accustomed to find in works of this genre. Most important is the breadth and depth of insight which the Colliers bring to their work. Few can match them in this matter.

Sorting the wheat from the chaff, I will try in this introduction— letting the reader discover for him- or herself the richness and relevance of this work—to make some basic points concerning a few of the elements that have figured in the Colliers' contribution. The story begins at age seven when John was hit by an automobile, suffering a fractured skull and what later was demonstrated to be severe damage to the left hemisphere of his brain; he became se-

verely handicapped in spelling and mathematics, both of which are essential to normal schooling. The hearing centers were so traumatized as to impair permanently the integration of auditory information. Severe dyslexia, as well as difficulties integrating auditory information, has, since that tragic event, been a heavy cross for John to bear. There were unforeseen consequences of the accident which were to be quite extraordinary in their implications. This personal disaster explains in part, if my interpretation is correct, not only some of the depth and importance of his photographic imagery but of his thinking as well.

The damage to the left hemisphere promoted a compensatory development in the visual and integrative right hemisphere. That is, the holistic right hemisphere took over some of the functions of verbalized language. Viewing the photographs for this volume (and I have been stimulated by both the man and his work for thirty-five years) I was struck again by their richness and depth. A photographer myself, I kept finding something else in his images which was not present in either my own work or that of other photographers I have known. Though it is something that is not easy to describe, Collier's photographs are not simply visual images; in compensating for his lost hearing, he has managed to incorporate an auditory quality into his photographic images as well as his vision. People have commented repeatedly on how the individuals he photographs do not seem to be aware of his presence, an observation I would agree with. It is almost as though he were listening instead of seeing—projecting that lost ear into the scene.

The auditory and the visual worlds are different. The former is more linear and the latter more holistic. And while "a picture may be worth a thousand words," this is true (if it ever is true) only if the picture is taken in a particular way and is then properly analyzed. One of Collier's contributions has been to teach us how to use photographs in new ways: scientifically for the information that could be gained from them, and as a means of reinforcing, documenting, and checking ethnographic statements.

One modern cliché is that the validity of a given photographic statement is measured according to its authenticity. Sounds fair enough, yet Erving Goffman once criticized a photograph of three men (a father, son, and a close friend of the father) which had been taken as a commemorative snapshot—data which Goffman ruled out because it was posed and not natural. What Goffman failed to recognize was that while the pose was arranged, the kinesics was not. In fact the microkinesics and microproxemics, because they were out of awareness, provided an easily decoded record, not only of generational proxemic change but of the fact that "contact" and

"noncontact" cultures extend their basic mode through all relation-ships. The data were obviously proxemic, which was what I was looking for at the time. Other related disciplines might have been looking for other data. It was all there—and Goffman—as acute an observer as he was—might have benefited from what the Colliers have to offer. In the aforementioned case the data were primarily surface manifestations. But there is more to it than that because there is another dimension—another way of slicing the cake—which pertains to the artificially created discontinuity between the *manifest* image or statement and its deeper latent meaning where my own work and that of the Colliers overlap.

This gap—between the manifest and latent interpretation of an event—separates the compartmentalized, segmented, linear world of Western thought and reality from the more integrated subterra-nean centers of the mind. Freud developed at some length the dif-ference between the manifest and the latent content of a dream. Jung approached this same discontinuity as a function of the dif-ference between individual consciousness and the collective uncon-scious. Campbell and others have looked at the same theme from the point of view of the archetypic character of myths as contrasted with the daily-life preoccupations and clichés of humans.

The Colliers have given us ways of penetrating the cultural cliché—the projection of our own Western patterns for organizing the visual world onto non-Western peoples. They have also put in our hands tools which enable the Western viewer to see a little more of the worlds that others inhabit. In John Collier's words, "The auditory is coded language that can directly express mood which is reinforced by the verbal signals of the listener. With discipline the eyes perceive the factual shapes of realism, but the ear must trans-late, for language is a set of abstract symbols. Regardless of this evident epistemology, Western people reverse this order and per-ceive the written word as reality and visual imagery as impression. Navajo observers, by projective test, see photographs as literal in-formation and language as coded interpretation. If you do not know this you can wholly misinterpret the Navajo message."

Few of us Westerners are aware of the degree to which our visual perceptions are highly selected stereotypes. Yet my own ex-periments and observations have consistently revealed that two in-dividuals looking at the same thing can and do see entirely different aspects of that event. All of this is supported by the work of the transactional psychologists (Ames, Cantril, Kilpatrick, Ittleson, et al.) following in John Dewey's footsteps. Their results contradicted some of the most basic of our core beliefs concerning this underlying perceptual relationship between the individual and the surround

(the world). The Colliers state, "Realistically what we perceive may be only part of the reality before us. Science assumes freedom from this bias, but behavioral scientists in particular form much of their belief within the context of their (own) established values."

There is in our culture a common belief that vision has little or no context, that what we see is the result of a direct stimulus-response linkage between the image as stimulus and the cerebral interpretation of the stimulus. That is, that a direct connection exists between the external world and what we see, without intervention on the part of the culturally conditioned central nervous system. Ergo, vision is independent of experience—unaltered by experience. Yet hundreds of experiments by the transactionalists have demonstrated that vision, like language, is not only *structured* but deeply contextual. As a consequence, once the grammar of vision has been mastered, it is possible to manipulate the "meaning" of an image by manipulating the visual context of which the image is a part. This means, in the Colliers' words, "Once the grammar of vision is mastered, not only can photographic imagery be realistically understood (getting the information *off* film) but in media it is possible to manipulate meaning by shifting the authenticity of the visual context."

Contrast the above with the broader, more inclusive inner world of hearing. It is not so difficult for us to believe that sounds are vibrations. We can see it and feel it in the vibrations of the strings of the violin as the artist's finger moves from the low notes at the far end of the neck to the higher notes close to the bridge. Auditory input is experienced as less specific than visual input. There seems to us to be a greater need to synthesize the auditory message in the head than there is with vision. That is, we are more aware of the relationship between what is going on inside and the stimulus to those internal processes. The distance between the manifest and the latent content of music (and speech) is less than for vision. As a consequence the auditory has the potential for deeper coherence on the experiential level. In a word, it is somewhat more personal.

One more observation concerning the way in which we believe the two senses function: when working with people in a foreign country, most of us have no difficulty accepting the fact that the noises coming out of the people's mouths are different from what one hears at home; it is not so easy to grasp the notion that two individuals from different cultures viewing an identical scene are not necessarily seeing the same thing. The matter rests on the fact that *seeing is viewed as passive and speaking as active,* an assumption which happens to be blatantly wrong, as the Colliers say, "for it assumes that we cannot see with objective accuracy." Nevertheless,

the point is difficult for individuals to understand since it involves literally setting oneself inside the other person's visual world; this is the very point with which all visual anthropologists must eventually come to terms.

Defined in this way, *it is the task of the visual anthropologist to identify the structure points in the system which he is studying as well as its contextual components*. Context, in the sense that I use the term, applies to the stored information in the CNS which is necessary to give these structure points meaning. The Colliers have gone farther down this particular road than anyone I know, and it may take some time for others to understand what they really have been doing.

Clearly, the analytic processes I have been discussing are far from simple and mean confronting one's own culture (and frequently one's colleagues) at those levels of meaning and interpretation of basic issues that are taken as axiomatic. This means that *every culture must be seen in its own terms*. Now this can be accomplished. For, as the Colliers state, "Through photography it is possible to *learn* to see through native eyes. Verbally we can interview natives and share the realism of their visual context." Every culture creates its own perceptual worlds. And until this fact is learned by the human species, horrendous distortions in understanding are inevitable.

The two Colliers have managed in an extraordinary sense to provide a coherent statement concerning what visual anthropology might be. Their potential contributions to this little-known, pioneering field could, if things work out, be quite significant. The Colliers believe—and I agree—that visual anthropology is a legitimate field of anthropological observation in its own right.

—Edward T. Hall

We no longer describe for the sake of describing, from a caprice and a pleasure of rhetoricians. We consider that man cannot be separated from his surroundings, that he is completed by his clothes, his house, his city, and his country; and hence we shall not note a single phenomenon of his brain and heart without looking for the causes or the consequence in his surroundings . . . I should define description: "An account of environment which determines and completes man." . . . In a novel, in a study of humanity, I blame all description which is not according to that definition.

Emile Zola in *The Experimental Novel*

Introduction:
How to Study This Book

It is through perception, largely visual and auditory, that we respond to the humanness that surrounds us. Our recognition of cultural phenomena is controlled by our ability to respond and understand. The camera is an optical system that has no selective process and by itself offers no means for evading perceptive sensitivity. Therefore we begin this book with discussion of observation before going on to practical field application of the camera, the promise of moving images, research design, analysis, and the achievement of research conclusions. The book is primarily concerned with visual observation and the insights that can be gained through the use of camera records. Only in the final, but extensive, chapter does the text deal with the technology of photography, film, and video.

We feel that the humanistic and theoretical issues are more important than the technology. In our joint years of experience in teaching ethnographic photography we have rarely found lack of technical skill to be a serious problem in the use of cameras as a tool for human understanding. Yet we have frequently found that fascination with the technology and the mystique of technical paraphernalia can be a deadly block to making significant camera records. Hence, the order of our presentation begins with the drama of the fieldwork experience.

While we suggest that the text be first read in its presented order, some readers may wish or need to approach the material in a different manner. One could begin with the chapter on technology and only later move to those sections that deal with methodological and theoretical issues. The text is designed to allow this by including

repetition of the basic philosophy and concepts of visual anthropology.

The remainder of this introduction defines the content and organization of the book so that you can make effective use of it in terms of your own needs and experience.

Chapter 1, "The Challenge of Observation and the Nature of Photography," establishes a frame of reference for the rest of the text, defining the promise and development of photography as a research tool.

Chapters 2 through 10 cover field applications of the camera as a data gathering tool. These are presented in the order they might commonly be needed in fieldwork, beginning with initial orientation and moving on to various levels of more structured and detailed activities. The discussion is primarily in terms of still photography, but most specific methods described could be used when working with film or video. In these nine chapters a number of fundamental types of photographic investigation are described:

1. *Survey and orientation.* Chapters 3 and 4 examine informational and research possibilities of "photographic mapping" and other survey applications of photography that can be essential in the orientation phase of fieldwork. These include photography of geographic relationships, montaged records of agricultural patterns, the designs of rural villages, and the shape of urban environments. The role of the photographer and the use of photographs as an aide to social orientation are also reviewed.

2. *Photographic Inventory.* Chapter 5, "The Cultural Inventory," introduces photographic inventories as a means to systematized study of material culture and the use of space, particularly in the setting of the home. The chapter discusses material content and other aspects of environments as keys to understanding individuals and culture.

3. *The study of technology.* Chapter 6 suggests how to photograph technology and discusses fieldwork processes necessary to the recording of technology in culture. This includes enlistment of the assistance and knowledge of the local craftsperson, raising the question "Who makes the photograph, the fieldworker or the local expert?"

4. *Recording behavior and relationships.* Chapter 7, "Photographing Social Circumstance and Interaction," reviews recording of behavior and communication in public and private gatherings, in schools, families, and institutional settings. The tracking of behavior and interaction through time is a particular focus. Additional aspects of this application of the camera are found in Chapter 12, "Film and Video Research," as well as in later chapters concerned with analysis.

5. *Use of photographs in interviews.* Chapters 8 and 9 cover the use of camera images in interviews, including ways to gain and validate information through the interview use of photographs. Included is discussion of how local expertise can be mobilized, through the use of photographs, for accurate and swift acquisition of knowledge regarding geography, technology, and social relationships. This is followed in Chapter 9 with general examination of the use of photographs in projective interviewing.

The section of the text on fieldwork applications concludes with Chapter 10, "Risks to Rapport," which examines some of the common pitfalls that can threaten rapport when working with the camera. Basic procedures for minimizing rapport problems are defined.

Chapters 11 through 13 deal with film and video as essential records of process and behavior through time. Chapter 11 examines the difference between still and moving images in field research, and Chapter 12 summarizes methodological designs for research recording with film or video. Chapter 13, "Ethnographic Film and Its Relationship to Film for Research," reviews the educational value of film and asks "What is ethnographic film? Dramatized anthropology, closed visual lectures, or open learning opportunities that allow students and other audiences opportunities for responsible exposure to cultural diversity?"

Chapters 14 through 18 cover research design and analysis. Chapter 14, "Principles of Visual Research," defines basic designs for all use of still and motion records in research and is significant to all chapters that deal with specific methods for obtaining insight from visual records. Following chapters are directed toward methods for "breaking" the visual code of camera images and arriving at conclusions. This process of analysis is crucial, for if visual information remains locked in visual content then the camera makes little contribution to anthropological understanding. Because the analysis of still and moving images is usually similar the chapters include material on both.

A final chapter, "Technical Considerations in Visual Anthropology," examines what one needs to know about photography, film, and video on a technical level. Even though good research can be carried out with snapshot cameras, refined equipment and technique can extend the scope of photographic data. Yet the technology can obscure the primary necessity of sound research design and systematic observation, so we attempt to simplify photography to minimal skills through discussion of practical problems that may be encountered in the field.

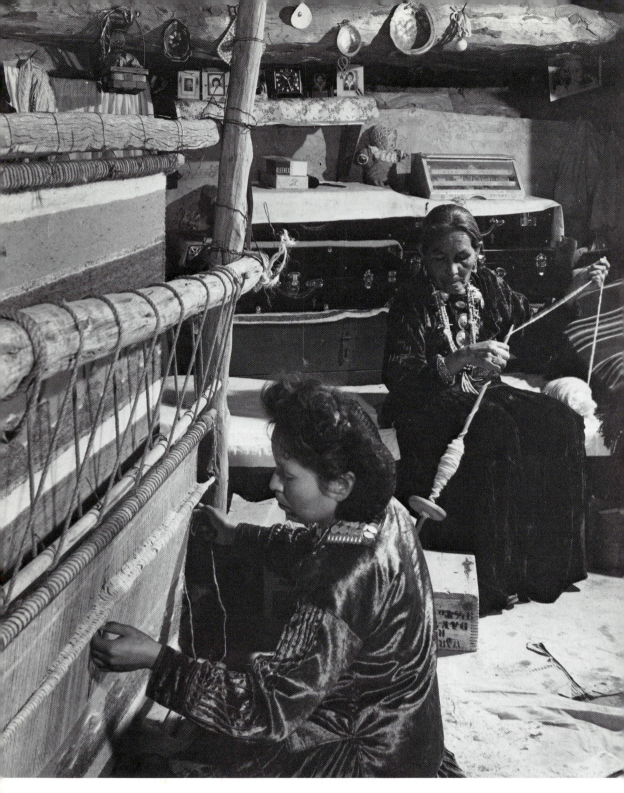

Navajo mother spinning and daughter weaving vegetable dye rug, Wide Ruins, Arizona. The scope of the camera's eye covers more than the technicalities of the textile craft: age relationships, elements of acculturation, inventory of property, use of space. Can the human eye and mind, unaided, recall this complex whole? (Unless otherwise indicated photographs are by John Collier.)

Chapter 1 The Challenge of Observation and the Nature of Photography

This book is about observation. It explores ways to accomplish a whole vision in anthropology through the use of photography. The critical eye of the camera is an essential tool in gathering accurate visual information because we moderns are often poor observers. Its sharp focus might help us see more and with greater accuracy. The camera is not presented as a cure-all for our visual limitations, for it takes systematized and acute recognition to benefit from its mechanistic record of culture, behavior, and interactions. We explore photography as a research tool, with associated methodologies, that extends our perceptions if we make skilled and appropriate use of it. Photography is only a means to an end: holistic and accurate observation, for only human response can open the camera's eye to meaningful use in research. Hence, we first turn our attention to the phenomenon of modern observation.

There are problems in modern conception that must be recognized if we are to make reliable observations of culture. Only in specialized fields do we see with undisturbed accuracy. We are not generalists, and imagery beyond our professional area is apt to be peripheral and often projectively distorted. We see what we want to see, as we want to perceive it. Learning to see with visual accuracy, to see culture in all its complex detail, is therefore a challenge to the fieldworker whose training is literary rather than visual. Generally, the fragmentation of modern life makes it difficult to respond to the whole view. An observer's capacity for rounded vision is certainly related to the degree of involvement with environment. We have

drifted out of an embracing relationship with our surroundings, usually dealing only with portions of our environment.

In contrast, the perceptions of many other peoples are related to their interaction with their total environment. People with limited technology necessarily have to live in harmony with surrounding nature. They have to be astute observers of all their world or perish! Natural forces surround them, and they are constantly struggling to survive with these forces. When an Eskimo leaves his home to go sealing, he must deal firsthand with every element of his surroundings and be master of every available technique to cope with it. Often he must make each life-and-death decision independently. These decisions determine whether he finds game or not, whether he makes it home through the ice flows or is swept away on the Arctic seas.

Our cultural development, in contrast, has been oriented to commanding nature by super-technology, carried out collectively through super-organization and specialization, making it difficult for us to accomplish holistic understanding. Despite this environmental isolation, we believe we are masters of our world, and we no longer deal personally with its natural forces. This curtaining security has limited the range of phenomena that we, as individuals, have to deal with in order to survive, making us limited observers.

Only at a few points in our daily lives do we have to make survival decisions entirely by our own senses. We jam on the brakes when we see a red light, accelerate when the light goes green. Or we step unwarily out across the pedestrian lanes, confident that other specialists will guide their movements by the same signals.

It is true that within select areas we too are keen visual analysts. In our own specialized fields we see with extreme precision, though when we leave these areas we may be visually illiterate. The radiologist can diagnose tuberculosis from a lung shadow on an X ray; the bacteriologist can recognize bacilli in his microscope. Yet when these technicians leave their laboratories they find their way home efficiently guided by copious road signs. There is no reason to look up to the heavens to see whether they will be caught in the rain. Their raincoats have been left behind, for the radio reports "Fair tonight and tomorrow with gentle westerly winds." Other specialists made highly technical instrumental observations to reach these conclusions for them. It is only by considering the collective sum of all of our specialized visions that we can consider ourselves the most acute observers in man's history.

Unquestionably the personal blindness that obscures our viewing is related to the detachment possible in our urban, mechanized society. We learn to see only what we pragmatically need to see.

We go through our days with blinders, dealing with and observing only a fraction of our surroundings. And when we do see critically it is often with the aid of some technology.

Many shrewd observations are made with instruments. We can observe life in a drop of water with our microscopes, look out into celestial space with telescopes, and even see back in history with instrumental reading of carbon 14. We observe with the aid of radarscopes, calculators, computers, light meters; these instruments have still further specialized our vision. Instrumentally assisted vision has allowed us to see elements microscopically near and telescopically far, through abstractions of light, heat, and cold, in measures of body satisfaction, or electrical impulses generated by stress or joy.

The camera is another instrumental extension of our senses, one that can record on a low scale of abstraction. The camera, by its optical character, has whole vision. No matter how select a unit we might wish to photograph, the camera faithfully records this specialized subject and also all other associated elements within focus and scope of its lens. This capacity makes the camera a valuable tool for the observer.

The adaptability of camera vision has made photography a standard of accurate perception in many fields. Many disciplines depend upon the camera eye to see what the human eye cannot, whether this be to trace the development of plant fungi, to look for soft landings on the moon, or to decide a photo finish of the Kentucky Derby.

THE MIRROR WITH A MEMORY

The camera's aid to observation is not new; Leonardo da Vinci described its principles. Light entering a tiny hole in the wall of a darkened room forms on the opposite wall an inverted image of whatever was outside. The *camera obscura,* or literally the darkened room, was the first camera where artists could study projected reality, the character of light, the delineation of perspective. By the eighteenth century cameras had shrunk from a room large enough to hold a man to a portable two-foot box with the peephole replaced by a ground lens. Tracing paper was used instead of film, and copies of reality were traced right side up on a ground glass that resembled closely the mirrored image of a Graflex camera.

The *camera obscura* could retain the projected image only by a manual tracing, a laborious and often stilted operation. In 1837 Louis Daguerre perfected the first efficient light sensitive plate, the mirror with a memory. The daguerreotype introduced to the world rela-

tively cheap, rapid, mobile imagery that changed the character of visual communication. Now it was not only perspective and principles of light that were recorded for study, but the human image, a precise memory of exactly how a particular person looked, that could be examined again and again by any number of observers, now or years later. Because of this facility, the camera image ushered in a new phase of human understanding that continues to expand our social thinking.

The persistent problem in centuries past and in our human relations today is to see others as they really are. Before the invention of photography, the concept of world humanity, flora, and fauna was often a fantastic one. This is why the camera with its impartial vision has been, since its inception, a clarifier and a modifier of ecological and human understanding. Man has always used images to give form to his concepts of reality. It was the artists' imagery that defined heaven and hell, the shape of evil, and threatening savages in the images of people who were so startlingly different. People conceived the world through these representations, which generally bore out what the artists wanted to see or were shocked to see.

The excitement that greeted the invention of photography was the sense that man for the first time could see the world as it *really* is. This confidence came from a recognition that photography was an optical process, not an art process. Its images were made by real light, as natural as a shadow cast by a hand, rubbings taken from stones, or animal tracks on the trail. Critics can justly point out that this acceptance of the camera's convincing realism is at times more of a mystique than a reality. Yet for multitudes, the photographic record is true because "the camera cannot lie." This simplification is, of course, supported only by the camera's relatively accurate recording of certain physical aspects of reality, such as views of the pyramids and Niagara Falls. But despite any discrepancies between reality and the touted realism of the camera's vision, photography has greatly affected modern thinking. We have changed our views of the world to approximate the universal view of the camera.

Photojournalists' views are certainly edited ones. The important element of these records is that because of the impartial process of the camera's vision, even these edited documents often contain a sufficient number of nonverbal truths to allow the audience to reconstruct schematic reality and to form concepts that have changed social thinking dramatically, demonstrating the fact-presenting value of the camera. The documentary records of Mathew Brady, commissioned by Abraham Lincoln, were among the first photographic views of war. There were not hasty snapshots, but time-exposure

records of the fallen bodies, the burnt wreckage of buildings, and the faces of the maimed and the captured. Gone were the brave banners and charging horses; Brady recorded the effects of war, not simply its dramatic actions. Several decades later, police reporter Jacob Riis turned to the camera to present slum conditions in New York City. Unwieldy cameras and powder flash recorded such scenes as the "Bandits' Roost," interiors of slum homes and schools. These early records of "urban anthropology" helped establish the first building codes and apartment regulations. In the first decades of this century, the sociologist Lewis Hine recorded the entry of immigrants through Ellis Island, preserving the original look of Europeans before acculturation into American life. Hine also turned his camera to children, and his images were influential in passing the first child labor laws (Newhall 1949:167–73). Observation, synthesis, and action—is that not the essence of applied anthropology?

Paralleling these urban studies was the work of Edward S. Curtis, photographer and amateur descriptive ethnologist, who carried out extensive photographic salvage studies of American Indian culture, recording native life from the Arctic to the Southwest. Curtis often engaged in "creative reconstructions," but the photographs are history, frequently providing our only visual record of many Indian cultural patterns that now have perished, a "salvage" effort comparable in spirit to Dr. Samuel A. Barrett's films in the 1960s.

The effect of photography as an aspect of reality is felt throughout modern life. In a sense we think and communicate photographically. The nonverbal language of photorealism is a language that is most understood interculturally and cross culturally. This fluency of recognition is the basic reason the camera can be of such importance in anthropological communication and analysis.

THE CAMERA AS A RESEARCH TOOL

What are the camera's special assets that make photography of great value to anthropology? The camera, however automatic, is a tool that is highly sensitive to the attitudes of its operator. Like the tape recorder it documents mechanically but does not by its mechanics necessarily limit the sensitivity of the human observer; it is a tool of both extreme selectivity and no selectivity at all.

The camera's machinery allows us to see without fatigue; the last exposure is just as detailed as the first. The memory of film replaces the notebook and ensures complete quotation under the most trying circumstance. The reliably repetitive operation of the camera allows for comparable observations of an event as many times as the needs of research demand. This mechanical support of

field observation extends the possibilities of critical analysis, for the camera record contributes a control factor to visual observation. Not only is it a check on eye memory, but further, it allows for an absolute check of position and identification in congested and changing cultural events.

Photography is an abstracting process of observation but very different from the fieldworker's inscribed notebook where information is preserved in *literate* code. Photography also gathers selective information, but the information is *specific*, with qualifying and contextual relationships that are usually missing from codified written notes. Photographs are precise records of material reality. They are also documents that can be filed and cross-filed and endlessly duplicated, enlarged, reduced, and fitted into many diagrams and scientifically extracted into statistical designs.

A large volume of photographic content is tangible. Any number of analysts can read the same elements in exactly the same manner. To be sure this takes training, but so does the reading of maps and bacteriological slides.

But what are the camera's limitations? They are fundamentally the limitations of those who use them. Again we face the problem of whole and accurate human observation. No field is more aware of this challenge than anthropology. Seeing the stranger as he "really" is, in ethnography as in all human relations, too often becomes a casualty of our personal values and incomplete observation. Social scientists appreciate that there is little we can see that is truly free from bias or personal projection. The realism of this anxiety of course extends to photographic records as well as to the products of direct observation.

Early ethnographers were enthusiastic photographers, for the camera gathered the descriptive details sought for in the material inventory phase of anthropology. Modern anthropologists generally use photographs strictly as *illustrations,* perhaps feeling that the overload of photographic detail interferes with more controlled analysis. Anthropologists mostly agree that photographic records are good, but in many researchers eyes they are "too good, with more information than we can refine." Possibly this is one reason why little research in anthropology has been based on photographic data. In another dimension, anthropologists, not unreasonably, have not trusted the mechanics of the camera to defeat impressionism and the value manipulation of vision. Only physical anthropologists with their body measurements, and archeologists with their burials, postholes, and ancient constructions have trusted the camera to make fine research records. Our text addresses these issues and presents methods to meet these concerns.

High points on the trail of direct research accomplished with the camera are quickly recounted. Pioneer photographer Eadweard Muybridge, seeking a method to catch elusive action the eye could not follow, perfected an early method of time and motion studies. In 1887 he published *Animal Locomotion,* eleven volumes with 20,000 photographs of almost every imaginable motion of animals and men, including a mother spanking a child. While Muybridge's effort was conceived as a service to artists seeking realism in their drawings, his method was seized upon by a French physiologist, Marey, to study minutely the movement of animals, birds, and even insects.

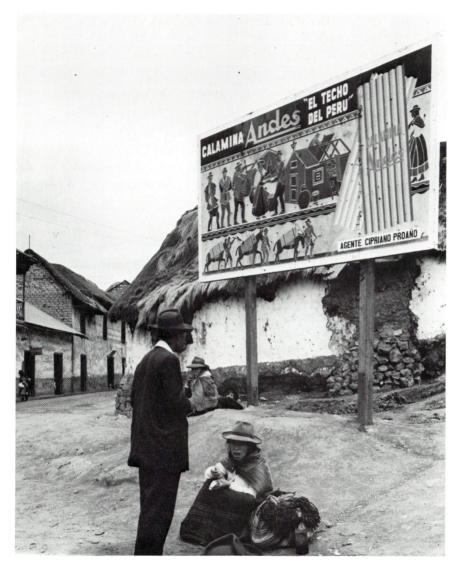

Technological acculturation in the Andes. Industrial advertising capitalizing on traditional culture, Cerro de Pasco, Peru.

In the process Marey developed a camera with a moving plate with which he could photograph twelve frames per second, the forerunner of the movie camera. Marey's frame-by-frame analysis provided a method of investigation which has been pushed into every corner of the sciences, in combination with the microscope and the X ray (Michaelis 1955:118; Newhall 1949).

In the less controllable field of human behavior, probably the most intensive work with photography is that of Arnold Gesell, director for many years of the Yale Clinic of Child Development. Based on the photographic record of many children day by day and at scheduled intervals over many years, Gesell drew up a timetable or sequence of the normal maturation and social development process. This work profoundly influenced child psychology not only as a science but as practiced by the parents of the children in our culture (1934, 1945).

Gregory Bateson and Margaret Mead made the first saturated photographic research in another culture, the results of which were published in *Balinese Character* (1942). After this work, both continued to use photography, Mead in her continuing concerns with child development (for example, Mead and Macgregor 1951) and with ethnographic and research film, and Bateson in the study of nonverbal communication (1963; and Ruesch and Kees 1956).

Richard Sorenson, the founding anthropologist of the National Film Research Archives, is one of the few anthropologists who followed the footsteps of Margaret Mead and Gregory Bateson. Thirty years after the publication of *Balinese Character,* Sorenson published *On the Edge of the Forest* (1976), a photographically researched text on child development in New Guinea.

The field of ethnographic research photography is still specialized and experimental. Edward T. Hall continually referred to photographic data in the development of his concepts of nonverbal communication (see *The Silent Language,* 1959), and he studied photographs to stabilize many aspects of the significance of the use of space, or "proxemics" (see *The Hidden Dimension,* 1966). In the 1960s and 1970s he turned to the use of Super-8 film to examine subtleties of movement and communication in cross cultural settings (Hall 1974).

Ray L. Birdwhistell has used photography and film to systematize the study of culturally patterned posture and gesture, which he terms "kinesics" (1952 and 1970), a field virtually impossible to approach without photography. Paul Byers, combining the skills of professional photographer with anthropological training, has worked toward a clearer understanding of photography as a three-way process of communication involving photographer, subject, and viewer,

each in an active and expandable role and has made pioneering studies of synchrony in nonverbal communication (Mead 1963:178–79; Byers and Byers 1972). John Adair and Sol Worth used 16mm film as means of obtaining an inside view of the manner by which Navajo's structured their visual world and cognition (Worth and Adair 1972).

Other fine photographers and fieldworkers have carried out organized investigations with cameras, film, and video in anthropology. But in anthropology as a whole, still photography remains an unusual research method. Use of film and video as research tools is somewhat less rare, for some cultural circumstances can be researched only in this manner.

Certainly the overload of photographic information presents problems for controlled analysis. Quoting an anthropologist, "Photographs are just more raw realism. They contain everything. We have worked out ways of digesting verbal data, but what can we do with photographs?" Indeed this is the challenge! One photograph may contain a thousand elements. Even more confounding, most photographs are a minute time sample—a hundredth-of-a-second slice of reality. Until fieldworkers know what to photograph, when and how many times to photograph—and why—anthropologists will see no functional way to use the camera. Finally, if researchers are without reliable keys to photographic content, if they do not know what is positive responsible evidence and what is intangible and strictly impressionistic, anthropology will not be able to use photographs as data, and there will be no way of moving from raw photographic imagery to the synthesized statement.

Beyond the challenge of informational complexity appears to lie an even more formidable resistance. Anthropology is already a classical field with established belief systems about non-White indigenous peoples. Photographic imagery can reveal sensitivity and humanity of native people that challenge classical ethnographic texts, methods, and conceptualization.

This volume attempts to outline how the camera can be used to explore and to analyze, so that we can use photography not only to *show* what we have already found out by some other means, but actually to extend our visual processes and to help us *find out more* about the nature of humanity and its multifaceted cultures.

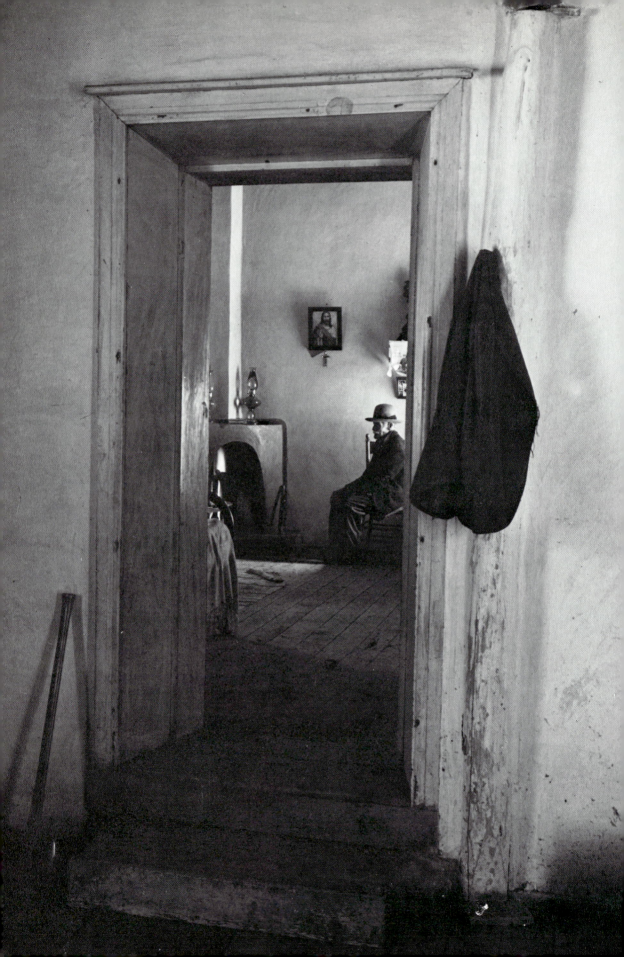

Chapter 2 The Camera in the Field

Photography's practical place in fieldwork can be demonstrated by relating its functions to the development of a field study. The introductory step in many projects is an ethnographic overview or a phase of descriptive study. This period is necessarily one of orientation and education of the researchers. It is a phase of fact gathering about the total environment under study, often essential to obtaining a wide view within which cultural detail can find an organic place. A grasp of ecology and cultural geography opens an orderly road to future levels of investigation.

As research progresses the general view is necessarily laid aside in efforts to make a more penetrating study of selected aspects. During this second phase, fieldwork reasonably narrows its focus in search of *particular* evidence pertinent to the goals of the research. The reconnaissance of the initial ethnography interrelates, guides, and provides a setting for this cultural trenching and sampling. As understanding deepens, research methods become increasingly specialized, interviewing more structured, speculations more analytical with the support of psychological examinations, tests, and questionnaires. Specialists from many disciplines may enter the field, each viewing the people and their culture differently, contributing additional understanding to the research. With this multiplicity, the earlier background of the whole view as one basis of homogeneous understanding is more important than ever.

In the final phase the study involves synthesis, when the research must be developed into conclusions. In this phase photo-

graphic evidence must, of course, be abstracted in the same way as all other data, verbalized, translated into statistics, even computed electronically in order to become a genuine part of the fabric of scientific insight. If this process does not take place, the camera is not a research tool in modern anthropology. This book will follow the course of these three phases, referring again and again to actual and to hypothetical research situations for examples of the various processes. We begin with an exploration of the uses of photography in the first phase of field research.

In line with the culture of anthropology, which places considerable value on intensive firsthand experiences, photography has had its most enthusiastic use in the initial phase of field research. This appreciation is realistic, as a foremost characteristic of the camera is its ability to record material that the camera operator may not recognize or yet understand. Photography offers the stranger in the field a means of recording large areas authentically, rapidly, and with great detail, and a means of storing away complex descriptions for future use.

Early stages of fieldwork usually involve meeting strangers in a strange land. This initial experience is one of diplomacy and orientation, introducing ourselves to people and gaining local knowledge and clearance to begin our research. We begin with limited prior knowledge of the wilderness of a new environment and culture. Photography can accelerate this entry process. With the mechanical memory of the camera, responsible fieldwork can begin with rapid gathering of regional intelligence.

The challenge faced in accelerating the field experience and gathering responsible information is that notes on an unfamiliar, complex environment are often limited and/or impossible to make. We can write down first impressions, which we feel constitute invaluable data, for as Robert Redfield (1955) has observed, the longer you remain in the field, the less vivid become your responses. This describes a serious problem in lengthy fieldwork, which tends to concentrate on cultural parts at the price of significant responses to the whole circumstance. Over time in the field our response may deaden through monotony. Hence early impressions, when senses are at their responsive peak, can preserve the liveliness of a strange culture.

Photography can be an aid in preserving these vivid first impressions in a responsible and usable form. These first photographs also document basic environment, for the camera does not need our detailed knowledge to record the complexities before us. We can accurately record materials and circumstances about which we have limited knowledge. These early records can be decoded intelligently

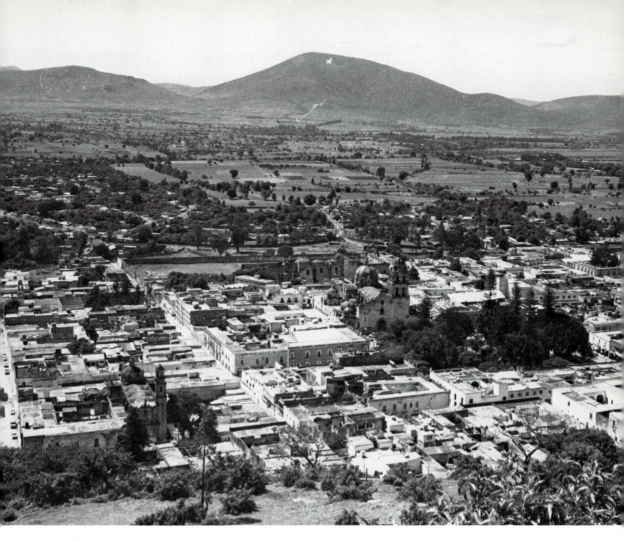

The camera records pattern and relationships. In this image we can define the colonial center, twentieth-century suburbs, agricultural lands, and distant mountains in precise relationship to each other. Detail from 360° panorama of Atlixco, Mexico. (Photo by Malcolm Collier)

by any native collaborator in the immediate present, or read significantly by the investigator as knowledge deepens.

We can speed up orientation with the aid of photography by making an overview journey through our research territory, recording geographical and cultural phenomena met in this introductory survey. Local assistants in many cultures have proven ability to read photographic records accurately, identifying landscape, interpreting cultural processes, and even defining ethnicity and personalities. In a few interview sessions, photographs can provide accurate geographic names and identification of towns and technologies. We can begin assembling a file of demographic, social, and economic information immediately. In a few weeks such a photographic over-

view can yield information that might take fieldworkers many months to gather by traditional means.

Panoramic photographs can set the stage for research. Long views establish relationships of ecology and community. They hold the broad view within which many levels and disciplines of abstraction can take place. Through interviews, they can become the source of a wide range of social, cultural, and ecological information. Nor does the use and value of the photographs made during early orientation necessarily diminish with time, often they can be used again in later, more structured and focused stages of the research effort. In the following chapters we explore uses of photography in the field that can lead us from initial orientation and overview to investigation of complex and detailed subjects.

Chapter 3 Orientation and Rapport

When we use photography as a means of orientation, we make use of its illustrative function. More important, we exploit photographs as independent specimens of data, not fully perceived until held in place by the camera record. It is difficult, sometimes impossible, to observe accurately phenomena we do not understand, and the camera provides a solution to this problem.

Social Orientation

The orientation phase of a research project should give the researcher a sufficient grasp of a new culture so he can observe, identify, and relate. The basic form of a culture must be learned before we can see that culture in depth and compare one part to another. This learning may take weeks or months of valuable field time. Photography can accelerate this orientation experience. For example, in the Cornell Community Studies Program, Morris Opler provided his students with two years of study in the complex culture of India before they went overseas. Part of this orientation was a saturated exposure to photographs of Indian social roles, of priests, moneylenders, matchmakers, and government officials (private communication).

There is necessarily a time lag in developing familiarity with a strange culture. A "first view of strangers" taken with a camera can allow the newcomer to an alien culture to make accurate records of an environment of which he has little knowledge. Interviewing native specialists with these early records allows for rapid identification

and orientation. In this way, photographs used can teach the new-comer the visual language of a new cultural ecology.

An example of this visual problem solving is the experience of Michael Mahar when he first arrived in India for fieldwork as a Cornell graduate student. One of Mahar's goals was to chart the social structure in one neighborhood of a large Indian village by tracking social interaction in the lanes, residential compounds, and during weddings attended by several hundred people. Who talked to whom? Who stopped where? The problem necessitated writing down repetitive observations at key points of sociometric move-ments and then relating this scheme to the community social struc-ture. Immediately he had grave problems. He knew only a few of the villagers by name during the early phase of his fieldwork, and he could not readily ask for the identity of individuals in large groups without creating suspicion. Spontaneously he reached for the cam-era in hopes of solving his dilemma (private communication).

Mahar soon gathered a comprehensive view of the lanes and gathering places. When he was sure he had recorded each resident, he took his records to a key informant in the community who easily identified each person. This information was used in conjunction with census materials to construct a code that indicated the social and spatial position of each resident of the neighborhood. Attention could then be given to the selective process of when and where to record. He could leave precise identification to future laboratory study, two or even five years away, when he would again use his photographic key to complete his sociometric analysis.

A fine statement of how insights are built in the field and how the camera can teach is given by John Hitchcock.

> Complexity of response is the clue. The good
> anthropologist knows some significances and learns
> others by living with the people in the community. He
> records some of the things he regards as significant,
> using the camera. Then he can begin responding to
> pictures as well as to people and place. All taken
> together help him to see further significances. You must
> emphasize this complex two-step and feedback process
> (private communication).

THE PHOTOGRAPHER: A PARTICIPANT OBSERVER

Consider the difficulties of a fieldworker exploring technological change in a Canadian fishing community. How much can one see and record of such a complex technology—of the subtleties that differentiate one fishing technique from another, and that represent

technological changes in the industry, in fishing methods, in the character of boats, and in the technology of fish packing? How much time would be spent learning the basic movements of this complex process, *fishing,* before any refinements of different technologies or change could be accurately observed? For the fieldworker who has never experienced this industry, long questioning would be needed to learn even the language of this maritime tradition.

Measure this against the fieldworker from some similar maritime culture, who would come prepared with a spontaneous recognition, who could single out fine points related only to this area as compared to elements common to all Canadian fisheries. This fieldworker could immediately begin making pertinent observations significant to the study, while the first fieldworker would be spending weeks, if not months, mastering the language of the technology.

Consider a third circumstance where a novice fieldworker, who knows nothing about fishing but who is in command of a camera, approaches the technology with photography. Observation begins at five in the morning as the dragger fleet prepares to set to sea. In

The invisibility of the photographer is usually best accomplished by participant observation, not the telephoto lens. Rondal Partridge photographing an interaction. (Photographer unknown)

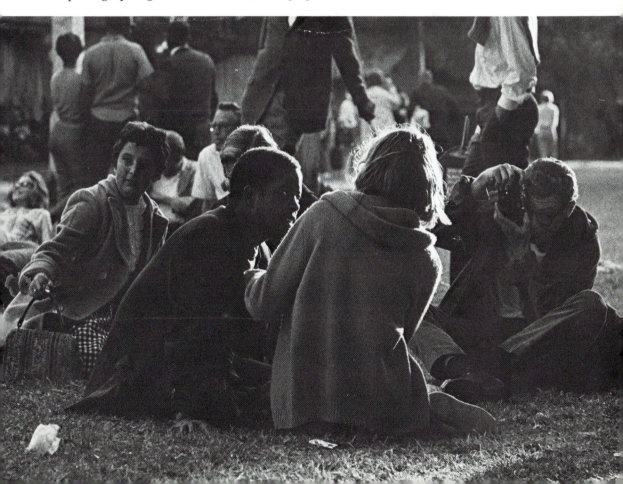

the misty light the community pier of the fishing port is filled with activity. The vessel our observer is to join lies below him, a maze of cables and lines and nets, which the crew are coiling and securing for sea. Coming down from the hills to the long pier the photographer makes a sweeping view of the harbor showing the vessels lying in the shelter along the pier inside the breakwater. He focuses on the activity of the people hurrying and lowering equipment into boats, groups of people standing together smoking. As he comes down the dock he makes an overhead view of the fishing boats, moored separately and sometimes three and four together along the pier.

As the fieldworker leans out over the vessel, the skipper hails him with "Here's the fellow who's going to take photographs, boys." The observer is introduced as someone who has a job to do; he will be as active as they are. A critical problem of role is solved by this introduction. The fieldworker's camera has played a part in this assignment from the very beginning. The skipper had been somewhat reluctant to take a greenhorn along. "We don't have time to answer a bunch of questions out there on the grounds; the wind's getting up and we're going to be pretty busy." When the fieldworker explained that he simply wanted to take photographs, the skipper's tone changed.

"Give the man a hand with his gear." The fieldworker jumps aboard the vessel and looks for a vantage point where he can keep out of the way and still see all that is going on. He settles on the deck of the pilot house and methodically films the as-yet unexplained activity in the waist of the vessel. The steel chains of the dragger gear are shackled, tightened. Cables are wound onto winches. Lines are coiled and secured. One by one the vessels follow each other out of the breakwater, out into the bay, past lines of fish packing plants, fueling docks, yards, and warehouses. The fleet turns seaward, rounding a rocky headland and meets the deep swells of the Atlantic. Astern, the observer records the sweep of the coastline, the rocky promontories, and the distinct patterns of farms and fields in the rising sun.

The routine of the vessel quiets; the crew relaxes awaiting the next phase of activity when they reach the grounds—a proper time for more formal introductions and explanations. "What are you taking these pictures for? Fun? Are you going to sell them to a magazine?" And the fieldworker is faced with his first important accomplishments—selling himself and explaining to the natives the purpose of his observations. Taking photographs is a reasonable activity, one which can be understood. Each time you take a picture your purpose is further recognized. Your ability to observe without asking

many questions is vital in the circumstance where talking is difficult over the roar of the diesel engine and the critical activity of the crew.

Again, from his station on top of the pilot house the observer photographs the rapid sequence of lowering the drags and huge steel nets into the Atlantic. The engine slows, and the bottom of the sea is being swept for fish. It is a question of waiting, watching, and not asking. The vessel's engines stop, the boat rolls in the swells, and the screaming winches begin to haul a netload of fish from twenty fathoms of water. Activity quickens into a chaotic routine of lines, winches, and orders as the purse seine, streaming with water and burdened with hundreds of pounds of fish, is lowered down onto the dragger's deck. The purse is stripped and the deck is covered with many varieties of fish. Some are pitched overboard with a fork, others down into the icehold. Nets are rerigged and the dragging gear plunges again into the sea. Repetition of this activity over the day offers a very precise photographic record of technology. The crew becomes more involved in the observer's recordings; concerned that he capture each element of their trade, they begin offering him loud direction, "Stand by, now is the moment!" "Try it from the fo'c'sle head, you'll get a better view." This opportunity for cooperation, in which the native can tell the observer where to stand and what to see, creates a firm basis for rapport.

Afternoon sees the dragger fleet rounding the headlands and tying up to the packing-plant wharf, each boat waiting its turn to unload its catch. The most sociable time of the day begins. The relaxation of waiting invites shouted conversations from boat to boat—friends, families, children, wives, managers of the packing plants, wharf hangers-on lean down from the wharf. The day's work is done. The catch is in.

"Are we going to get to see those photographs, Jack? Could we get some snaps?" The fieldworker is invited to come to call and bring his photographs. These invitations open a second and critical phase of the day's observations: the identification and reading of the photographs by the fishermen themselves. This opportunity brings to photographic orientation the control and authenticity that makes photographic exploration so valuable to anthropology.

PHOTOGRAPHY AND RAPPORT

The spontaneous invitation to the fieldworker to show his pictures is the result of a unique function of the camera in many kinds of studies. Informally we can call this photography's function a "can-opener." The fieldworker, having spent one day recording on the dragger, has already introduced himself to the whole fishing com-

munity. Everyone knows who he is. Everyone has been told what he's been doing. Bridges of communication, established by the visual medium, can offer him rewarding collaborations within the field of study.

The fieldworker who photographed aboard the dragger can make a rapid entry into community research. "Will you show us the pictures?" can be his key to the homes of the dragger's crew. The first logical human step would be to call on the skipper who, when shown the pictures, is at once put in the role of the expert who teaches the fieldworker about fishing. The multiple details of the photographs offer the captain an opportunity to express his knowledge and authority. He educates the fieldworker's untrained eye with pictures of *his* boat, *his* crew, *his* skills.

This initial session of feedback can be very gratifying to people, setting a strong identification with the stranger-observer. The skipper can become the fieldworker's champion, using the feedback pictures to add status to his position in the fishing community. After all, it was *his* boat that was chosen for study.

The evening's discussion of the photographs establishes a friendship with a community leader who can vouch for you and introduce you throughout the community. Your initial role is, "I'm the man who photographed Jim Hank's dragger." The skipper in return must explain to friends and community who you are. After all, everyone saw you photographing aboard his boat. Of course you must be a good person with an important mission, or your presence aboard would detract from the skipper's status.

Walking through the community with your new friend opens other opportunities. Entering the community proper by the side of an important fisherman is an excellent introduction. Have a glass with the skipper at the local store, and you will find yourself in the center of all his cronies. "Jack's the fellow who photographed my dragging." Here is a chance to talk casually of your study. Contacts are made—a foreman at the fish plant, the owner of the mercantile store—and your study can begin to fan out into the community at large. You have been introduced, your purpose factually understood, now you can proceed by various designs to gather the larger image of the community.

Of course we must recognize that the selection of local assistants is crucial, particularly in the early stages of fieldwork. As Patricia Hitchcock puts it:

> If a man's research plan involves the people he wishes to photograph he has to consider their feelings. He is not a tourist or press photographer whose aim often is to get a picture and get out, broken camera or no. Resentment of

the camera can be overcome with the help of the right
man—not the most willing man necessarily, who may be
looking for attention, or who may be a deviant without
the respect of the group—but a man who may have to
be convinced the project is a valid one, a man who has
power in the village and if possible the respect of all
factions (private communication).

This is also true with regard to choice of informants for inter-
viewing; research goals must be pursued with realistic appreciation
of social structure. The photographic fieldworker is especially con-
cerned with these issues simply because his research takes place in
full public view. Photography offers no covert methods for research-
ing the community.

Successful field rapport can be aided by your behavior as a
photographer. Usually you want to move slowly, not rushing your
shots, letting people know you are there, making a photograph.
This demonstrates your confidence in your role and allows them
time to object if your presence is inappropriate. If you act evasive,
hurried, "sneaking" photographs, then they will be doubtful of your
motivations.

The photographer's role becomes even more critical when he
is one of a team; what he does or does not do can jeopardize the
whole research structure. His sensitive position stems from the role.
Photographers are public figures, and the use of diplomacy and tact
is of great importance in carrying through a community study. It is
apparent that photography can either give the project a thoroughly
negative introduction or provide community contacts that lay the
foundation for extensive research, covering months or even years.

Because people can grasp just what the photographer is doing
and are therefore in a position to assist him, photography can pro-
vide a rapid entry into community familiarity and cooperation. The
feedback opportunity of photography, the only kind of ethnographic
note-making that *can* reasonably be returned to the native, provides
a situation which often gratifies and feeds the ego enthusiasm of
informants to still further involvement in the study. The concept of
photography as a "can-opener" into human organizations has proved
to be a sound one, *if* the research opens in a logical and sympathetic
way, in terms of values of the native culture.

Dwight B. Heath, of Brown University, stumbled upon this rich
possibility quite by accident while working, with Anna Cooper, on
the ethnography of the Cambas near Santa Cruz, Bolivia. He prefers
the metaphor "golden key" to "can opener." He writes:

The research design called for general recording of the
technological and social culture of this lowland jungle

area. Although the people were friendly enough, a dispersed settlement pattern of isolated homesteads and haciendas made systematic observations of many aspects of behavior difficult. Among our equipment we had a 35-mm camera and plenty of positive film, both color and black-and-white. Despite considerable delay and risk of loss, film was processed in the United States and returned to Bolivia where, in a casual gesture of friendship, a village priest once invited us to view our slides through his projector. The half-dozen bystanders were excited to see familiar people and places "in the movies," and told their friends. So many people asked to see the slides that a public showing was scheduled for an evening after church. More by popular demand than by design, a couple more showings drew ever larger audiences. At the same time that local people began affectionately (and a little proudly) to speak of "Cine Camba," the feedback to us was becoming increasingly rich. The slide-shows thus became an enjoyable and informative weekly institution. Comments by the audience provided valuable attitudinal and conceptual data in a sort of localized TAT (Thematic Apperception Tests) that might not otherwise have been elicited. Furthermore, we anthropologists took these occasions to explain our work briefly, and found an unexpected flood of goodwill and interest in our studies. It was probably not only in gratitude for the entertainment and excitement provided by the slide-shows, but also in the hope of appearing in them, that people began to give a virtual guide to each day's activities and to invite us to participate even in events that were normally restricted to a few kinsmen. Rites of passage, specialized techniques, and a host of other things that might otherwise have been missed were brought to our attention, and the camera became a "golden key" to anywhere. As interest and attendance increased at an almost exponential rate, the unexpected audience soon outgrew the patio of the churchyard. When a local farmer suggested that a suitable place for the showings be built, the priest offered to provide materials if the men would provide the labor. It was the first time in the memory of anyone in the area that a communal work project had been undertaken, but within a few weeks an area had been cleared and new benches doubled the former seating capacity. A whitewashed wall built as a projection screen was soon expanded upon to form a stage for school, church, and civic functions, and a surprising momentum carried over into a series of other voluntary public work projects. In this instance, an

unusual use of visual ethnography not only resulted in
goodwill and invitations that markedly increased our
effectiveness as investigators, but also had the equally
unforeseen value of fostering local community
development (private communication).

Many anthroplogists have realistic anxieties about photograph-
ing freely in the cultural community, but experience has indicated
that in many places of the world having one's image made with the
camera can be a very gratifying experience, provided the native
recognizes your view as a complimentary one. In many cultures
documentation of human activity, technology, and social life, when
photographed within the dimensions of protocol and human taste,
can be a readily understandable form of investigation. It is an open
form of recognition which people can thoroughly accept and un-
derstand, and the feedback of these documents of recognition proves
to be a very stimulating experience.

Fieldworkers have found they can safely approach human or-
ganizations by operating in a logical sequence, *from the public to most
private,* from the formal to the informal, in a reasonable fashion from
the outside in. The rule of thumb might be: photograph first what
the natives are most proud of. In South America this might be the
new water works, or the three-hundred-year-old church. In the
Maritimes of Canada it could be the dragger fleet, or prize oxen at
the county agricultural fair. The general impression you can work
toward is, "I like *you,* and I admire what *you* like." On the other
hand, the minute you begin making records of circumstances which
natives feel reflect criticism of their way of life, they can become
dangerously hostile. In Mexico you can be arrested for photograph-
ing poverty. As the community's trust of you and an intelligent
appreciation for your research increase, the natives will have a grow-
ing tolerance for what you choose to photograph. After all, what
you photograph is their *image,* and the nonverbal image often tends
to be more emotionally charged than the one they express verbally
and intellectually.

Speaking out of considerable experience with photography in
the field, Patricia Hitchcock adds a note of caution in regard to
feedback.

We cannot assume that all people want to see
themselves in pictures. We have to learn what they like
to see. In some cultures pictures of people who have
died turn the audience away. In a north India village
wives are in purdah to protect them from outsiders.
A husband would become very angry if you showed
pictures of his wife to men outside the family. Even

though village girls are permitted to dance outside the home on festival occasions, village elders would not like pictures of their daughters dancing shown to the public. Nice girls do not dance in public (private communication).

Suspicion usually falls on the fieldworker when the native finds his operations irrational. Seeking a rationale for "Why is that man making all those pictures?" they can give the fieldworker the role of government spy, labor agitator, or worse. The man with the listening ear can pretend all kinds of reasons for his presence acceptable to the native, but when the photographer records slums down by the tracks, everyone in the community forms motives for the worker's photography. Hence, it is safer to leave the alleys to the last and start by photographing historical monuments and local dignitaries.

Used with discretion and imagination, the camera can provide the fieldworker with rapid orientation to new circumstances and means of establishing a role and rapport.

Chapter 4 Photographing the Overview: Mapping and Surveying

In addition to general human orientation and rapport building, the first phase of fieldwork usually includes a variety of descriptive operations, outlining cultural geography and environment as a frame of reference within which the structured research goals can be accomplished. Usually this involves a mapping and sketching in of environmental areas. Here the camera serves a logical function.

Visual orientation can be vital. During the Second World War the loss of pilots and planes of the Air Transport Command flying the Burma Hump to China was dangerously high. Pilots lost their way, planes ran out of gas and crashed, planes landed on enemy airfields. The weather conditions on the Burma Hump made visual orientation extremely difficult. Also one monastery looked like another; one mountain peak looked like another mountain peak. Every tool of briefing was used to cut down fatalities. The Command seized upon photography as one important tool of orientation and education. First a photoplane mapped the Burma Hump making continuous records, taken at the vantage of the pilot at normal flying altitudes. The negatives were enlarged to photomural proportions and hung around the walls of the briefing hut in Burma where pilots would be kept for hours at a time while they engraved the imagery of each view of the Burma Hump on their minds. Significant landmarks along the way had been carefully selected—lamaseries, valleys, rivers, airfields—every point that the pilot might quickly see to discover where he was. Even in tremendous clouds, through one opening in the mist a mountain peak might emerge to orient the

pilot so he would know exactly where he was on the route (Russell Lee, private communication).

MAPPING

When we think of photography as a tool for mapping, we, of course, think of aerial photography, for this is one of the most accepted uses of the camera. Refined techniques of both aerial recording and aerial photographic reading have been developed. Interpretation of aerial photographs has been pushed further than any other application of this medium, simply because photography was pragmatically seized upon by mappers as an indisputably useful process. Indeed, today very nearly every square mile of the world has been put on film. So complete are the files of aerial surveys that major archeological investigations have been based upon them. Subsurface structures that are indiscernible at ground view become strikingly clear when seen at 1,500 to 2,000 feet elevation, particularly when the rays of the sun are falling in the right direction. Site after site has been found in this way. Archeology in England, Peru, and elsewhere owes a great deal to aerial photographic reconnaissance.

Aerial photographs have been used as a source of sociocultural data. Harvard University's Chiapas Project, under the leadership of Evon Z. Vogt and George A. Collier, carried out major community investigations using photographic aerial reconnaissance (Collier and Vogt 1965; Vogt 1974). Charles Rotkin, a New York photographer, provided most of the photographs for a book on European village patterns as seen from low-flying planes. These records have great historical value and present ecological relationships almost impossible to grasp except with this kind of photographic reconnaissance (Egli 1960).

Petroleum exploration demonstrates the dynamic relationship of aerial photography to ground-level investigation. In the worldwide search for oil, photo-geology allows exploration over very wide areas. Potential oil fields are examined first with aerial photographs taken when the sun is at the proper angle that reveal subsurface geology the same way they reveal Viking tombs in the heaths of England. A highly developed interpretive technique allows geologists to project subsurface geology from the outcroppings that relate to structures thousands of feet below the surface. Then the petroleum geologist, like the archeologist, moves from aerial photographs to ground investigation. Ground parties study the outcroppings first-hand. The field geologist carries the aerial photographs with him and usually begins his analysis of the outcrops with geological compasses and transfers these readings directly onto a regional map

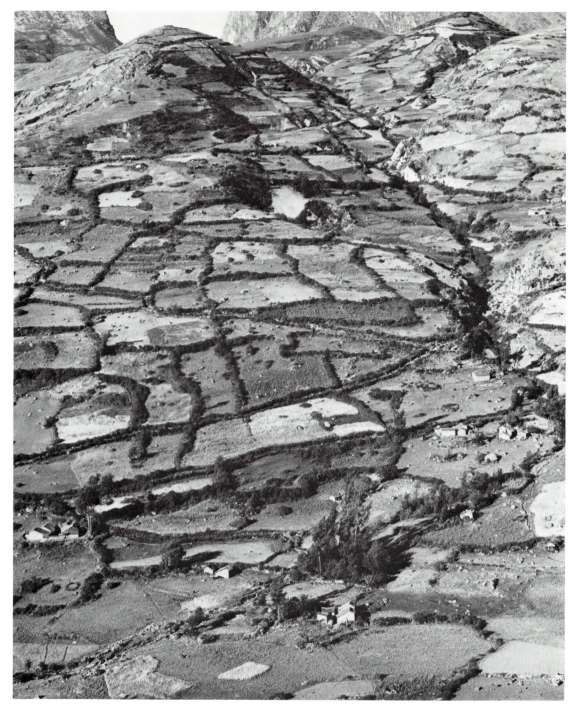

Indian peon field and home relationships in the Andes, Hacienda Vicos, Peru.

Relation of agriculture to geographic features—how far out in the desert, how close to the sea, how far up the mountain.

Field patterns, large fields, small fields.

Land divisions by walls, hedges, fences.

Engineering of irrigation systems from watersource to the fanning out of ditches.

Soil fertility—good land, poor land.

Rocky soil as compared to alluvial delta soil.

Water erosion—areas where soil has washed, or where alluvial movement has built soil.

Wind erosion.

Distribution of rock-strewn fields.

Fields plowed with rocks in situ (technology necessarily with hand tools; mechanized agriculture would be impossible).

Fields cleared of rocks, large stone piles and stone fences bespeaking effort.

Agricultural technology—use of contour plowing, understanding of soil conservation in irrigation, plowing to retard erosion or without regard for it, presence or absence of terracing.

Proportion of farmlands that are going back into brush and forests.

Forest growth. Timber cutting and timber farming operations. Areas of forest blight.

with aid of a mapping transit. The Harvard Chiapas Project moved from aerial photographs to village studies in much the same fashion.

Aerial photography can be supplemented, or substituted for, by long views taken from whatever high points are present. Where aerial photos are hard to get, long vistas may serve as well, particularly if the area has already been mapped. Panoramas and dioramas with a sweep of 180° are especially valuable. Ground-level sampling of the characteristic ecological features will help in the reading and interpretation of the aerial and long-view photos. Both color and black-and-white photographs reveal the altitude belts of agriculture and natural ecology. Color photographs, used with a color key for variety of soils, can rapidly indicate the geological topography of a whole farming region.

When we move from air to ground-level mapping with the camera our descriptive goals remain the same—to project onto the diagrammatic map the full detail of ecology and human activity. As an example, the U.S Soil Conservation Service has relied heavily on the camera for ground mappings. The nature and quality of the terrain, the good and bad range recognizable in detailed records of grass

and bush, the character of erosion by wind or water can all be responsibly read from ground photographs and the photographic data factually transferred to mapping overlays.

The Photographic Shape of Community Designs

If an anthropologist could float over a community in a balloon what could he observe of the patterns of community design? Foremost would be the community's relationship to surrounding ecology: desert community, sea coast community, forest community, crowded city neighborhood, isolated rural town. Beyond these geographic considerations the fieldwork would want to observe and record the community as a kind of organism. The small American town has its main street, around which the town is often structured; the Mexican community has its central plaza; Pueblo Indian communities used to nestle on mesas for self-protection.

Villages in diverse environments often have distinct designs, sometimes related to ecology, sometimes a product of culture. Aerial photographs of Europe show intense concentration of cities to reserve space for farmlands. Are technology and super populations breaking down this traditional conservation? Breaking down by what pattern? The patterned spread of habitations out into the open lands is revealed distinctly in both aerial and panoramic photographs.

French communities in Nova Scotia are strikingly different from English communities, though they share similar ecology. In photographs it is possible to define the space between houses, the French clinging to a village pattern even though the village street may be five miles long. The English, who are more individually oriented, scatter their communities loosely over their respective farmsteads. Each culture uses land in a particular way; the differences may be subtle, yet the patterns divide one people from another. This is common knowledge, but specific measurements and comparisons will help establish this character responsibly in anthropology. Photographs of community design from the air and ground provide a basis for such measurement and comparison.

A first photograph of the community could be the panoramic view that would give us several 180' sweeps of the full pattern of the village and its surroundings. Is the community centralized? Or is it scattered? A fishing community might be built near docks and around harbors. Panoramic photographs, if taken from a high point, are like aerial photographs. They can provide immediate data on land tenure patterns and boundaries between different social and cultural groups within the area, and often they can alert us to changes that are occurring in the region. Are the fields being filled up with

A long view of a Spanish American community, showing its setting within the ecology. Wood supplies are in surrounding hills, grazing lands on mesas, subsistence irrigated farming and pasture in the valley, Rodarte, New Mexico.

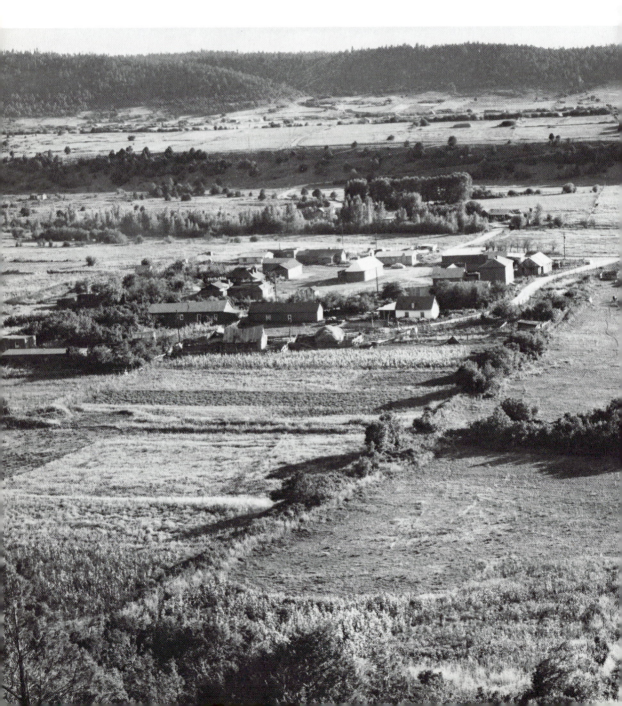

Visual anthropology is a search for cultural patterns. The organization of this Acadian village in the Maritimes of Canada contrasts with that of the Spanish American village of Rodarte.

new buildings? This may be a sign of declining agriculture, rising land values, or other factors unknown, but the evidence of such an encroachment would alert us to questions we would need to ask later.

It may be possible to obtain historical photographs of landscapes and panoramas. If the location from which these were taken can be identified, new photographs can be taken from the same spot and a comparison of the two coverages can alert the fieldworker to important patterns of culture and change. Panoramas taken by Malcolm Collier over an eighteen-year period from the same rock overlooking the Taos valley in New Mexico provide an example. Early panoramas showed clearly defined separations between residential and farm lands. They also recorded a residential pattern of relatively closely spaced housing located along irrigation ditches. Ten years later there was still no major change in housing patterns, but a large block of land had clearly gone out of agricultural production. In the final set, eighteen-years later, these fallow lands had been subdivided into a residential pattern that was distinctly different from the one still maintained in adjacent older residential areas where land was still in some degree of production. The demarcation between the two land use patterns reflected the different residential patterns of Spanish Americans and incoming Anglos.

As we enter the community with the camera we ask again the question of economic function and status. Though questions become more complex, many nonverbal variables still remain on the surface, allowing us to compare the town regionally or examine it individually for internal structure and organization. Conspicuous consumption becomes an important variable and one that may be recorded with the camera. We ask is this community economically a hub of the region? Has the town a lively mercantile center? What are its major offerings—feed, fertilizer, or ship chandlery supplies? Photographically we attempt to record every bit of propaganda and advertising—political, cultural, and commercial. We photograph to count how many and how large are the stores. If we photograph on a shopping day we can observe how popular this center is as compared to nearby villages, how many cars are parked on the streets, how many people are coming and going.

Beyond the physical and economic schemes of the town there remains its well-being and cultural vitality. Any park benches to rest on? Bandstand for concerts and gatherings? Is the town dominated by Catholicism or by many splinter Protestant churches? Are there places of recreation—bars, restaurants, movies theaters?

Photographing strictly in the public domain, the camera can, in a few hours, record the *outer face* of the community. Some major outcroppings of regional culture can be recorded as well, again provided we seek reliable variables of measurement and comparison. Many elements in this community visit are just as discernible with the eye, but how can written notations preserve the wide variety of ecological and cultural details? And how precisely? How will we compare field notebook records made in one locale to those made in another? Or geographically to other regions which might contain comparable environment? Impressions gained with the eye alone grow dim, fuse with other impressions, and with time fade away. When we use the camera it is possible to assemble a complex model which contains literally thousands of tangible elements to be compared to other communities photographed throughout the region.

Fieldworkers turn to government maps and geophysical charts because of their dependable character. Photographic mapping and surveying in careful conjunction with such graphic records greatly increase the dimensions of detail of these geophysical charts, and enable us definitively to relate ecology to culture, social structure, and technology.

Photographic profiles of communities, both rural and urban, can be transferred to the conventional diagrammatic map either in

Main entry and thoroughfare of Manizales, Colombia (1940s). Ground-level recording presents new viewpoints of organization and function. Here, pack horses enter the town while down the street wait trucks that may carry these goods to more distant markets.

overlays or with colored pins. The goal of our efforts is to use the intelligence of photographic mapping to relate ethnographic considerations to the larger ecology. The concept of overlays can be extended to include many visible schemes of community culture, as well as such variables as affluence and poverty.

The mapping of these characteristics was attempted in Cornell's Stirling County Study in the Maritimes of Canada directed by A. H. Leighton. The field team's first attempt to gather their data for an affluence and poverty mapping overlay indicated how important photography can be in this kind of surveying. In the project's first attempt to gather data teams of fieldworkers, two to a car, toured the area. Roads, yards, sizes of houses, conditions of repair were checked off appropriately on dittoed forms as they drove down the

country lanes. In this test run, teams were paired against each other and, to the discouragement of all, the evaluations of the housing did not agree. Fieldworkers quite naturally rated housing against their own environmental background; a fieldworker from the country would treat the houses one way, while a fieldworker from an urban environment would evaluate them in another way.

The result was quite a range of impressions. In an effort to stabilize this operation, I (John Collier) went into the same area as the project photographer, making shots with a Leica of houses down one side of the road and up the other. These were enlarged to 8 by 10 in. and presented to the evaluation team who sat in a circle and passed the photographs, rating each one of the houses on the back. Again, the discrepancy of judgments was far too great, but now the operation had a powerful control—photographs. They were laid on the floor and argued over until the judgments were responsibly established. The field team then went about making their survey. The survey could have been completed by photographic reconnaissance, with a group judging of the housing photos, which would have given the added advantage of a permanent file record. In the course of the continuing research, I recorded several whole rural communities, each in a matter of hours. This material was shown to key informants who were able to give instructive information about every household in one interview. This offered a responsible source of community mapping and personality identity, obtained without a house-to-house questionnaire (Collier 1957).

Photographs can become more intelligible to the researcher when the precise visual symbols of interpretation are systematically recognized. In both rural and urban surveys, measurements that allow for anthropological typologies are not just graphic impressions. Instead they are pinpointed observations of variables that can be responsibly counted, measured, and qualified.

Mapping and surveying affluence and poverty in rural areas operates around a few visual norms which have psychological, cultural, and economic significance. Starting from the simplest dimensions, we have the absolute comparisons of large homes and small homes, and of run-down homes and well-kept homes. How commodious the houses? How many stories? How many outbuildings? Photographs allow for exacting comparison of scale. When we move further into the culture, economic level may become just one of the factors to be noted in the charting of regional mental health. Emotional and cultural well-being may also be reflected in photographs of dwellings.

Variables for recognizing psychological levels would have to be put together within the value system of the region under study.

Some Variables of Well-Being in a Rural Setting

ECONOMIC
 Fences, gates, and driveways
 Mail boxes, labeled, painted
 Telephone lines
 Power lines to house, to outbuildings
 Condition of house walls and roof
 Condition of windows
 Condition of yard, flower beds, or vegetable garden
 Farm equipment near house
 Trucks and cars in yard

CULTURAL AND PSYCHOLOGICAL
 Intrinsic care of the house
 Decorative painting
 Curtains in windows, potted plants
 Self-expression in garden: abundance of flowers
 Self-expression in yard: raked, swept, wood and tools stacked and
 stowed, or property scattered about

Each culture has its own signposts of well-being. Once these signs are understood, a photographic survey offers an opportunity for rich interpretations. How can we arrive at these variables? Briefly, we can standardize cross-cultural nonverbal language through projective interviewing with environmental photographs. This procedure is be covered in a later chapter.

A city offers a community research project even greater visual challenges, for the units involved run into thousands. Door-to-door questioning and census material form the basis of much urban anthropological mapping. When samples of streets are photographed, evidence for mapping increases. In our courses at San Francisco State University students use this approach in mapping complex urban neighborhoods. The students divide up areas by streets, and proceed to photograph angle views of each street. These angle shots are supplemented with more selective detail and medium-range shots. All the photographs can then be mounted on long rolls of paper or in folding sets of mount board. When mounted in proper geographical relationship to each other, such collections may stretch over twenty feet, providing an encapsulated visual walk through the neighborhood.

Examination of these compilations define boundaries between neighborhoods, locate and describe centers of economic and social functions and historical trends, and serve as the source from which

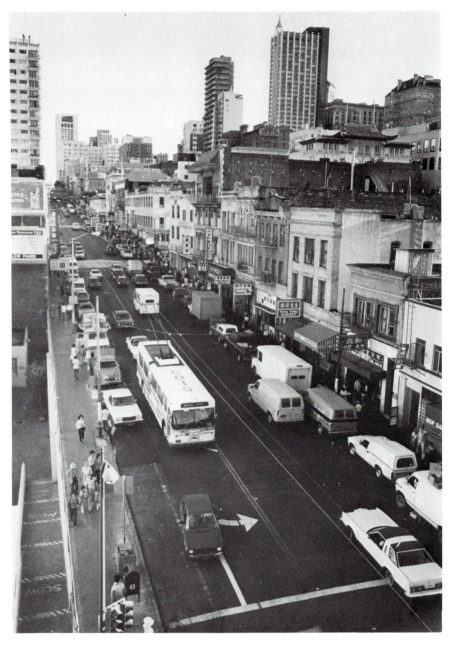

The complexity of an urban area challenges sampling and recording. How do we capture important organizational, functional, and historical patterns? Stockton Street, main shopping section of San Francisco Chinatown, California. (Photo by Malcolm Collier)

to develop focused questions for further investigations. With careful work, precise statements can be made regarding social and cultural features of neighborhoods, the character of housing, and the human "feel" of the locale. The photographs can be examined by a group and "scaled," so that agreed upon readings can be made of the photographic evidence.

Survey and mapping photography often begins as a part of the first phase of fieldwork, but as it becomes more complete and detailed it involves a movement from initial orientation into more focused aspects of fieldwork. Many photographs taken during the orientation and overview period will be found valuable in new and different ways as the fieldwork *and* the analysis continues. The multilayered potential is a product of the depth and detail of good photographic records.

Shooting Guide for a Photographic Survey
of an Urban Neighborhood

LOCATION: Where is it? Shots that show location, boundaries, landmarks, geographical features, signs, anything that defines location.

APPEARANCE: What does it look like in a general sense? Record the visual character of locale, range of building types, character of streets, visible subsections. Hilly? Flat? Both? Are streets straight, winding, a mix? Are buildings short, tall, wide, narrow, new, old? In repair or run down? etc.

ORGANIZATION: What are the components of the neighborhood? How is it arranged? Where are businesses, public places, religious institutions, residences, etc.? Make wide shots to define relative location, close-ups that show details.

FUNCTIONS: How is the neighborhood used? Record range of activities, services, functions. Businesses, residences, restaurants, schools, recreation facilities, etc. Whom do they serve? Local population, the city, the region? Particular ethnic groups, age ranges, subcultures, men, women, social classes, occupational groupings, etc.? Make photos that record the orientation of places toward clientele and the character of who comes, goes, for what, where, when? Wide shots for relationships and context, closer shots for details and identification.

PEOPLE: Who lives here? Who comes here? Works here? Is the population homogeneous? Mixed? Young? Old? Transient? Record the range of people to be seen and other evidence of the human mix of the area. Store signs, goods for sale, club names, decor, etc.

continued on next page

TRANSPORTATION: How do people get around? What are the major transport arteries, pedestrian routes? Are there pedestrians, who are they? Bus lines, crossroads, transfer points, parking lots, congestion?

RESIDENTIAL AREAS: What do they look like? Character and condition of buildings, sidewalks, streets? Mix of business and residences? Transition zones? Range of building styles, age, nature of units (single, double, multiple, etc.). Who are the residents? Look for details that may provide clues as to the cultural and economic character of inhabitants, age ranges, living styles.

DAILY CYCLES: What is the cycle of the day in this place? Who goes, comes, when and where? Record the flow of people, activities, functions. Extend to larger cycles of weeks and months. When and where are the peaks of activities?

HISTORY: What can be seen that reflects the past? Old buildings, signs, sidewalk markings, stores with declining patronage, physical characteristics of past functions, evidence of past populations incongruent with the present mix of people and functions.

CHANGE: Where is this place going? What is its future? What is changing, what is not? New construction, what is it for? Demolition, of what, where? Store clearances, closings, openings, relative mix and character of old and new businesses, institutions? Liquor license details, permits posted? People moving in, out? What things are constant? Active older institutions, stores, functions? Old-time people, new-time people, who has children, who does not, age distribution of different groups? Photographs that record all or some of these variables.

An understanding of the whole is important to many people. Among the Navajo, history, cosmology, and ecology are interrelated elements that shape the world and decisions. A Navajo singer looks over a valley in the early spring, prior to planting, near Piñon, Arizona.

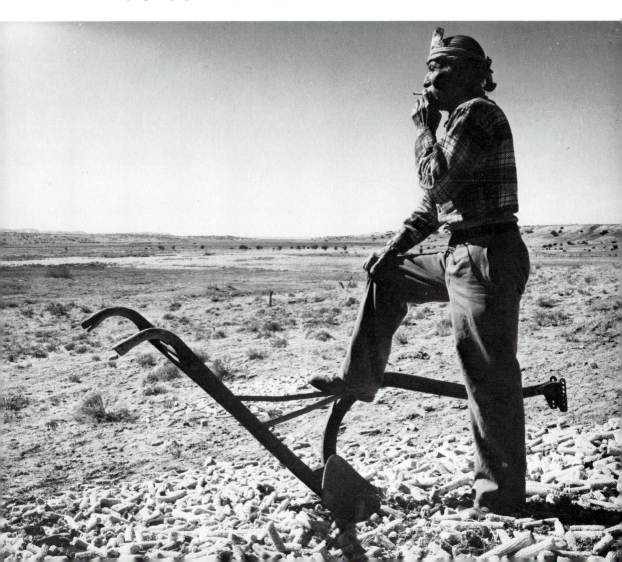

Chapter 5 The Cultural Inventory

The concept of inventory is usually associated with the listing of material goods, as in a store, or the listing of artifacts from an archeological site. But a cultural inventory can go beyond material items to become a detailing of human functions, the quality of life, and the nature of psychological well-being. The photographic inventory can record not only the range of artifacts in a home but also their relationship to each other, the style of their placement in space, all the aspects that define and express the way in which people use and order their space and possessions. Such information not only provides insight into the present character of people's lives but can also describe acculturation and track cultural continuity and change.

John Roberts, of Cornell University, made the pioneering effort in controlled cultural inventory in his complete recording of three Navajo households near Ramah, New Mexico (1951). He used photography in his publication to illustrate the surface character of the hogans, but the elaborate listing of objects, to our knowledge, was done entirely with a notebook. This study remains impressive and excites speculation as to what could be concluded from such effort, for Dr. Roberts has left up to the reader what the implications of family property might be.

The value of an inventory is based upon the assumption that the "look" of a home reflects who people are and the way they cope with the problems of life. John Honigmann states this proposition:

Cultural inventories are rich sources of insight. John Collier recording in a Pueblo Indian home, New Mexico.

A bookcase can become an informal shrine that reflects family concerns and character. (Photo by Edward Bigelow)

> An inspection of material culture may contribute insights into character structure and reveal emotional qualities. Product analysis entails examining utilitarian constructions, like houses and toboggans, to determine the values they embody, as revealed, for example, in careless or perfectionistic construction. The proportion of non-utilitarian objects to utilitarian objects in a culture may also be meaningful. Type and number of possessions may reveal drives and aspirations in a class structured community (1954:134).

Jurgen Ruesch and Weldon Kees emphasize the importance of the use of objects in the identities and expressions of people and cultures.

> The selection of objects and the nature of their grouping constitute nonverbal expressions of thought, need, conditions, or emotions. Thus, when people shape their surroundings, they introduce man-made order (1956:94).
> Foremost in the array of things that men have ordered are the objects with which they surround themselves in their own homes. . . . [Though] not

everyone is fortunate enough to live in a structure built to meet the demands of his own taste . . . every building indicates in some way whether or not it is representative of those who live in it. This is particularly true about interiors, where the nature and arrangement of possessions say a great deal about their owners' views of existence (1956:132).

An inventory not only deals with material content, it also records the arrangement and use of space. The spatial configuration of otherwise ordinary objects, common to a mass society, may often reflect or express the cultural patterns and values of distinct cultural groups or may provide insight into the well-being of the inhabitants. Edward T. Hall comments on the use of space:

> . . . the inside of the Western house is organized spatially. Not only are there special rooms for special functions—food preparation, eating, entertaining and socializing, rest, recuperation and procreation—but for sanitation as well. *If*, as sometimes happens, either the artifacts or the activities associated with one space are transferred to another space, this fact is immediately

Home away from home in the Canadian Arctic. Each bunk in this oil camp was a reflection of the inhabitant.

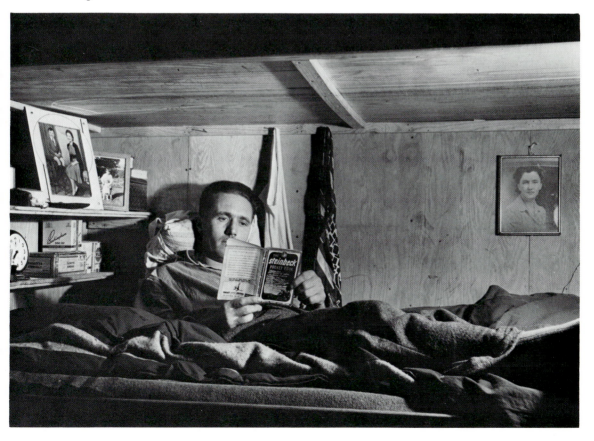

apparent. People who "live in a mess" or a "constant state of confusion" are those who fail to classify activities and artifacts according to a uniform, consistent, or predictable spatial plan (1966:97).

The content and organization of a home is usually a reflection of its inhabitants that, if read properly, can give considerable understanding of the people themselves. Home inventories have been a routine assignment for students in classes taught by the authors at San Francisco State University, both in visual anthropology and Asian American studies. These inventories have demonstrated, on numerous occasions, the richness of the inventory content.

In one case, Filipino American students were able to define both the ethnic identity of the inhabitants of a home and the time of their arrival in the United States from photographs of a Filipino American home in which there were *no* overtly Filipino artifacts. The key to their reading of the photographs lay in details of spatial use and the arrangement of common household items, all of which could have been bought at any suburban shopping center. A comparison of photographs of homes of different Asian American groups clearly demonstrated that each group maintained culturally distinct homes, as reflected not only by explicitly ethnic artifacts but also by the range of objects chosen from the larger American scene and the manner in which homes were organized and maintained.

The cultural inventory offers, then, one of the richest pools of data which can gathered photographically. Just what *can* be studied responsibly in the details of an American home? Here are some of the questions that can be asked in relation to the cultural inventory:

WHAT IS THE ECONOMIC LEVEL?
> The condition of the furniture, rugs, wallpaper, curtains may reflect economic adequacy, poverty, or a conscious rejection of the symbols of material affluence.
> Economic stress often shows throughout the home's possessions, and economic stress necessarily limits the range of *choice* in the determining of style.

WHAT IS THE STYLE?
> Home styles have a great deal to do with life-styles; some ways of life are associated with one style, other ways with another. Some styles reflect regional background, with their prototypes in the midwestern farmhouse or the California ranch home. Others may reflect European or Asian models.
> Some styles have names which represent quite specific models in materials, aesthetics, and use: for example, Early American, Traditional, Modern, Louis Quinze, Empire, Provincial, Danish Modern.

Each area has a going value system, for example in San Francisco, a Nob Hill apartment and a Pacifica tract home call up entirely different images.

Style often places the household in the class and status structure.

WHAT IS THE AESTHETIC OF THE DECOR?

Not only pictures on the wall, but every object of decoration, each item selected and kept for its own sake, is a clue to the owners' value system.

These reflect ethnic identity or affinity, religious expression, political sentiment, and aesthetic judgments.

They may have a subject-content focus: Nature orientation, open spaces, mountains, seas, forests, gardens, wild animals; social orientation, scenes of history, humanity, children, dogs, cats; nonrepresentational, interested in form or color rather than content.

They may show a distinct preference for one or several styles; Traditional Euro-American styles: biblical, Greek, Roman, Renaissance art, Old Masters, established "masterpieces"; Progressive styles: modern art, abstraction, nonobjectivity, industrial ornaments, parts of machines as elements of industrial design, beauty as function, Oriental or exotic designs and ornaments, primitive art.

They may express ethnic or cultural identity: Pendelton blankets, ceremonial objects, bows, religious shrines and figures, paintings, modern "folk art" associated with a particular ethnic group.

WHAT ARE THE ACTIVITIES OF THE HOUSEHOLD?

The house may be only to eat and sleep in, or it may be the scene of and the product of a great deal of activity, work, play, and socialization.

It may give evidence of self-expression: craft, "do-it-yourself" home furnishings, needlework, textiles, modelmaking; artwork, drawings, paintings, sculpture—made by the inhabitants or their personal circle of friends; children's school art.

Is the home a standardized copy of magazine taste, or does it show inventiveness of these people?

Are there organic interests—plants, birds, goldfish, pets, nature collections?

Is there music in the house? Music produced here, piano or other instruments, sheet music, music stands; music listened to, record player, stacks or cabinets of records, hi-fi equipment, radio. Are sports and games represented? Evidence of active sports, equipment, trophies, games, toys, for children, for adults, or both.

Evidence of sports interest (spectator sports), pictures of Joe Montana, etc., sports schedules, newspaper sports page, sports magazines.

What is the level of literate interest in the household? Quantity and choice of books, standard works, classics, text books, best sellers, detective stories, extensive library on one or several subjects, poetry, art books, avant-garde works; magazines—women's magazines, sports magazines, news magazines, political comment, girlie magazines,

continued on next page

newspapers, funny books, religious tracts—all help to categorize the mental concerns of the inhabitants.

Is the home the place for social life? For the family only, or for the entertainment of friends? The answer may be reflected in organization as well as content; there may be a formal living room, informal room for family and friends, private areas for family only.

Is eating a major focus of family values? Food technology and attitudes are often culturally determined, often reflected in kitchen tools and the inventory of cupboard shelves.

WHAT IS THE CHARACTER OF ORDER?

The order of the home may reflect the means by which people pattern their lives. "A place for everything and everything in its place," represents one ideal of mastery over the material objects of life's circumstances. This could be evidence of one kind of organized personality, or it might represent a psychological compulsion.

Mess is the clutter and chaos that accumulates as things are *not* in a reasonable place, either because the reason of their ordering is not established or because the housekeeping function is not being fulfilled, for whatever reason of insufficiency of time, energy, health, or motivation.

Another form of clutter occurs, even when things are "in their place," if there are too many things or if the basis of their ordering is unreasonable or interferes in some way with function.

WHAT ARE THE SIGNS OF HOSPITALITY AND RELAXATION?

In "mainstream" American culture, by cues of placement and ordering of furniture, we know when we come into a room whether we are expected to remain standing or sit down, and if we are to sit down, where, and how. Furniture is placed to offer hospitality or refuse it. A bookcase may invite you to help yourself, or it may prompt you to ask first, or it may be so forbidding you would never think of doing more than looking. Each culture has such patterned messages.

The different styles of furnishings present different values of hospitality. Sometimes roles are clearly defined in formal fashion. Sometimes informality is given the higher value. The attitude expressed in "If I'd known you were coming I'd 've baked a cake!" has its expression in many details of furniture choice and arrangement.

In evaluating the cultural cues, we have to ask, what does this kind of a chair mean in this particular setting?

REVIEW OF TWO CULTURAL INVENTORY PROJECTS

The procedures for making a cultural inventory with the camera can be explored through discussion of two research efforts involving use of the cultural inventory. The first was carried out in the Peruvian Andes and the second in an urban setting in California.

The Vicos Inventory. Four years after John Roberts's study of four Navajo households, John Collier made a detailed photographic inventory of a home in the Indian community of Hacienda Vicos, in the Andean Sierra of Peru. Here, Cornell University and the University of San Marcos in Lima were carrying out a project in applied anthropology. Its goal was to prepare the Indian peons of Vicos to take over their colonially established hacienda and live as free citizens of Peru. Methodologically, Cornell had become the hacendado or proprietor of Vicos and its two thousand inhabitants. Through a program of step-by-step innovation, the project introduced new agricultural techniques, improved health services and social service, an expanded educational program, and other innovations. These were intended to change the Indians' state of mind, as well as provide them with new skills and technology, releasing new culturally determined energy and confidence that would allow them to function as a free community.

After three years the project staff decided to make a photographic cultural inventory of every eighth home in Vicos, to measure systematically some of the influences of the project on Indian families. A random sample was made from census lists, and John Collier proceeded to photograph every wall, in every room, of every home in the sample. Indians were loath to open locked storerooms that would reveal the agricultural wealth of each family as well as, in some cases, items borrowed, given, or appropriated from the hacienda. Hacienda power was invoked to unlock all storerooms where harvest and property were stored. The homes had no illumination, but it was possible with electronic flash to photograph in great detail in even the darkest corners. It took two months to complete the inventory but the record made was comprehensive.

A Rollicord camera was used, producing 2¹/₄ by 2¹/₄ in. negatives from which readable contact sheets could be printed without the need for enlargements. Fundamental patterns of Vicosino home culture were easily seen in the contacts. The sample included homes a few hundred meters from the hacienda administration center as well as homes five miles away on the periphery of hacienda lands. Innovation was most evident in the homes nearest the center and diminished toward the outskirts of Vicos. Near the center, homes reflected contacts with project staff and programs: snapshots of American scenes, items of technology, the early effects of schooling including printed political propaganda and school books. Homes on the periphery revealed little or no evidence of these contacts or any other influences of the project.

Public health was a serious concern of the project, for intestinal and other diseases affected every Vicosino, but the inventory showed

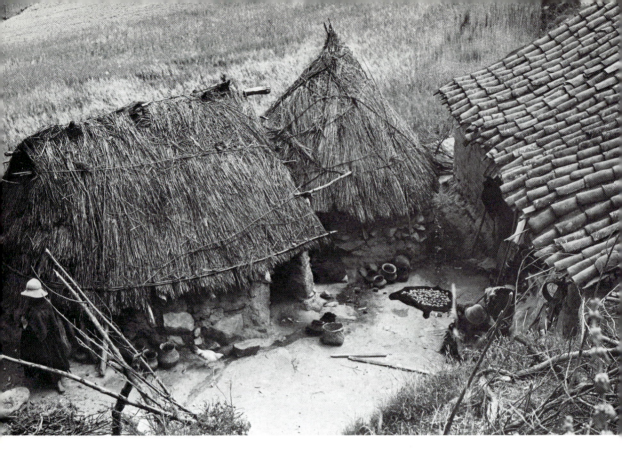

A photograph of the exterior of a home in Vicos sets the context for inventory records.

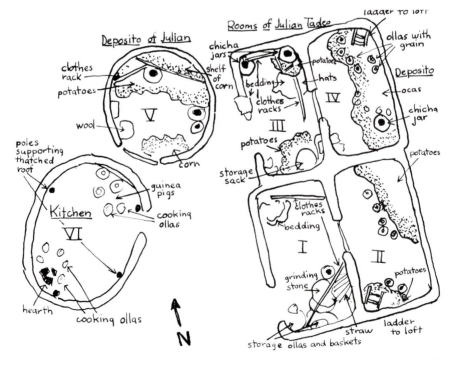

Deposito of Julian

clothes rack
potatoes
wool
poles supporting thatched roof
Kitchen VI
guinea pigs
cooking ollas
hearth
cooking ollas
corn
V
N

Rooms of Julian Tadeo

ladder to loft
chicha jars
shelf of corn
bedding
clothes racks
potatoes
hats
ollas with grain
Deposito
ocas
chicha jar
potatoes
III
IV
potatoes
storage sack
clothes racks
bedding
grinding stone
I
II
potatoes
storage ollas and baskets
straw
ladder to loft

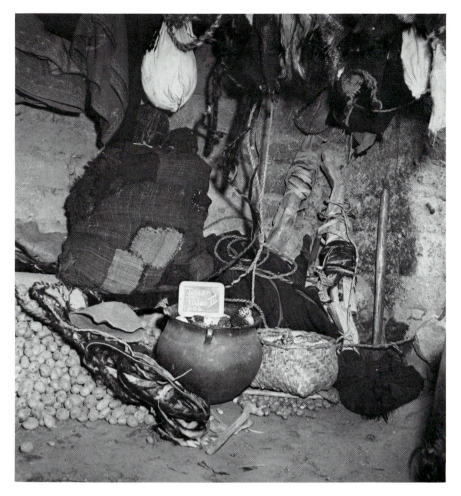

Storage area in room III of the home. Storage areas held key information on wealth and technology of each family.

that domestic hygiene practices were unaffected by educational programs. Food preparation practices were unchanged by project efforts; the same fire stones and utensils were found in every home in the sample whether wealthy (by Vicos standards) or poor, close to the hacienda or on the distant edges. It appeared that health- and food-related practices would be among the last things to change. Agricultural innovation in the form of improved potatoes, fertilizer, and use of sprays was evident, but tools stored in the homes reflected little change in agricultural technology.

Opposite: Diagram of the same home, keyed to slates in photographs. Graphic floor plans help to organize the findings of photographic inventories.

This two-thousand-negative inventory presented a wealth of information, both statistical and qualitative. Detailed analysis of large cultural inventories can provide mathematical volume to ethnographic research. Such statistics can quantify and stabilize the details of studies of acculturation and change. The Vicos study was a saturated recording process; in contrast we can compare a visual inventory study of the welfare of relocated American Indians in the San Francisco Bay Area.

The Relocation Study. In 1963, San Francisco State College made an investigation of the cultural and psychological welfare of relocated Indians in the Bay Area. Approximately 10,000 Indians were relocated in the San Francisco Bay Area at that time. How did they adapt to the urban environment? What were their methods of adjustment and acculturation? Why did some succeed in the urban center and others did not? Why did some remain in the city while others returned to their reservations? The very mass of statistical data to be studied presented the need for computerized techniques, questionnaires, and psychological tests in conjunction with conventional interviewing. Some fifty researchers were involved, all working under limitations of time and funds with which to complete the study so that it could be integrated into national research on migration and human displacement—a primary concern of the National Institute of Mental Health which sponsored the program.

Photos of walls often provided information on entertainment, literacy, and political concerns of families.

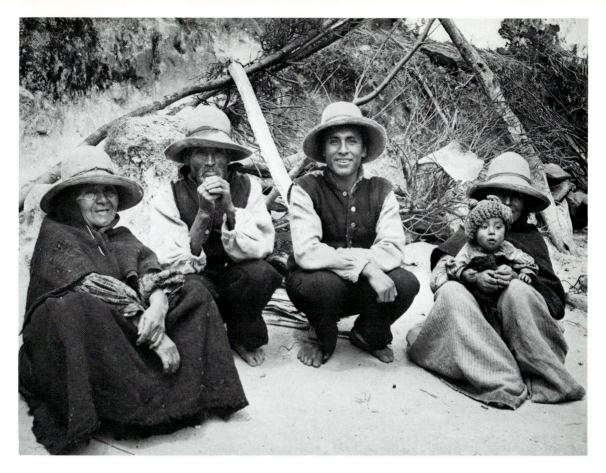

The Julian Tadeo family, whose home is seen in the preceding photographs. He held a position as guard for the hacienda, and the family was affluent relative to many in the community.

This was an anthropological and a psychological problem having to do with changing cultures of Indians from many diverse tribes. Methodologically, the real challenge was to retain the ethnographic view in the strictly urban setting. Could models of the new urban Indian culture be drawn? How could cultural description be systematically correlated with the larger statistical findings?

Photography was chosen as a tool for synchronizing ethnographic description. This choice offered the project a number of tangible supports—a variety of recordings, accomplished by photographic observation in depth of a fairly small sample, and a return of data that could be processed by statistical analysis. Thus a correlation could be established between the questionnaire data and the ethnographic descriptions. The challenge was to recover and apply the factual levels of photographic recording, and then go beyond to correlate the holistic schemes of the culture gathered in the open view of the relocated Indian's life.

Informal shrine in relocated Sioux home, Oakland, California. Analysis of this assembly could begin to reveal complexity of urban Indian acculturation and adjustment.

The Indian homes were clearly defined units where comparable routine recordings could be made. The cultural inventories thus assembled offered an opportunity for observing and measuring acculturation and analyzing schemes of success and failure in relocation. We were concerned with *what* was in the Indian home, with its quality and condition, the manner in which it was ordered, and its relationship to the Indian family.

Since the sample of twenty-two households was too small to offer the validity of random sampling procedures, the families to be photographed were selected on the basis of rapport and cooperation, but the fieldworkers involved did their best to provide range and variety in tribal background, economic level, age, length of time in the area, and the methods of relocation—self-initiated, or government sponsored for employment or for training.

After contact and sufficient rapport had been established by one of the project's interviewers, each home (with one exception) was photographed on a single visit with consent and by appointment. The fieldworker was present as well as the photographer, John Col-

lier. In all cases living rooms and kitchens were thoroughly photographed. In all but four households one or more bedrooms were also covered. The focus was chiefly upon the contents of the households and their arrangement, with wide-angle shots to show placement of the various items and furniture and the relationship between rooms, and with close-up shots to show areas of particular interest, such as mantles and bureaus and the tops of television sets where small but presumably valued objects were collected.

In the course of the session informal individual and group portraits were made of the family, for the benefit of the family as well as the project. Beyond this the normal activities taking place were

"Can you tell an Indian family lives here?" Two distinguishing elements, a tuft of eagle feathers and the rosette, suggest an Indian presence.

photographed if the situation remained fluid and cooperative. The photography was not allowed to push beyond the tolerance of the family involved and was discontinued if it was perceived as threatening. This occurred in two instances, though in both cases the major part of the coverage had been made before this point was reached.

The photographer (John Collier) used a Leica and available light in the belief that this would give the most accurate rendering of actual living conditions. This assumption proved correct, dispite the disadvantage of limiting detail in poorly lit homes. For certain types of recording, bounced strobe light might have greatly increased the depth of focus and made reading of detail easier.

One or two 36-exposure rolls of 35-mm film were taken of each household. These were contact printed, and six to ten key pictures were enlarged from each set. For analysis both the enlargements and the contacts were studied, the latter with the help of a magnifying glass.

The analysis included an inventory of the objects in each of the houses. The inventory for each family consisted of a listing and description of furnishings and visible possessions, including quality, condition, material, and style, where relevant. The following sample inventory gives an idea of the sort of data that can be gathered by direct examination of the pictures.

Inventory: Laguna Family
(taken from the field study)

MAJOR FURNISHINGS
 upholstered sofa and matching chair
 heavy wooden dining room table
 old kitchen table
 four light metal frame, plastic seat, chairs
 wooden chair by TV
 three double beds, all with chenille spreads
 crib, moderately priced
 inexpensive chest of drawers, ragged bureau scarf, and large round
 mirror
 Venetian blinds and drapes to floor in living room
 small worn rugs

USE OF SPACE
 large room divided between living room space (sofa out across the
 room, facing television) and dining room-workshop space with table,

chairs, and kitchen-type cabinets; dining-room table used by children for homework; books, etc., piled on cabinets
two double beds in one bedroom
one double bed and crib in second
kitchen work area off dining room, very compact

COMMAND OF URBAN TECHNOLOGY
large double-oven gas stove with timer
large refrigerator
cabinets and work counter built-in
small television on stand
Taylor-Tot stroller
wind-up alarm clock
lights in dining end but not in living room end of big room

ORDER—CLEANLINESS, NEATNESS, CONSISTENCY, AND STYLE:
kitchen spotless, everything put away
floors clean
miscellaneous objects piled, freshly ironed shirts hanging on a cabinet in dining area
cartons for storage in bedroom corner, thermos on bureau
back of sofa exposed showing older upholstery style—essentially utilitarian, unpretentious

LITERATE CULTURE
set of books, probably inexpensive encyclopedia
school books
newspapers

ART, MUSIC
large picture of aircraft carrier in frame
plaque of horse's head inside a horse-shoe
two wall plaques (made in school?)
one photo-portrait with glass frame
school photo-portraits in cardboard frames
snapshots

SPORTS, TOYS
dolls and animals on ledge above living room window
doll in crib, other toys
child's rocking chair with music box attached
trophy for basketball

CHRISTIAN RELIGIOUS ITEMS

continued on next page

INDIAN OBJECTS

 two woven ceremonial belts

 rattle

 three rather plain kachinas

 striped Pendleton blanket, woman's plaid Pendleton shawl with fringe

 abalone shell (While not an exclusively Indian item, abalone shells from
 the West coast have been trade goods for centuries and are valued
 by many Indian groups for use in jewelry and sacred objects.)

"SHRINE" AREA

 dummy mantle (no fireplace) on one side of living room, basketball
 trophy in center, photo portraits on either side, pair of baby moc-
 casins at far left, horse's head in horseshoe and small ceramic animal
 at far right

 picture of aircraft carrier is centered above mantle, two snapshots
 tucked in corner

 a foot or so away on either side of the mantle there are hanging, at
 the right a kachina and a rattle with a woven belt draped over them,
 at the left two kachinas and another woven belt.

A first and overall impression of the photographs was that almost all households were well equipped, in variety if not in quality–with the essential items. Anyone with a memory of the thirties, or a knowledge of rural poverty, or a familiarity with houses on any of the remote Indian reservations in the 1960s was apt to be impressed that every family has a refrigerator as well as a kitchen sink, gas or electric stove, and bathroom. Bathrooms were not photographed, but no family in the sample had to share theirs with another family, as was the case in many urban slums. All but two households had television sets, and one of these acquired one soon after. Nevertheless, the range of quality and adequacy of the furnishings was considerable.

Further analysis embodied a comparison of the homes with one another, and a comparison of the inventories with what was known about the families from the interview and questionnaire data. Finally an attempt was made to bring these together with the general concerns of the project. This was done by indicating how the houses reflected attitudes toward "Indianness" and toward the dominant culture, and by attempting to identify the value systems by which the various families operated in the urban setting. Mary Collier made the detailed analysis of the inventory, prepared the charts of comparisons between the photographic data and the questionnaire and interview data, and coauthored the written report. A sample chart shows relationship between time in the Bay Area and quality of furnishing:

TIME IN THE BAY AREA COMPARED WITH QUALITY AND CONDITION OF FURNISHINGS

	Time in the Bay Area				
	Less than 1 year	1–3 years	4–9 years	10–20 years	Over 20 years
I		Pomo I Pomo II			
II	Sioux I Sioux II	Eskimo II Eskimo I	Hualapai- Navajo Sioux III		
III	Kiowa I Kiowa II	Kiowa III Kiowa- Eskimo	Navajo		
IV			Kiowa- Choctaw Sioux IV Basque- Rincon	Miowok Sioux V	
V				Italian- Seminole	Chippewa- Tutunai Sioux VI

Despite the absence of a general study of the contents of American households, we could say how these homes compared with the national image. In search of that image we turned to the women's magazines but found that their standards of elegance left all but possibly two or three of the homes far behind. But the Montgomery Ward catalog did provide models—almost specific ones for several homes—and its range of styles and prices in many articles of furniture proved a valuable guide to relative values.

As noted, the research was concerned with the response of Indian families relocated from their familiar ecological and cultural surroundings into the complex and often stressful environment of a major urban area. We were looking for home models of both success and failure, seeking to find in the inventory records the details of home content and character associated with and reflective of differing degrees of adaptation to the urban setting. These could then be compared with the results of other, more conventional research methods, and it was in correlations between different types of data that the true value and significance of the cultural inventory became evident.

We found that successful adaptation to the urban setting was related to two factors: first, a level of education that allowed for

skillful coping with urban life; second, a retention of Indian identity and the development of renewal processes that involved Indian cultural activities. Many would fail until they rediscovered their Indian self and gained support from the larger urban Indian community.

The cultural inventory clearly reflected how each family was meeting and coping with the urban setting. A key question in looking at the photographs was "how can you tell that an Indian lives here?" The answer to this question, combined with additional attention to the character of "order," proved to be a reliable means of judging the degree to which the family was successfully handling their life in the new setting. Disorder, in close association with a low level of expression of Indian identity, was consistently found in homes of families who were failing to cope with relocation.

These examples do not exhaust the possibilities of inventory and home photographs. An inventory can be combined with other uses of photography, as when people use the camera to record their own homes. In such a process, not only is there a selection of what to record in the house that may reflect what people themselves consider to be important but the photographs can be used in formal or informal interviews as well. In this manner, the significance of ordinary, mundane items that might escape the attention of an outside observer can be identified. Equally important, a well-organized effort of this type can result in expanded self-knowledge on the part of the inhabitants.

These potential expansions of the inventory process are particularly important with subcultural groups within larger societies, as in ethnic communities in the United States. Commonly, homes of any group in American society are at least superficially dominated by material goods that could be bought at any large shopping center. Seeing photographs of such homes, most people might assume that all these articles reflect an acceptance of general American cultural patterns and see ethnic identity as expressed only by whatever explicitly ethnic artifacts may be found there. Closer attention to collections of photographs of many homes from different groups will, however, usually reveal that each group is characterized by fairly consistent patterns of *what* is selected from the general American scene and *how* things are placed and used in the home.

This can be illustrated by the case of Danish butter cookie tins and Seagram's VO whiskey bottles in many Chinese American homes. Both these items show up regularly in photographs of homes made by Chinese American students and can be seen while visiting in many Chinese American homes. The tins may appear all over the house, often being used for storage while the Seagram's bottles are

often found, on examination, to be either unopened or barely touched. The presence of these items in a Chinese American home is a reflection of involvement with Chinese American social activities and processes. The cookies are a common gift when visiting and the Seagram's whiskey is a traditional item at many large banquets. It is usually used only to flavor the soup and then brought home to avoid waste but rarely consumed in any quantity, so the bottles tend to accumulate. The absence of such items might suggest a low level of involvement with the larger Chinese American community, while their presence in a Chinese American home devoid of explicitly ethnic artifacts might well be an expression of strong connections with a Chinese American identity. In many cases such indicators of *modern* ethnic identity may be overlooked if we think only in terms of "traditional" expressions of the cultural identity. A good inventory may assist in discovering these developing reflections of ethnicity.

The photographic inventory remains, therefore, a potentially rich and still untapped use of photography in cultural explorations. It is an easy starting point for exploration of the details of cultural styles, maintenance, and change.

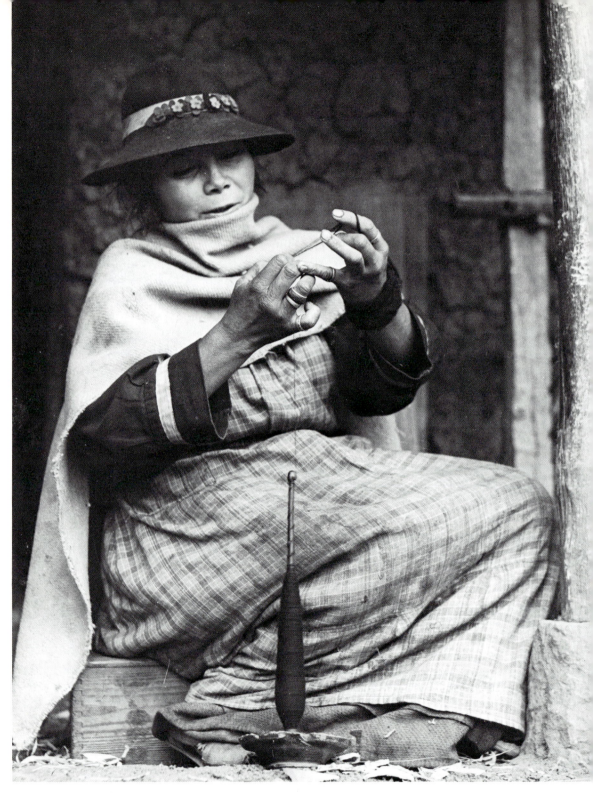

Mestiza woman spinning in eastern Andes of Colombia. Spinning technology has many forms. Throughout indigenous America the whorl and spindle is consistently encountered. The delicacy of this highly skilled ancient process makes it hard for the eye to follow or the memory to reconstruct. Photography fixes the image for analysis and reappraisal. (Photo by Mary Collier)

Chapter 6 Photographing Technology

There is no more logical subject for photography than people's technology. Craft and industry are the means by which people survive in an environment, and they often appear to local people as the most important areas to start a study. Here is the heart of anxiety and pride. In the Maritimes of Canada we heard: "The American draggers are ruining the fishing." "The trees are giving out." "Anyone who can build a boat can build a barn. We're woodworkers from way back. We can all build our own homes. . . ." Photographing technology means photographing economy, but also more. Technological change may be the most basic acculturation, and the death of an industry may spell the decline of a culture.

Comprehensive documentation of a technological process is practical and extremely rewarding in ethnography. This association is another example of Redfield's concept of the whole, for when we record all the relationships of a technology we have, in many circumstances, recorded one whole view of a culture. It is difficult to disassociate a people's means of livelihood from their symbolic relationship with ecology and their social structure or their value system. This may be less clear in an industrial society where life's goals are fragmented, but often in small or rural society the whole of culture is held together by the technology.

As we have said, a major problem is learning enough about the technology so we *can* meaningfully observe it. Cross-culturally this can be a challenge, for the significance of a craft is embedded in the very ethos of a culture. Swiftly moving technologies are particularly hard to understand and document.

The value of the camera in these circumstances has already been suggested. Using the camera with reasonable discipline the inexperienced fieldworker can record with accuracy the operations of a sawmill, even when he has only a shallow grasp of what is going on. Saturated recording, especially with the 35-mm camera, makes it possible to follow technological sequence in great detail. On first examination these photographs may contain information too complex for a reasonable understanding, but they can be restudied later when the fieldworker is adequately oriented. Or if precise information is needed at once, the native specialist, away from the frenzied activity of the mill, can read the photographs giving precise names and functions for the record. Thus, an encyclopedic understanding of an otherwise bewildering operation is obtainable.

When technological photographs have been read and identified in this fashion, the fieldworker is able to study his documents independently, with an increasing opportunity for research supported by the details of the photograph. He can observe the characteristic position of personalities in the industrial circumstance, whether these be laborers or foremen. The repetitious human positions invite the writing of a complete and precise description supported by the imagery of the photographs.

What skills do you need to photograph how a man makes a canoe? Or how he catches a fish, or harvests his wheat? Your goals in recording are twofold: the step-by-step craft operation, and the relationship of the industry to the total culture. The first goal is achieved by comprehensive sampling, the second by an expansive scheme of observation.

Keeping abreast of a fast-moving process requires more command than taking snapshots of your native host's children, but mastery of the camera does not ensure a good coverage. A box camera effort might be superior to the virtuoso's effort if a sound scheme of observation is used. The fine technological record is made by alertness and patience. If a technology repeats, stand back and study it. Analyze what appear to be the various peaks of activity, when tools are changed or technology varies. If the process is baffling, make a saturated record and with the help of a specialist pick out the key steps. In this way you will quickly acquire an authoritative functional understanding of even an unfamiliar industry.

The larger relationships of a technology require us to photograph not only the processes but also the source of raw materials and later the cultural end of the created product. Otherwise we will not have an integrated view of native skills.

Technology is an area where acculturation can be observed. Hence, it is particularly important to make records of tools. These

A Scheme of Observation

ENVIRONMENTAL LOCATION OF THE TECHNOLOGY
Forest-ringed sawmill
Desert-surrounded farmer
City-congested craft center

RAW MATERIALS IN THE SHOP
Hewn wood
Earth for clay
Metal for forging

TOOLS OF THE TRADE: AN INVENTORY OF TECHNOLOGY
Plows of metal
Plows of wood
Digging sticks
Hooks, nets, and harpoons
Floats and traps
Tools of stone, bone, or wood for chipping, piercing, and pounding
Tools of metal for gouging, cutting, hammering, etc.

HOW TOOLS ARE USED
Show each tool's support of the technology
Show how tools are cared for and stored; this can be as vital a part of
the culture of technology as the shape of the finished product.

HOW A CRAFT PROCEEDS
Logs drawn from the millpond
Ground furrowed for planting
Ground pierced for seeding
Wool fluffed for carding
The first cuts of the craftman's chisel
Mound of clay on the potter's wheel
The first coil of clay for a bowl

CONCLUSION OF PROCESS
The bowl is drawn from the kiln or firing.
The kachina doll is completely painted.
Timber has been cut into boards and stacked.
The corn has been husked and stored.

THE FUNCTION OF TECHNOLOGY
What do the weavers use textiles for?
How are kachina dolls used?
What does silver do for the Navajos?
Do the fishermen eat their fish?

SOCIAL STRUCTURE IN TECHNOLOGY
What are the relative degrees of skill?
What are the most skilled jobs?
What are the most dangerous assignments?
What are the skills of the people of prestige?
What is the lowest status job in the mill?

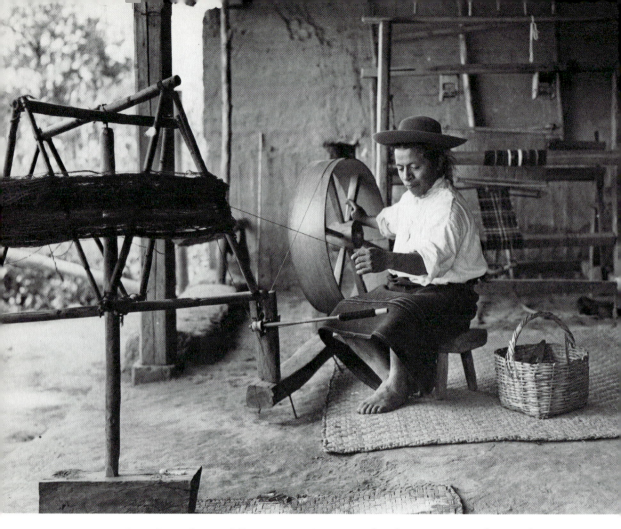

Otavaleños learned European spinning technology as peons during the colonial era. Here, in twentieth-century Otavalo, the technology provides the base for economic independence.

should be photographed so that a precise comparison with like tools in another culture is possible. We must also be alert to the ways in which tools are used, because sometimes in acculturation new tools are adapted to old functions. Use may change more slowly than the adoption of new materials and artifacts in many circumstances. Alternatively, new technology may be adapted to new uses, different from those for which it is used in other places.

Understanding the use of craft and manufacture is an integral part of a technological study. In this phase we observe the function of the craft in the culture. Is one culture technologically superior to another because the items it manufactures for trade are more complex? or superior because technology allows people to live more fruitfully in their environment? A culture might show a very high

level of skill in the production of ceramics or textiles, yet not involve these products in daily living. Or they may have low levels of technology in other areas of endeavor. By tracking technology's manufacture into the culture its integration in daily life can be evaluated.

Roles in technology often define or reflect the social structure. During the early 1950s in the Maritimes of Canada, status was held by "high-line" fishermen, the most skilled men in the fishing community. Work assignments in structured communities establish one's place in the society, and mobility is a function not only of accumulation of wealth but also of a higher place in the prestige system of skills. In the community enterprise, in the operations of the fishing dragger or the sawmill in the forest, each technological job should be carefully recorded so that later, through photographic reading, personality identification can be made and workers' positions in the structure considered. This social record of skills allows you to perceive where to look for status. The native photographic reader can help interpret the social significance of skills.

Very often in a limited field period, the observer is faced with the negative circumstance in which an important link in the seasonal technology has past: you cannot photograph haying in the spring, for example. But many craft technologies can be carried out at any time at the request of the fieldworker. "We make our lobster nets in the fall before the season hits." "Can you show me how to make them now?" Craft is sufficiently ritualistic so the craftsman conscientiously carries out an operation in the traditional manner. There is only one way to knot a lobster net, only one correct way to set a coyote trap. With the aid of the camera very exact models of native technology can be gathered in the same way as interviews. "Tell me how you feed the stock in winter," is just a more abstract way of asking, "Show me how." Samuel A. Barrett of the University of California at Berkeley made most of his ethnographic footage in just this way, in acted out interviews.

A process must be photographed so exact steps can be isolated. It is by this systematic observation that a technology can be conceived functionally.

For the follow-through of a process, film and video are suggested as fluent media. In Western cultures these are stimulating tools for acting out all manner of circumstances, whether as sociodrama or in carrying through a craft. *If* you had enough film or video tape and *could* keep the camera going for the full duration of a process through hours, days, and weeks, indeed you would have the unbroken sequence. In effect you would have essentially unaltered reality, which would be as unwieldy for analysis as the raw circumstance. Photography is an abstracting process, and as such

French Acadians in northern Maine using a more modern variation of
the Otavaleno spinning technology.

is in itself a vital step in analysis. It is seldom practical to make an
unbroken document even of a simple technology because of the
relationships and time span involved. Whether we use a Leica cam-
era or a movie camera we must still *sample* and structure the whole
view around significant time slices that demonstrate the continuity
of a process.

Still cameras can also stimulate people to act out a process and
have some advantages, including facility of feedback. We have the
instant pictures of the Polaroid Land camera and the video recorder,
but we also can exploit the relatively fast return of the conventional
camera, even though the contact prints may be small. Feedback in
the technological circumstance has proven to be very stimulating
to the craftsmen, provoking them to refine and make very complete

enactments of technology, the point being that the feedback of photographs allows them to share in the progress of the study as they see the documents of their skill.

An ideal research occurrence of this kind took place during our study of the weaving culture of the Otavalo Indians in Ecuador

Modern American craft spinner. Comparisons of similar technology in different settings can help define the evolution of the technology, Muir Beach, California. (Photo by Richard W. Brooks)

(Collier and Buitron 1949). We were faced with the problem of having incomplete knowledge about the technology of this area. This was coupled with a rapport problem, for the Otavalo weavers were somewhat uncooperative about being photographed, in some degree because of a sense of magic danger in the photography, or more likely from a sense of being exploited by the gringo. A solution to this dilemma was found when we were introduced to a master weaver of the area. We asked him if he would weave us the yardage for a suit. This offer was enthusiastically accepted as we bargained for a price during the early Sunday market. We seized this circumstance as the key to our research and explained to the weaver that because of peculiar circumstances it would be necessary to photograph our

There are two basic weaving technologies in the Andes, the backstrap loom and the European loom. An Otavalo weaver ties in the warp on a European loom, such detail shots can precisely record every step of a technical process.

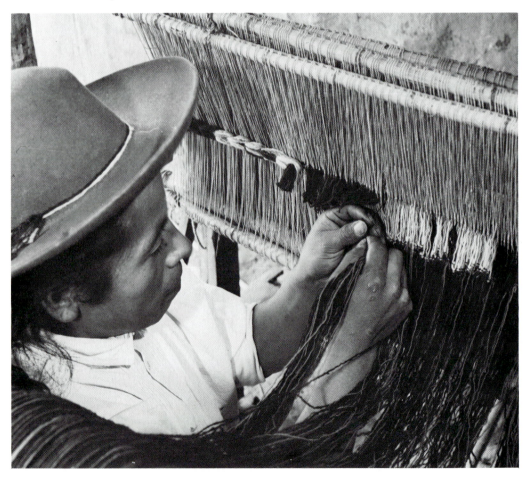

tweeds being woven, and that we wanted to follow our suiting from the raw wool to the finished cloth. The Indian looked with puzzlement, and possible annoyance, at this unusual request, and thinking it over, said in effect, "Well, it is your suit."

A date was made to call on our collaborator to witness the first part of the textile process—the washing, the drying, and the carding of the raw wool. Our welcome at the Indian's home was perfunctory, but the weaver proceeded swiftly to carry through the process of preparing the wool for carding, while we recorded the activity with a Rolleiflex camera.

We developed the film immediately in our field laboratory, made contact prints, and returned with cameras and contacts a few days later. The weaver greeted us with some surprise as we handed him the proofs of our photographs. His knowledge of photography was limited to portrait photography done in the Otavalo Plaza. He spread the contact prints out on the ground, arranged the pictures in technological sequence, and surveyed our results. He stood up, shook his head in disappointment, and made it clear that we had not done a good job on his craft. And more, he said, he was very concerned that the world would see him in these photographs as a poor weaver. He insisted that we repeat the process, so each step could be more plainly shown and with more honor to him. (He had neglected to keep his hat on, a major status symbol in Otavalo.) He made it clear that this time he would let us know *when* to take the pictures. The process was duplicated much more slowly and with great care. When we returned with our prints a second time, he accepted them with approval, and we proceeded on to the other steps—carding, spinning, and dying the yarn, and finally weaving the cloth.

We continued to show him all the pictures we made, and the Indian weaver took a key role in directing and organizing how the technology was to be recorded. He so identified with our study that by the end of the cloth he said, "There are many kinds of weaving that you have not photographed that other Indians do. I will go with you and see that these pictures are made. These men are doing weaving for me which I will sell, and they will have to let you take pictures."

The cooperation of our Indian collaborator allowed us to make a study of the Otavalo textile industry more complete than we ever could have made if we had tried to direct the course of this photographic coverage. This experience can be spoken of as an acted out interview stimulated by the feedback of photographs. Whether in a fishing boat off the coast of Canada or in a forest sawmill, or with an Indian weaver in Ecuador, if the subjects of a study have the initiative of organizing and informally directing the fieldworker's

observation, the result can be a very complete and authentic record.

To be sure, one may have to pick and choose a craftsman to collaborate with in this way. But a similar degree of rapport is needed for any form of depth investigation, and mutual involvement is a major element in rapport. As Oscar Lewis says of the family in the foreword to *Children of Sanchez*,

> Their identification with my work and their sense of
> participation in a scientific research project, however
> vaguely they conceived of its ultimate objectives, gave
> them a sense of satisfaction and of importance (1961:xxi).

Technology can influence family relationships and culture. A family cigar manufacturing business in the upper Magdalena Valley of Colombia.

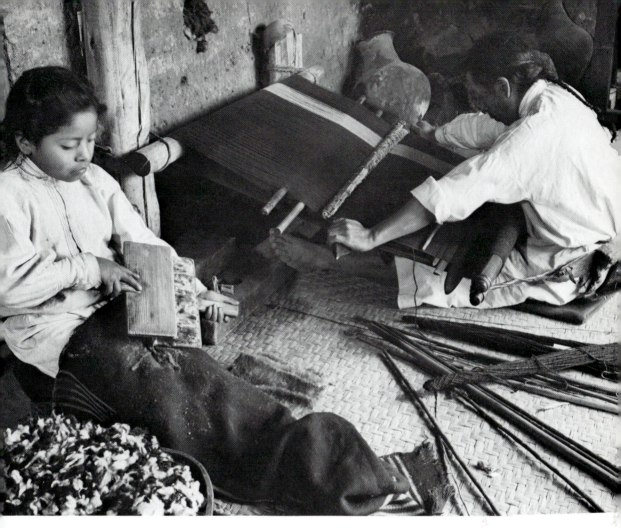

Local expertise can enhance photographic recording of technology. This photograph of an Otavaleño father and son was one of many made with the guidance of a skilled local weaver.

Social relationships and interactions can often be photographed in marketplaces. Here, Indians of Vicos trade with mestiza vendors in Marcara, Peru. Traditionally, only mestizos had mercantile roles. Photographs made today might show how relationships have changed since this picture was made in 1955.

Chapter 7 Photographing Social
Circumstance and Interaction

The photography of social actions leads us into a rich area of non-verbal research. A variety of reliable evidence can be read directly from photographs of social and ceremonial activity, for in them is reflected complex dimensions of social structure, cultural identity, interpersonal relationships, and psychological expression. Pictures of people mingling offer us opportunities for measuring, qualifying, and comparing, but these measurements can go much further and help define the very patterns of people's lives and culture.

Photographic recording of social phenomena requires attention to a number of basic factors. Our record must contain *proxemic* information, defining the spatial relationships among the people we observe as well as the general character of the social context. Usually, the record must also contain a *temporal* flow that tracks change and continuity of behavior recorded over time. This temporal flow helps define progressions of social actions and from these the inter relationships of the actors. We must also record the details of *kinesics*, the postures, gestures, the nonverbal character of individuals and groups. In any given situation we must be alert to the particular details that provide cultural definition. These include such factors as costume, hair styles, accessories, or other material content that is associated with social identity and behavior.

SOCIAL RELATIONSHIPS

Many aspects of social relationships are readily discussed in verbal interviews, for people feel they know their place in the social

77

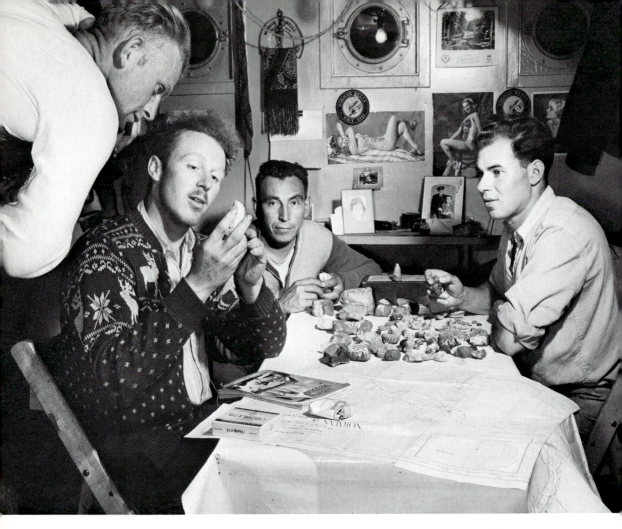

Interaction often shapes itself around occupation. An Arctic oil survey team on the lower Mackenzie River discussing fossils that provide clues to oil discovery.

strata. But it is equally true that there are aspects of social relations and status about which people are unaware or which they suppress. To experience these social levels visually, we must observe natives acting out their roles. Who speaks to whom? Who goes where? And when? Who goes to the late Saturday night movie? Who gathers and comes from bars and cocktail lounges? Keeping track of these movements with our eyes alone requires astute observations. Juxtaposition of people must be recognized and memorized in a flash, and personalities must be accurately perceived. This takes time and considerable familiarity. With the camera and a little care this task can become fairly automatic and be accomplished without advance familiarity. From such records we can not only gain direct understanding of social structure but also begin to define explicitly that

which we do not know. This knowledge can then be used to form more precise questions for interview purposes.

City streets can be a practical laboratory for photographic analysis of an urban society. The cultural, economic, and racial characteristics of urban areas can be examined in the ebb and flow of city thoroughfares. This flow of population, spontaneously performing and grouping, is a monolithic social structure in motion. Bus stops and crosswalks are like the waterholes and trails in the jungles: wait patiently, and all the forest life will pass before you. Photo journalist W. Eugene Smith stalked the city of New York by keeping a telephoto lens trained on six feet of pavement on the corner of Eighteenth Street and Sixth Avenue. Over a period of a year, as he worked on a book, he shot frame upon frame of street culture. Beggars, lovers meeting, drunken fights, muggings, snow in winter, cloud bursts in summer, all came to his six feet of paving (Smith 1958).

Photographs of a bus stop from early morning to night in a scheduled design will tell you many things about a city neighborhood. Who goes to work at seven every morning—Blacks, Asians, Caucasians? Men and women poorly dressed, well dressed? Who takes the bus at eight in the morning? How many school children? How many office workers with gray flannel suits and brief cases? How many women? How many men? How young and how old? Through the use of photographic detail, all this can be classified into rough scales of affluence and poverty, or analyzed for social roles, occupations, or functions. Over the period of a week the statistical evidence from such a visual log is impressive and can yield reliable profiles.

The mingling of people on the city streets can roughly classify most urban communities. In New York City there is often an inverse relationship between affluence and the number of people on the streets. The more poverty, the more the city dwellers flee to the openness of the pavement. Crowds of people on the streets of a residential area mean small rooms and overcrowding. Each city community has touch points where the character of its populace can be tracked and measured, the mingling in front of supermarkets, libraries, coming and going from churches, and relaxing in city parks. All these are key points where social flow can be documented and where social structure can be observed in motion.

Whether in a rural center or in a city neighborhood, fieldworkers working through one Sunday can reasonably characterize the religious affiliations of the community, by photographing the arrival

text continued on page 82

A church supper in a rural community in the Maritimes of Canada. This
record is a key to the social culture, the interrelationships that reach

beyond this isolated settlement. Family ties and community alliances are
re-established at this annual summer gathering.

and dispersal of the various church congregations. The lone field-worker could accomplish this same study over a series of Sundays. The interlocking movement of the social structure could be determined by this technique. Who runs the town's bazaars? Who hosts the church suppers? The participant fieldworker can systematically observe all the community gatherings in this fashion, see the leaders in their roles, and with the help of a native, establish the personal associations with accuracy.

Recording what people look like, what they wear, and the condition of their clothes is a descriptive opportunity offering rich clues to identifications comparable to those provided by exteriors and interiors of homes. Records of clothing can be rated as satisfactorily as can the conditions of roofs and yards. Ethnographically, clothing provides evidence for the comparison of ethnic groups and social organizations, defines roles of the rich and the poor, and differentiates the rural dweller from the city dweller. A saturated statistical view of garments can reveal sociocultural characteristics as much as can the property of the home.

When time and motion records are added to the image of social interaction we have the opportunity to examine the ebb and flow of gatherings or locales. The camera offers us time slices that can be measured and compared. The interaction of minutes, hours, days, weeks, and even a full year, can be calculated from timed observations of the flow of life and social relationships on the village street.

Observations of Social Relationships

We record social relationships to seek the formal and informal associations of society, woven into the national social web or reflecting ethnicity, provincialism, tribal, or extended family identities and relationships. Systems of social power, leadership, and status are traditional subjects of ethnographers, sought for in interviews or through systematic field recording over time, as in an intelligence agency's (disguised) request of fieldworkers that they write down each day "the name of the most important person you saw today."

The visual evidence of social structure can be obscured in casual situations, particularly to the outsider, but there are explicit circumstances in which caste and status may be clearly visible and can be photographed. A number of categories of circumstance are routinely sources of social information. These include: *programmed public events*— cutting the ribbon to open the new bridge—welcoming prestigious visitors, these activities define the formal and public leadership, although the real power may be hidden behind the scenes. *Cere-*

monial occasions—organizing and leading religious processions, benedictions for agricultural prosperity, clan and family banquets, political meetings—all such occasions can shuffle people into their appropriate rank in the social structure. Because such positions are repeated over time and are frequently traditional it may take only a few photographs to reveal social position and power reflected in spatial relationships and posture. *Occurrences of disasters*, observe who is in charge, what groups and individuals take control? Who is deferred to for decisions? Of course, such recording should be followed up with good photo interviewing to determine if such visible leadership and power is real or merely ceremonial.

Kinesic behavior, facial expression, and body posture can also indicate social status. A photograph of a provincial meeting in Marcara provides an example of all these elements. Along the wall are three men; to the right a Mestizo leader with cane of office, in the left foreground, seated, an Indian leader with his cane of office, and in the middle a Criollo (Spanish decent) townsman. He stands above the other two, head up, arms crossed, papers in hand, dressed in European business suit, his body and face positioned in a stance of waiting but tolerant power. He is focused on the proceedings, in which he *knows* he is a true participant, whose view can be heard with influence. In contrast, the Mestizo and Indian leaders are withdrawn in their posture, eyes down and away from the proceedings with facial expressions that convey no active involvement in the process. They wait, dressed in traditional woolen homespun clothes, hands holding their canes and hats, waiting to *receive* the decisions of others.

Spatial positions and costume can reflect and express social status.Sometimes it will be possible to capture this in a single photograph. One example is seen in a photograph by John Collier of people watching a procession honoring a touring image of Our Lady of Fatima in the Andean town of Marcara, Peru. People have gathered in advance to watch the procession, they are arranged in their proper social positions. Standing in the front is a Criolla woman with two girls dressed in school uniforms that are modeled on navy uniforms. The woman is formally dressed in European fashion with coiffured hair, her dress and stance signaling the urbane sophistication of the town elite.

To her right and seated in the front are townswomen representing the Andean middle class, their clothing a mixture of Mestizo and modern European elements. *Behind* them are the Mestiza women of the town and behind them rural Mestizo men and women. The movement from front to back is a movement in social status, reflected both in spatial position and in dress. Those farthest to the back wear

Meeting of the Los Angeles Chamber of Commerce, late 1940s. The behavior of participants at formal meetings often reflects roles and relationships.

clothing that is the most "Indian" in style, although no one in the photograph is, socially, Indian. The formal circumstances demand that those with status may position themselves most advantageously, with others taking second and third positions behind them.

Even single images can often provide clues as to the levels and symbols of social status, formalities that usually change slowly. But single images do not provide us with the character of people's relationships with each other, the quality of their interactions, the behavioral give and take of culture in motion. That requires sequential *tracking* through time and space, series of still photographs taken from the beginning of a political meeting to the end or, ideally, film or video records. Such records would not only define social structure but would also give us information on exactly how each

participant approaches, responds, interacts with others. *Then* we could begin to describe the dynamics of the social structure. Saturated still photographic recording is needed to gather such information.

Finally, in addition to these unusual or formal social circum-

What makes an Indian in the Andes? Genetics? A frame of mind? A cultural way? Some of this subtlety can be verbalized, but much can also be seen. A political meeting in a small town in the Callejon de Huaylas, Peru. (See text for details.)

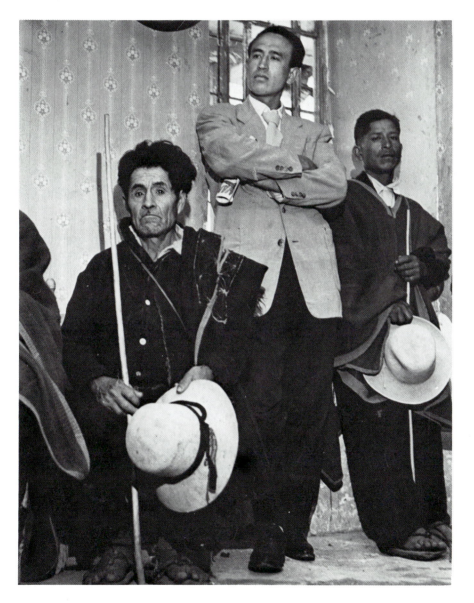

stances, there are many routine, daily situations, in which people become so established in their social position that it is visible in the photograph. Institutional lunchrooms, business meetings, school yards, and other such situations usually develop stable spatial and interactional patterns that are reflective of social status and relationships and can be photographed.

A wide variety of units within urban sociology present problems of observation and understanding: the social structure of the monolithic office organization, the structure of industrial plants, mobility and status within unions. As a project for a field method seminar at San Francisco State College, Arthur Rotman attempted to define the social structure of a hospital staff and observe the nature of interracial relations (1964). But hospitals have their own taboos and a staid hierarchy of roles and customs. Hospitals also have an aseptic facade of white coats and regulations. In search of the real social relationships, Rotman sought a circumstance of common ground, with maximum fluency, in hopes of observing the spontaneous groupings reflective of the social structure.

When the procession of Our Lady of Fatima passed through Marcara, the social structure was reflected in the crowd. (Further discussion in the text.)

The point of observation selected was the hospital cafeteria; the method of observation was photography. Methodologically, the choice involved three field problems: (1) the time factor of balanced interviewing throughout the institution was prohibitive; (2) protocol made interviewing within the hospital itself dangerous if not impossible; (3) the pace of life and the probable hierarchical lines would make asking questions regarding social relationships difficult. The captured locale of the lunchroom would allow observation of social relationships in motion in a controlled fashion. Rotman's role was that of participant observer, for he worked at the hospital and also wore a white coat. The study was made with the permission of the hospital director.

Rotman's technique was a time-and-motion sociometric study made at fifteen-minute intervals every day for a week from nine positions that gave him a record of all the staff throughout the lunch period. Completing his sample involved meeting with some individual agitation, but without serious offense. The costumes worn by all hospital staff members allowed for responsible identification of each individual's position. Nurses' aides, trained nurses, X-ray technicians, and other specialists wore emblems and written identifications. Doctors wore stethoscopes. Surgical aides wore green coats.

The photographs were made with a 35-mm camera and a wide-angle lens. Thirty-five millimeter film is edge-numbered, offering further control for the analysis of the time and motion factors of the study. All frames were enlarged to 8 by 10 in. so precise reading of the relationships could be made.

Data divided into two basic categories of readable evidence: the flow of interaction, day by day and hour by hour, as seen in the hospital lunchroom, and the exact seating of individuals day by day throughout the week. This latter evidence was the most significant in the study for it showed that the social structure was related to the technological structure and there was little visiting between specialties in this free period. No racial segregation was apparent within the going structure. Blacks sat with specialists of the same professional level; doctors sat with doctors, whether they were black or white. On the other hand, the study showed considerable range in the proportion of black and other non-Caucasian groups in different departments—an imbalance of actual roles comparable to and reflecting the levels of real opportunity in the larger society.

The spontaneous nature of the circumstance chosen for tracking and counting operated as a control over what the hospital public relations officer might tell the outsider looking into hospital culture. Indeed, the empirical nature of the evidence would have qualified

The character of education for cultural and linguistic minorities is often a complex issue. Here in Cebolla, New Mexico, graduating eighth graders receive final grades, for many in the 1940s the end of their school experience. Interviews using such a photograph might provide information on social relationships as well as attitudes and values regarding education and change.

data gathered by individual interviewing, if the design of the research had included such an investigation. This was a study of social relationships in motion by direct photographic observation.

Observation of school culture in San Francisco presented a similar problem for Alyce Cathey, a teacher in a racially diverse grade school (1965). The formal culture of the classroom was another facade across the real social structure and personal interaction of her pupils. To deepen her understanding of her students' problems, Miss Cathey went to the school yard to view the spontaneous regrouping of her children's social life.

Before she could analyze the school culture of her pupils, Alyce Cathey, like Rotman, needed a large pool of empirical data of *what really happened in the yard*. Noontime in the school yard offered her

the same sort of opportunity as the lunch hour in the hospital. For two weeks Miss Cathey made sweeping, as well as detailed, studies of her students eating lunch and playing games in the school yard. Her role as a teacher allowed her to circulate around the grounds and photograph without causing social disruption, and she was able to get a repetitive sample of her children's world in motion outside the schoolroom.

Miss Cathey studied the photographs on the 35-mm contact sheets and selected 8 by 10 in. enlargements. She used these contact sheets in her interviews with her students. The pictures clearly showed

Lack of opportunity to learn Spanish often left Indians linguistic prisoners. Here, the principal of the Vicos school tests Quechua-speaking students in Spanish terms for objects. Details of eye behavior, posture, expression, and gesture provide a reading of both school content and social relationships.

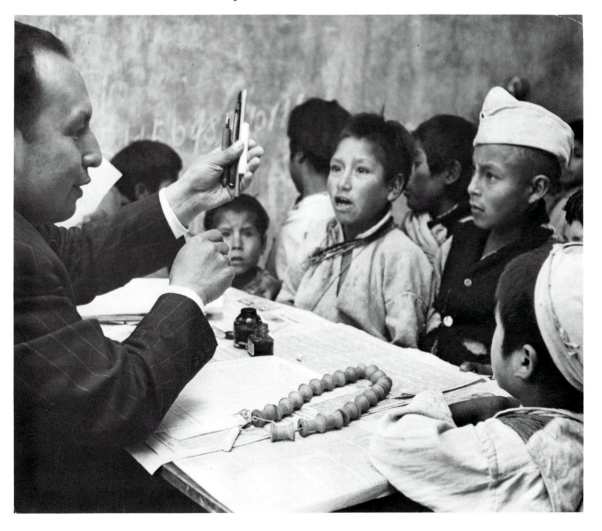

the personality roles and clique patterns within which the girls operated, and the interview statements gave insights into the students' culture and a recognition of the way they viewed themselves and each other. For example; one black girl from the high fifth apparently felt rejected by her predominantly Chinese classmates and sought daily gratification by eating with the younger Chinese children of Miss Cathey's low fifth. Day after day the camera revealed her sitting on the periphery of the low fifth group. Closer study revealed strong but covert prejudices among the students.

The photographic study also threw light on the nutritional habits of her students. Some of the students brought large lunches which they often shared. Others brought small lunches, usually devoid of vegetables and fruits. A few individuals had money to buy chips and imitation fruit juices; this functioned as a status symbol for the more affluent children. All but one brought their food in paper bags; this girl brought her lunch in a tin lunch bucket, saying, "My mother feels paper bags for lunch are wasteful and you can't carry tea to drink in a paper bag."

An added research value of a photographic tracking study such as this is that the examination can be repeated next year or the year after that to evaluate any evolution of school culture in this multi-ethnic neighborhood.

In any community we may be confronted with the problem of the ideal, as compared to the actual functioning of community, the first with its roots in formalized history and tradition, and the second based on rapid change and opportunism within which pragmatic developments take place. In a sense, these are the overt and covert scenes of human relations, where ceremonial decisions are made at the Episcopal church, for example, and other formal gatherings of the town, but the actual deals are made under the table.

How can we distinguish the functioning real from the traditional ideal? This was one of the problems confronting a fieldworker on a community study project in Canada. He suspected that he had been seeing only the facade of the social structure. A unique social occasion presented itself where the less formally structured functioning of the community might be observed. This was the opening dance of the local yacht club which had traditionally been a high-status occasion in the social life of the town. He had reason to believe that a new aggressive crowd had taken over the yacht club, and this occasion, which was not open to the general public, might indicate how social structure in the town was bending. As project photographer, I offered to photograph this opening event, an invitation that was accepted with a sense of fun by the club officers. But what would the guests and members feel when the fieldworker and I

appeared with flash bulbs and cameras? In the spirit of the party circumstance, or because of it, the photography was greeted hilariously, and we were able to record uninterruptedly throughout the evening who danced with whom, who embraced whom, who flirted with whom, who withdrew in confidential talk. The interaction observed was a scramble of the conventionally presented image of this town's social structure. Old status mingled significantly with new power groups in the seclusion of the club. There was considerable drinking despite the traditionally dry sentiments of the community, where drinking in public was taboo.

We rapidly made enlargements of representative scenes of the evening showing all the participants of the event. The fieldworker, to his delight, found that everyone involved wanted to look over and talk about the yacht club pictures. The research result of this feedback was complete identification of all personalities, and with the aid of tracing paper overlays it was possible to make sociograms of complex interactions representing a real view of the social structure and interaction.

The cluster patterns between various individuals did suggest a shifting power structure. In this confidential circumstance historical leaders were seen paying court to lower status business operators who were indeed taking over the effective leadership of the community. Interview responses pointed out the covert nature of this interaction. Mr. So-and-So would never be sitting next to Mr. X, except on this occasion. In a sense, the yacht club party was a projection of covert social structure that might become the acknowledged structure in another decade. One of the rich returns of this experiment was the significant measure of private social relations which could be compared to the formal social positions of public life, the latter creating the facade of historical social structure. Sociometric tracking often offers an opportunity for precise measuring and comparison of social interaction.

SOCIAL INTERACTION AND PROCESS

Photographic records of events and social processes can provide us insight into the dynamic structure and form of social interactions and relationships. The camera's value in such recording is that it can catch the simultaneous details of such processes, freezing them for later definition of relationships among different elements that might well escape the unaided observer.

As an example, a student at San Francisco State University made timed records of campus noon hour political assemblies in hopes of defining a pattern of gathering. On first glance, the results were

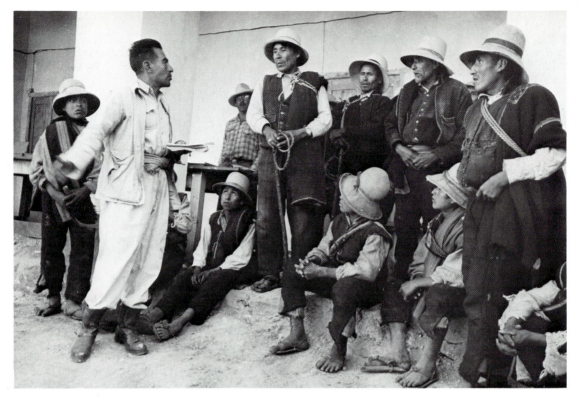

Freedom for the Indians of the Andes also means a change in their perception of their roles relative to others in Peruvian society. Hacienda administrador giving orders at the weekly mando, Hacienda Vicos, Peru.

chaotic. There did not seem to be a strong pattern or an impressive definition; rather there were multitudes of small changes. The student then related his time lapses to three factors: class schedules; who was speaking, and the subject of each speaker. When the photographs were enlarged and examined in their precise time association, the suggestive photographic patterns of students running to and from the gathering, groups breaking away and dispersing, sudden influx of students arriving, all began to take on intelligible schemes.

Detailed study at this point reflected patterns in listening, bodies pressing forward as the content log revealed a certain student had the floor; then in other photos, students would be turning away, laughing to one another as the content of the debate changed again. When the gathering was correlated to class schedules, still another crowd movement became discernible. On closer view, when students simply drifted off for lack of interest a different pattern appeared than when students were breaking from the crowd to go to class. In the latter case students either left on the run, or showed

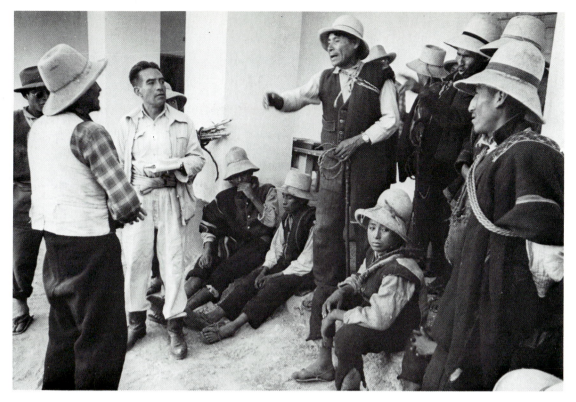

The Cornell-Vicos Project encouraged the active involvement of
Vicosinos in decisions. Here, a community foreman disputes with
hacienda administrators. Close study of these photographs suggests that
transition to a more equal power relationship was not yet complete;
people are attentive to the administrador but attention wanders when
the foreman speaks.

their reluctance, listening, heads turned to the crowd, as they moved
away.

Such studies lead us into the examination of "microculture,"
the situationally conditioned patterns of behavior that shape the
daily activities of most humans. Observing how people mingle and
regroup themselves is basic to an understanding of social structure
in motion. Psychologically and socially, photographs diagram spatial
relationships of gatherings. What are the cluster patterns? Do they
represent focal points of leadership?

In the dynamics of microculture, the details of person-to-person
relationships can be analyzed through the use of still pictures and
even more successfully, as will be discussed, with film or video.
Photographs allow for the observation of personal physical bearing,
posture, facial expressions, arm and hand gestures. Birdwhistell has
developed methods for decoding this visual language of "kinesics"

(1952, 1970). Hall has studied the significance of what he calls "prox-emics," such things as the spacing between people and body orientation, which vary from culture to culture and according to circumstances (1966). Frederick Erickson has examined the subtle miscommunications of cross-cultural counseling and job interviews, basing his analysis on proxemic shifts, kinesic details, variations in communication pacing, and the tempo and stresses of the accompanying verbal communications (1979). Still photography was used by Malcolm Collier to record a day in a bilingual preschool, carefully tracking spatial relationships and associated behavior through different activities. Examination of the photographs provided important information on when students were able to sustain attention and activities to the satisfaction of the staff. Each culture and each situation has its definite established modes for handling space and other aspects of behavior and interaction, much of which can be captured with the still camera.

An understanding of such tangibles in group behavior allowed Paul Byers (Mead and Byers 1967) to abstract from photographs certain basic patterns of group dynamics observed at a conference of American and foreign Fulbright scholars held at an American college. By close analysis of just nine of these photographs Byers was able to demonstrate radically changing yet predictably patterned behavior as the circumstances of the conference progressed. His reading of three gives an idea of the sort of behavior that was objectively photographed for analysis.

The first example shows the scholars at a reception in the lounge. Behavior is structured consistently around the event of initial polite interaction. Byers observes:

The group is dispersed fairly evenly in the room. The space is filled fairly evenly throughout. The furniture is also dispersed evenly throughout the room.

All suit jackets are kept on and everyone wears his name tag.

People sit with a fairly uniform space between themselves and tend to sit at the front edge of the chairs and sofas (except in the bucket-type chairs in which this is almost impossible).

Coffee cups are uniformly placed in relation to the edges of tables. Although there is uniformity of coffee-cup placement on each table, the two tables are different from each other (at the edge on one table and about two inches from the edge on the other).

Backs are generally straight, with people leaning towards each other from the waist and inclining their heads toward each other.

There is little leg-crossing and no visible crossing of arms across chests.

There is a repeated male position of legs apart with forearms resting just behind knees and hands together (and visible) in front.

People are most commonly talking in twos—sometimes threes.

Almost everyone is in eye-to-eye contact with another person and every person exhibits at least some body-orientation toward the person to whom he is talking.

No two or more people in direct communication have furniture between them (Mead and Byers, 1967).

The second photograph was taken on the evening of the second day of the conference during a free time period. Here group behavior is in contrast to the first record above. Circumstances have altered the character of group patterns completely. People seem acquainted as suggested by freer expressions, closer body proximity.

Byers points out that it is significant that the room was dimly lit and hypothesizes that "all other things being equal, people will change the nature of their facial expressions, will interact with their faces closer together, and/or will increase their speech articulation when low illumination decreases the clear sharp visibility among themselves."

No one is seen wearing a suit-jacket but two have been brought.

The commonest sitting position is forward on the chairs or sofas with bodies leaning toward others. Men's arms again tend to be resting on legs.

There are more people in less space than in the earlier scene. Space between people is less and there is some body contact.

Furniture has been moved to form a kind of circle and people are interacting both one-to-one and across the circle (Mead and Byers 1967).

Byers goes on to describe other meetings, most of them conforming to one of three basic patterns of relationships: the one-to-one, the many-to-one represented by audience and speaker or performer, and the circle—a leaderless equi distance group in which any member may in turn command attention in a one-to-many relationship. These patterns are all so familiar as to seem only of theoretical significance; they represent culturally regulated behavior that we as Americans have always taken for granted. But would these scholars have performed in the same way within the context of an Arabian University with Arabian hosts?

Byers's ninth photograph illustrates the point that patterns in other cultures may be very different. This scene shows a group of scholars, only one of them an American, sitting on the grass in a

self-limited space within touching distance of each other. But body positions conform to no regular American pattern. Byers reports that most Americans studying the picture assume the group is listening to a concert or a lecture outside the scope of the photograph, which was not the case. This is the only reasonable explanation for an American. But the group is primarily not American. They may be meditating, relaxed and unconcerned, not compelled to relate in an American way to those next to them. A group of Navajos in similar positions could be having a political discussion. Byers demonstrates that "group" implies the participation by its members in shared and observable regularities of behavior. The pattern of these behaviors varies considerably, but always within a range which is culturally narrow and specific and can be accounted for by factors in the context.

Paul Byers observed that space reflected and programmed interactions, and Edward T. Hall suggests that culture programs space. Photographs consistently reveal social relationships mirrored in social proxemics, particularly when they record repeated social interactions. In 1970, visual anthropology student Marilyn Laatsch tracked the proxemic relationships between an American agricultural specialist and Bolivians with whom he worked in a series of rural gatherings in the Santa Cruz region of Bolivia. Study of the enlarged photos showed that the spatial patterns of these meetings never changed. The American specialist always stationed himself ten feet from his Bolivian hosts, who themselves were consistently positioned in a manner reflective of social position. The regional Bolivian agricultural directors always stood the closest to the American specialist and apart from the main body of listeners. In the larger group, local officials were in front of wealthy landowners, who in turn were in front of the Mestizo and Indian farm workers, who always remained in the distant background.

This example also demonstrates how patterns become increasingly clear with systematic and repeated recording. Ms. Laatsch made her photographs from the same position in every meeting, so a clear and consistent reading of the photographs was possible. Scattered photographs made unsystematically would have provided only impressionistic insights.

The small interrelated community is often baffling because of its fluid character. This can be particularly true in communities undergoing rapid change where the reality of social relationships is likely to be found in this regrouping process. The first look at a historically oriented community can be deceptive. Leaders may wish to keep the image of traditional culture alive and may be eager to give the impression that the social structure is based on historical

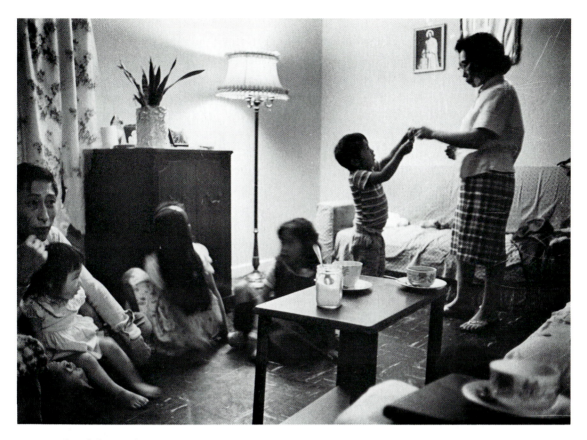

Confident adjustment to urban settings by Native Americans requires a reasonable reproduction of native proxemic relationships. This successful, relocated Eskimo family structures the social space of their home in Oakland, California, much as they might in the Arctic.

background, with old families whose forefathers settled the region identified as the first families—the status group that holds the power and gets things done. Stimulated by this lead we are tempted to cast personalities in this descending order: old families, owners of factories and large land holdings, down through an anonymous middle class, to laborers and industrial workers. This endowed order may have been real a few decades ago, but under the impact of economic change, with opportunities for rapidly shift of social positions, this classic structure can be misleading, for it tells us nothing about the fluid nature of society or the present real power divisions. The conventional view also tells us nothing about where specific people fit into the social structure. Such diagrams remain empty boxes until we can fill them in with the real functions of individuals.

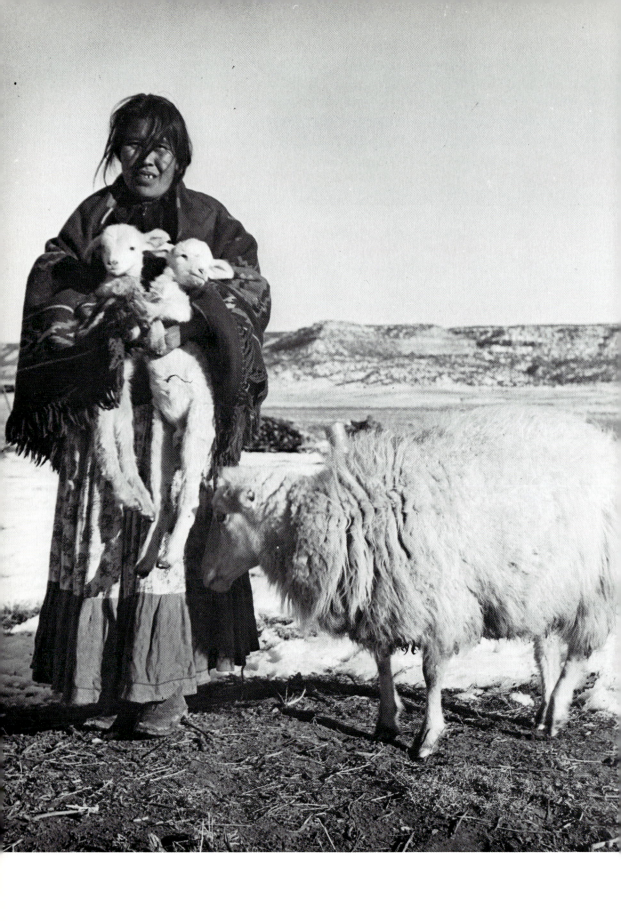

Chapter 8 Interviewing with Photographs

We have reviewed areas in which information can be gained directly from analysis of photographic records. The scope of such information is quite large, but photographs can also be *tools* with which to obtain knowledge beyond that provided through direct analysis. When native eyes interpret and enlarge upon the photographic content, through interviewing with photographs, the potential range of data enlarges beyond that contained in the photographs themselves.

Photographs can be communication bridges between strangers that can become pathways into unfamiliar, unforeseen environments and subjects. The informational character of photographic imagery makes this process possible. They can function as starting and reference points for discussions of the familiar or the unknown, and their literal content can almost always be read within and across cultural boundaries.

Opposite: The literal imagery of photographs can stimulate information beyond the scope of the camera. Old time Navajo sheep were a focal point of Navajo values and conflicts with the U.S. government, which advised "cull out these hairy sheep and replace them with modern breeds." But the long wool was preferable for hand spinning, the sheep often produced twins, and the ewes rarely abandoned their lambs, an important issue in a harsh climate. Here, lamb twins are carried toward a family hogan with the ewe following closely. Interviewing with this photo could carry discussion into many different areas of Navajo life.

The key elements of photo-interviewing are illustrated by an initial interviewing experience with photographs that occurred in the Stirling County study of mental health in the Maritimes of Canada. These interviews were not only an experiment in gathering information but also an effort to enrich and extend existing interview methodologies. This community regional study is an example of how an intense level of photography and projective interviewing can support anthropology. These examples are described in full in an article in the *American Anthropologist* (Collier 1957).

The study was particularly concerned with migration caused by technological and economic change, which appeared to be a major variable in the mental health of the region. Acadian farmers were moving into the English industrial town of Bristol to work in fish plants and lumber mills. This movement raised many questions on how the migration was taking place. Some Acadians sold their homes and moved permanently into the English industrial center, but there also appeared a gradual movement up the coast from the provincial heart of the French-speaking population. Acadians had bought farms on the periphery of the predominantly English area where they remained as part-time farmers and commuted to the mills each day to work. Were these French going to give up their farming and become urban dwellers? Or was the pull of culture going to keep them on the soil? Was there a notable shift to English values? Or were the Acadians remaining French with strong ties in their traditional settlements? Was this migration stressful? Did the Acadians like working in industries owned and run by the English? Was life in the urban English center satisfying?

Interviewing was the methodology at this phase of the community study, but fieldworkers encountered problems using normal interview techniques. The farmers and fishermen of the area appeared to have memory problems, one year would be confused with another and frequently their memory would not extend with any detail beyond the previous twelve years. The first interview session often seemed to exhaust the knowledge of the informants.

To deal with these problems and to gain further insights, a projective photo-interview study was considered. When we (John Collier and William McGill) began assembling the interview material the character of the photographic research changed. We were no longer just making a survey involving precise selection and documentation. Instead, we became involved in photographic essays, shooting and selecting elements to produce a comprehensive overlook in a limited number of enlarged 8 by 10 in. prints. Through

the use of these prints we hoped to evoke responses that would give an inside look into contemporary Acadian cultural issues.

The design required several separate photographic studies: (1) industrial life in the English center, (2) a photo-essay on the family, (3) a housing survey of the immediate area, (4) samples of public interaction in nearby towns. The questions raised included: Were Acadian migrants happy doing industrial work in the English town? Was the belt between the Acadian and English areas clearly one of migration and transition? Were the Acadians here going to remain French and part-time farmers, or were they in the process of shifting to an Anglo industrial workers' culture?

The Plenns, one of the families contacted for this study, lived on a farm in the presumed migratory belt, and both husband and wife worked in a lumber-processing plant in Bristol. The first subject of field photography was this lumber and box mill. I (John Collier) photographed long views showing the mill and the town of Bristol. I documented the man and wife at their various jobs and the interior of the mill in general. After quitting time we made records of Bristol's shopping center showing the stores and throngs of people on the streets. A date was set to call on the family with the first feedback. The mill pictures showed a most dangerous industrial interior, and we expected that they would tell us in no uncertain terms that they disliked their jobs.

George Plenn and his wife, Violet, met us cordially at the door of their neat two-story farmhouse and ushered us into the dining room. The anthropologist-interviewer got out his notebook, and we proceeded to examine the photographs. The Plenns looked at each picture with great interest and gave complete and detailed information. But we were completely mistaken in predicting an emotionally charged expression about life in the mill. They were equally noncommittal on the views of the streets of Bristol. They recognized no people and scarcely knew the names of any stores. Finally the wife explained, "When we are through work we are sick of Bristol and want to come right home. . . . When we want something during the week we buy it at the corner store, and on Saturday night we always do our shopping in Portsmouth," (a town on the edge of the Acadian half of the county, in the opposite direction from Bristol). Though we were disappointed about not getting one emotional statement about the industrial environment, the responses to the photographs were significantly revealing. The couple was not involved with the town of Bristol. They knew no one on the streets, and all their commercial life was south in the nearest French-oriented community. They went to Bristol to make cash wages, and talked about the mill as "a fine place to work . . . good pay . . . good job,"

and seemed to have a cultivated lack of concern for the questionable safety or the haphazard working conditions.

For the second photographic coverage we spent a day on the Plenns' farm. The Collier family, John, Mary, and two-year-old Malcolm, arrived at the farm on a Saturday afternoon just as the family was driving up after a half-day's work. The purpose was to gather material for an interview on home values and the rewards of living on a farm. This was definitely not a survey but rather an acted-out interview and a photographic essay on the family. It was also an example of participant observation requiring considerable mutual satisfaction. We had to be totally at ease and enjoying ourselves, and they in return had to be gratified and humanly rewarded for their hospitality and communication.

It is awkward and sometimes impossible to stand back aloofly while making human records. No type of fieldwork requires better rapport than an intimate photographic account of family culture. Yet in another way, spending a photographic day with a family can be less intrusive than the same hours spent asking and answering endless verbal questions. As with the observing photographer on the fishing boat, the intrusion is visual, not verbal. People do not have the stress of constant explanation, or anxiety over what you are doing standing by silently. The photographer is as active as the busy fisherman or farmer. The presence of the full Collier family added further human trust to a circumstance that might have been tense. Mary Collier was in the house sharing canning techniques with Violet Plenn, while John Collier accompanied Mr. Plenn on his chores.

After a period of tension as everyone got used to the routine of photography, members of the family began responding creatively to the opportunity of recording. They spontaneously began acting out particularly gratifying or significant elements of their lives. Pets, favorite hens, ducks, special skills were called to the attention of the camera. There was plenty of talk, but it was not an interview; it was mutual communication in which we returned as much as we were given. The afternoon ended with an excellent meal, and we parted feeling fast friends.

Our second interview was markedly different from the first. We were met at the door with great expectation and fairly dragged into the dining room to show the family pictures. The Plenns looked through the home studies with great intensity. They interjected their comments on the farm pictures with the heated statements about the mill in Bristol we had expected them to make on our first visit. It occurred to us that maybe they had never really seen the mill before they examined our interview pictures, and so were unpre-

pared to make comments. During the period between interviews they may have been considering and discussing the mill. Our pictures may have upset them very much, and the photos of home life may have provided a focused contrast to their jobs in Bristol, crystallizing their feelings into forms they could express. As they viewed their vegetable garden they commented on how sad life must be in Bristol for Acadians who had given up their farms. "There wouldn't be anything to do after work but sleep." They were vehement that they would never leave their farm and move to Bristol. Our projective examination had thus far given us many answers as to how the Plenns felt about migration to Bristol.

The third set of photographs was a series of surveys: the houses scattered along the road of the Plenns' community in the heart of the zone between the Acadian and the English areas, a religious festival at the Catholic church in Plenns parish, and the Plenns shopping in the crowded Acadian-English community of Portsmouth on Saturday evening. Our research goal in this final interview was to obtain, if possible, the names and backgrounds of all the people living along the mile of road in the Plenns' community, and to test the Plenns on their knowledge of Portsmouth. Were they really as involved in this center as they claimed they were? We hoped the religious picnic would indicate the degree of Acadian culture in this supposedly transitional area.

This third and final interview was the most exhausting for the Plenns and the note-taking anthropologist. The pictures were highly readable, and the data poured out. The family went down the road, house for house, describing in a structured way who the people were, if they were Acadian or English, and how long they had lived in the area. Only one house bogged down the pace of their reading. This house picture was looked at and passed over with smiles and shrugs. "Who lives here?" More smirks. "Just an old woman." "What does she do? Farm? Have a pension?" "She don't do nothing." "We don't know nothing about her." We passed on the next house and continued on our routine interrogation. Obviously they did know about the woman, but because the house was surely the scene of questionable or deviant behavior, they did not care to discuss it. Photographs will often unearth this kind of emotional censorship.

It was very clear that the Plenns' area was not a migration belt as such. People had owned homes here for generations. The church festival showed many Acadian people, but they were identified as coming from elsewhere in the French-speaking area.

It was late, and the interview had run beyond the point of productive return when we studied the Portsmouth shopping pictures. Still the Plenns were able to identify almost everyone on the

street, tell where they came from, even when a back was turned or when the person was standing a block away.

This is typical of the sharp recognition of rural people, whether they be farmers in Kansas or forest laborers in Canada. Photo-interviewing offers the anthropologist a key to this native knowledge. For the same reason, photo-reading can be a check on native familiarity. "Yeah, we know all the folks up there in Prairie Corners." But show your informant photographs of interaction in this community, and you will know just how much your native really knows about this settlement—many people, a few people, or no people. This check is equally clear in areas of technology and geography. It is easy to recognize when a man is out of his field.

Our pictures of the streets of Bristol, the Plenns' home community, and shopping in Portsmouth adequately tracked the family's geographic movements. A straight line to the mill and home, another line to Portsmouth to trade, and a very long line back to Plenn's traditional home in the Acadian part of the county. Plenn's English-Protestant wife seemed to have joined his social culture completely, for all their interaction took place to the south with his relatives; none took place to the north in Bristol.

It is methodologically important to note that our sessions with the Plenns were *group interviews*. Violet Plenn's eighteen-year-old daughter and an eight-year-old adopted boy, as well as Violet and George, all looked at the pictures together, handing them around a circle. This affected the quality of responses, possibly inhibiting emotional association and encouraging more factual responses. In the deeper probing about life in Bristol we may have lost data. But in the identification of the housing survey and social interaction in Portsmouth we gained immense data. Group interviewing with photographs can become a game, each member competing against the group to give the most comprehensive information. A group interview situation without graphic probes too frequently becomes nondirectional parlor talk.

This example describes the use of two very contrasting types of photographic recording—the intensely personal photo-essay analysis of culture and the impersonal documenting of community structure and interaction. Both approaches yielded valuable data, and our study could not have been completed without the support of both approaches. But the family essay brought insights that were more subtle and usually more difficult to recover, the heartfelt sentiments about migration into the English industrial center and, in the face of industrial wage work, the persistent fulfilling need of owning a farm. These sentiments were a projective response to the feedback which compared their ideal life to the driving, industrial

life in Bristol. These opposites would not have been clearly realized in the feedback of the Plenns' life without the support of photographic content.

How Photographs Function in Interviewing

These interviews with the Plenns serve as a reference point for discussion of the variables involved in the use of photographs in interviews. First, we must consider the basic requirements of *any* interview approach. The preliminary step in interviewing is finding someone to answer your questions, preferably someone appropriate. The second is getting invited into your informant's home, and the final challenge is to be able to return for subsequent interviews. Rapport becomes a major focus of concern; you think of favors you can do for your informant, giving them rides to town, helping them fix their cars.

You struggle to define a genuine functional relationship that can make your presence both agreeable and mutually rewarding to people. Only then can you retain your welcome and continue to observe and interview. In Stirling County one fieldworker resorted to distribution of chocolate-covered cherries in a desperate attempt to maintain rapport. The ideal is to complete second and third interviews that build on the first, but in the Maritimes rural people often resented extended questioning, and probing on repeat visits sometimes led to anger. More frequently, they welcomed friendship but had no intention of being manipulated for research purposes; "We told you that last time! Here, have some cake and ice cream."

The use of photographs tempered many of these difficulties. The images invited people to take the lead in inquiry, making full use of their expertise. Normally, interviews can become stilted when probing for explicit information, but the photographs invited open expression while maintaining concrete and explicit reference points. Of course, refined verbal interviewing can achieve the same flow, but the photographs accomplished this end spontaneously.

While thoughtful structuring of verbal probes was needed to elicit needed information we found that the photographs dominated the interviews. This domination allowed us to ask quite precise questions without inhibiting the informants. Psychologically, the photographs on the table performed as a third party in the interview session. We were asking questions of the photographs and the informants became our assistants in discovering the answers to these questions in the realities of the photographs. We were exploring the photographs *together*.

Ordinarily, note taking during interviews can raise blocks to

free-flowing information, making responses self-conscious and blunt. Tape recorders sometimes stop interviews cold. But in this case, making notes was totally ignored, probably because of the triangular relationship in which all questions were directed at the photographic content, not at the informants.

Interviewing is often a one-to-one relationship which closes out surrounding people. Photographs appeared to change this pattern, everyone in the room wanted to look, see, and comment. In addition people would discuss the photographs among themselves; these discussions of topics not always anticipated by the fieldworkers were none the less still structured and readily recorded in an organized manner because of the reference point each photograph provided.

Anthropology began and remains primarily an *outside-in* perspective, but over the years various attempts have been made to obtain insiders' perspectives. Franz Boas and others initiated approaches intended accomplish this goal through careful interviewing, life histories, and the study of myth in which informants were to speak for themselves. But most traditional approaches encounter communication problems of mastering the native language or the hazards of working through interpreters. Questions could be misconstrued, responses misunderstood or misleading. Do photographs serve to modify or compensate for these difficulties?

Photographs sharpen the memory and give the interview an immediate character of realistic reconstruction. The informant is back on his fishing vessel, working out in the woods, or carrying through a skilled craft. The projective opportunity of the photographs offers a gratifying sense of self-expression as the informant is able to explain and identify content and educate the interviewer with his wisdom.

Skillfully presented photographs divert the informant from wandering out of the research area. Without verbal pressure, another photograph drawn from your briefcase will bring the conversation back into the field of study. Photo-interviewing allows for very structured conversation without any of the inhibitive effect of questionnaires or compulsive verbal probes.

Because photographs are examined by the anthropologist and informants together, the informants are relieved of the stress of being the *subject* of the interrogation. Instead their role can be one of expert guides leading the fieldworker through the content of the pictures. Photographs allow them to tell their own stories spontaneously. This usually elicits a flow of information about personalities, places, processes, and artifacts. The facts are in the pictures; informants do not have to feel they are divulging confidences. All they are doing is getting the history in order and the names straight. This objectivity

allows and invites the use of a notebook or even a tape recorder. "You better get these names straight!" For the anthroplogist is making notes *about the photographs,* it appears, not writing down incriminating judgments about the informant's life (though often the hypnotic pull of the photographs does trigger very great confidences). Photographic interviewing offers a detachment that allows the maximum free association possible within structured interviewing.

How long can we extend these examinations? The interview visit commonly offers you new opportunities for photography. "I would like to come on Sunday and make portraits of your family." A second acting-out interview opens the door for another projective interview, and it is possible to continue interviewing indefinitely as long as the photographic process continues. Your second and third interviews can be as intense as your first, a rather rare accomplishment with strictly verbal querying.

In the Stirling County Study and later on the Navajo Reservation, we made tests comparing interviewing with photographs to interviewing with strictly verbal probes. In both tests the pattern was that the cycle of verbal interviewing went from good to poor, and second and third interviews were difficult and sometimes impossible to make. Interviews with photographs retained the same level of return form the first to the third visit. Explanation given by the fieldworkers in Canada was that isolated country people said all there was to say in the initial interview, and the succeeding interviews tended to become purely social. Often with the Navajos and to some extent in the Maritimes of Canada, intensive probing for structured information made informants uneasy or even angry. On the other hand the photographs provide something to talk about making structured questioning less of a strain.

When we consider the intensity of people's response to pictures of themselves, we raise the question: can any photograph offer this? This query implies another: how good must the ethnographic camera record be to allow for significant interviewing and interpretation? As we move from factual to projective reading of photographs, we must be concerned with the complete content of *all* the emotional and evocative elements that can be documented by the camera. Reasonably, the richer, the more provocative and intense the photograph, the richer the potential projective response.

THE PHOTO-ESSAY APPROACH TO PHOTO-INTERVIEWING

In the chapters on photographing technology and social interaction, we have touched on the most common return of photo-

interviewing, the gleaning of encyclopedic information. Interviewing with photographs of housing surveys, records of technologies, and public circumstances of interaction give valuable and complete factual insights and identifications. We have tried to stress that relatively simple photography *can* yield important data. The box camera is capable of distinguishing houses and counting the number of cars and people on Main Street. The functions of counting, measuring, and identifying that have proven to be scientifically reliable depend on relatively simple elements that any novice with the camera can record.

But below this surface content, so valuable in the orientation phase of a community study, photographs are charged with psychological and highly emotional elements and symbols. In a depth study of culture it is often this very characteristic that allows people to express their ethos while reading the photographs. *Ultimately, the only way we can use the full record of the camera is through the projective interpretation by the native.*

Procedurally, the challenge of comprehensive evaluation of life experience suggests the photo-essay as an approach to anthropological description using every sense and skill of the photographer-observer. When we assemble a photo-interview kit to probe Navajo life values, we are in effect presenting a selected essay on Navajo life which we have gathered and designed to give the Indian informant an opportunity to speak of the values and subtleties of his culture. The selection, stimuli, and language facility of the imagery determine the success of the venture. These are also the key elements in the reportage of the photo-essay.

The technique of photo interpretation by the subject of the photograph allows the ethnographic photographer to record and follow through scientifically themes such as the passage of a man through his culture, as Redfield suggests. When the photographic essay has been read by the native, it can become a meaningful and authentic part of the anthropologist's field notes, for when interview responses are studied against the photographs, overtones and circumstantial detail can be reevaluated and the full richness of photographic content can find a place in the data and literature of anthropology.

PHOTO-INTERVIEWING IN PRELITERATE CULTURES

"Many indigenous and nonliterate peoples have had no experience with photographs. They do not think in two-dimensional images. You cannot count on your photo-interviewing technique except with those who are well Westernized." This opinion was expressed by a number of colleagues. If this were true a major

application of photographic research would be lost to anthropology. But is it true? Much scientific tradition suggested it might be, though it had never been put to a systematic test.

Our first opportunity to seek an answer in an indigenous society was presented in Cornell's Fruitland Project with the Navajo Indians of New Mexico. Again, we (John and Mary Collier) were part of a community study, a development program among Indians who had recently been relocated as agriculturalists. The Indians were undergoing further rapid social change as the adjoining area was suddenly becoming industrialized because of the development of natural gas. Many of the Navajos were only part-time farmers, making wages laying oil lines and working in gas plants. To be sure, this was no primitive unexposed tribe in the highlands of New Guinea, but the group as a whole was sufficiently unacculturated to make our observations of their perceptual processes significant.

Since the focus of the study was the changing attitudes of Navajo life values, we assembled twenty photographs of typical Navajo circumstances. Most of the pictures had been taken on other parts of the reservation. We did not want to confuse our results by the conventional reluctance of Navajos to talk about familiar persons or familiar settings; this was bad taste and could be charged as witchcraft. The selection, which we planned to use as probes to get expressions of contemporary value, covered sheep culture, weaving arts, food, agriculture, and family life. William A. Ross, then a graduate student at the University of Arizona, was assigned the job of interviewing.

After the first round of interviews, we had our initial answer: there was no doubt at all that the Navajos could interpret two-dimensional images. The truth was that they interpreted photographs much more specifically than the farmers and fishermen in Canada. Like the Spindlers working with the Blood Indians (Chapter 9), we received little projective material, no stories about the universe or the future of the Navajo people. We were given instead exact detailed accounts of what was happening in each scene.

The Navajos read photographs as literally as we urban Westerners read books or mariners read charts. A typical example: We handed a panoramic view to Hosteen Greyhills, a Navajo farmer. He held the photograph firmly with both hands, studied it with some apparent confusion, then began moving in a circle, till finally his face lit up. "That's how he was standing. There is the East. Sun has just risen, it's early in the morning. The picture is in the spring, it was made at Many Farms the first year of farming." The picture was laid down emphatically. "How do you know it is Many Farms?" Greyhills raised the picture again with some irritation, "See . . .

those head gates. Nowhere else do they have head gates like that. See . . . it's the stubble of the first cover crop. No hogans. People living over there." He gesticulated out of the picture. "Spring— nothing growing." The picture was laid down for good and a second photograph was studied. Greyhills's analysis of the panorama seemed uncanny. With a magnifying glass shapes could be made out that might be head gates. There certainly were no hogans. To our amateur eyes the cover crop was unrecognizable. But the reading was 100 percent correct. The photograph had been made five years earlier at Many Farms, eighty miles to the southwest in the first year of this agricultural project from a mesa looking over the valley at perhaps 7:30 in the morning.

We were dealing with a phenomenon having nothing to do with modern acculturation—exposure to movies and weekly reading of *Life* magazine—but with the sensory perception of a preliterate culture in which a man must survive by astute visual analysis of the clues of his total ecology. Hosteen Greyhills was applying to our photographs the same level of visual perception and fluency he would apply as he stepped out of his hogan to look around the horizon for his grazing horse. We surmised that people living close to nature have to be specialists in natural phenomena to survive. Hence, Navajos read our photographs in the same way, reading each common clue, and coming to a shared consensus of what was happening. The Western observer in urban culture is usually a specialist in a single field. Outside this area, modern urban man tends to be visually illiterate.

We handed Greyhills a photograph of a handsome Navajo couple playing with a baby on a cradle board and expected information on child rearing and family relations, but instead: "That boy has been away to school. He has come back, and he's training to be a medicine man. He's either going to a ceremony or coming from one." The picture was laid down on the ground. "But how do you know he's been away to school?" Again the exasperated grab at the photograph. "See, anyone can see he's been away to school . . . look at that hair cut. Look at those glasses. Can't you see his moccasins? His turquoise? His concho belt? Of course he's going to a ceremony. Too young to be a singer. Must be helper. Wants to be medicine doctor." Again the analysis was correct. The photograph had been made after a sandpainting ceremony. The young man *had* been away to school and *was* training to be a singer. We, of course, saw the moccasins and jewelry but were not sufficiently versed in contemporary Navajo patterns to realize that moccasins were rarely worn except at ceremonies.

The result of our experiment was that the photographs were

When we presented this photograph of roast mutton, a symbolically central food for Navajos, it became a magnetic focus of discussion.

read so evenly by all our informants that the responses were similarly structured, both in content and in length. The test showed a very even containment of values. The longest responses were about sheep culture, next came weaving, and the poorest return was on the agricultural photographs. This was reasonable. Though Navajos have always done some farming, modern status and security had been measured in sheep. The picture that consistently drew the most enthusiastic responses, accompanied by grins and happy talk, was a close-up photograph of roast mutton!

Yet there was one photograph that, had we depended on its reading, would have made us conclude that Navajos could not interpret two-dimensional images. This was a very clear record of horses in the government corral in this Navajo farming community.

"What is going on in this picture?" Our informants looked at the photograph in utter bewilderment as if they never had seen horses in a corral before. "We can't imagine what is happening. Maybe it's a rodeo. Maybe they are going to have a race." *No one* would interpret this photograph. Here was a sense of deepest Navajo anger and hurt, the government corral where surplus stock was held for sale or destruction to rid the range of overstocked herds, which were useless to the Soil Conservation Service but a source of prestige and joy to the Navajos, whose status was traditionally measured in fine horses and livestock.

We were told that the Indians in the Peruvian Andes could not interpret photographs; this was an emphatic statement by an excellent fieldworker who had worked in the Andes and was based on a specific experience of the misreading of a photograph. Later we had the opportunity of spending a year photographing a cultural baseline for Allen R. Homberg's Cornell-Peru Project of social and technological changes at Vicos. On the basis of our colleague's experience, we were prepared to find that these Andean Indians had difficulty reading photographs. Then one day when Mary Collier was washing negatives in a ditch Indian children gathered around curiously, and to her amazement recognized portraits of their friends *in the negative.* Soon after that the young Indian who cooked for some of the hacienda staff recognized his house in an aerial photograph. We began to suspect that Vicosinos could read photographs as well as the Navajos.

Later in our study we informally tested the perception of the Vicos Indians. We made up a set of photographs that included Indians working in fields, scenes of weaving, views of Indian homes, and a view of the central hacienda buildings. Quechua-speaking Peruvian anthropology students took them on their routine interview visits to see whether they would function as interview probes. The Peruvian students returned and with wonderment agreed that the Indians did have problems about looking at photographs. But further questioning revealed that their performance was ambiguous. Yes, they could recognize acquaintances a hundred yards down the trail, they could point out in detail the technology of weaving, but they could not identify the panorama of the hacienda buildings. Their faces became bland. They didn't know where it was or what it was. On long scrutiny they finally recognized a little chapel on the far edge of the hacienda grounds, where they rested their coffins en route to the communal burial grounds.

Was the hacienda, the real instrument of their peonage, such a hateful place that they didn't even want to discuss it? Or was it so traditionally upsetting that they had in fact never looked at the

hacienda buildings? Likely the block was similar in nature to that which had inhibited the Navajos from talking about the government corral. But it was clear that the Indian peons could read photographs, even in the negative, even long distance-photographs, so long as the subject was one that they were willing to discuss and explain.

The Indians of Chiapas, Mexico, read photographs with sufficient perception to allow the Harvard Project to complete regional community surveys of demography and land tenure by photographic examination. This examination is reported by George A. Collier and Evon Z. Vogt (1965, Vogt 1974). The terrain of this region, ranging from 2,000 to 8,000 feet, the meager trails, and the multiplicity of communities necessitated developing a rapid technique of overview. A major goal of the project was analysis of land-use patterns and the general ecology. Since aerial intelligence was highly developed, aerial mapping presented an obvious solution. Picture reading in military intelligence depends on precise codification; this was an equal problem in the Chiapas community and agricultural survey. The gray scale of the black-and-white aerial print had to be rigorously standardized to identify the sites of various crops, natural verdure, geological structure, and the variety of Indian house types. With a reliable interpretation, aerial photographs made at standard mapping heights of ten thousand feet above the valley floors were able to yield an accurate ecological overlook of the patterns of settlement and land use.

> We have found the aerial photos most useful in ethnography when examined carefully with our Tzotzil informants, who, fascinated by this means of looking at the world, provide us with highly detailed information about their native communities. The photographs allow us to construct maps as accurately and completely as we might by surveying and sketching at a site itself with much greater expenditure of time and effort (Collier and Vogt 1965:2).

In an effort to avoid interpersonal tension, the interviews were not made in the Indian communities represented in the photograph, but instead the Indian informants came to the project's headquarters where they were able to express themselves freely about the photographs. Only in the case of land use and agricultural problems were Indians interviewed on location.

The Indians had no significant difficulty identifying communities and discussing land use from these aerial records. With the aid of matched prints and stereoscopes, Indians were able to identify spaces and objects down to two feet, and to provide information to

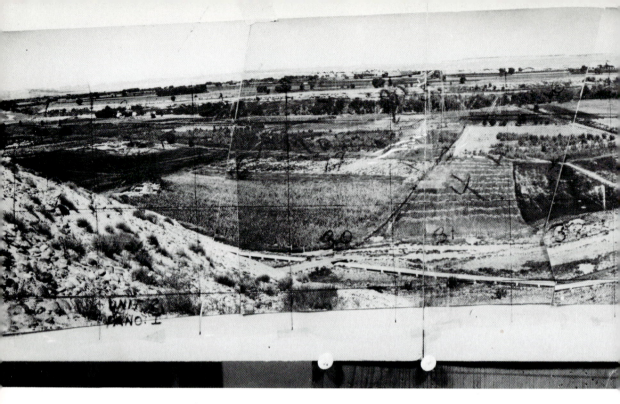

Panoramic photographs used as maps and in interviews can have information and codes written directly on the image, as in this panorama used for interviews with Navajo farmers in Fruitland, New Mexico.

complete community interviews on home ownership and social structure.

The reliability of the insights gained in the Chiapas study were comparable to the kind of data we have consistently recovered from interviewing with ground level regional and community studies: identification of village and habitation, ownership of land, explanation of technologies, and accounts of history and of social and technological change. The rewarding accomplishment of this experiment, a departure from the conventional readings of army intelligence, agencies of land management, and special surveys carried out in photo-geology, was that Indian informants were also able to make projective observations from the aerial prints.

> Several days' work with a few selected informants
> allowed us, on the basis of the photo, to compile an
> exhaustive house by house census, the catalog land
> ownership on over 400 land plots, and to identity most
> of the community's sacred waterholes, mountains, caves,
> and cross shrines. This task on a village of 670 residents
> world have taken many weeks' time without the aerial

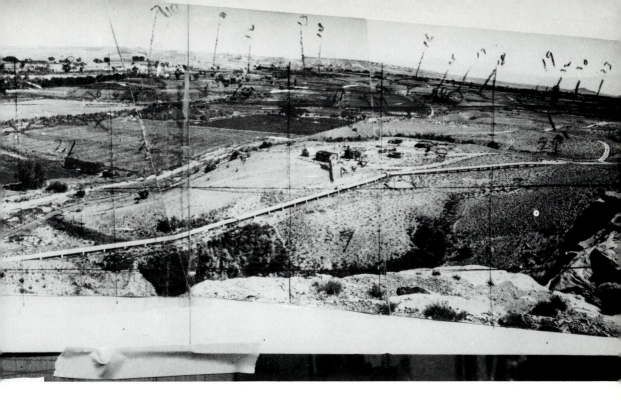

photograph. But the aerial photos are more than a time-saving device. They allow us to tackle problems of a more general nature whose solution requires a *quantity* of data which we usually have had to sacrifice for quality, and a *quality* of data which traditionally we have had to sacrifice for breadth of scope (Collier and Vogt 1965:2–3).

The technique proved so practical that the Harvard group carried out major investigations using these photographs in interviewing (Vogt 1974).

Can nonliterate people read photographs? Our testing of the Navajo, our more casual experience with the Andean Indians, and the Harvard Chiapas Project interviewing the Mexican Indians with aerial photographs provide an affirmative answer that people of preliterate cultures can transfer their native perception to the two dimensional image of a photograph.

Some photographs contain intense imagery that invites projective responses, as in this photograph made in the lobby of a computer convention. (Photograph by Ken Graves)

Chapter 9 Psychological Significance and Overtones of Visual Imagery in Projective Interviewing

Anthropology has extended its range of human study beyond the description and measurement of external structures and processes to a study of inner states and value systems. These latter concerns approach and overlap the areas of psychology and social psychiatry. Anthropology has also been called upon to support broad, humanistically motivated efforts of social change and development—action programs concerning education, health, and welfare and efforts to minimize the dislocation involved in rapid technological and cultural change and migration. Many disciplines might be involved in these investigations; techniques and tests of both a cultural and psychological character are used to probe the more submerged nature of the individual and the community.

Photography has a potentially important role in these refined understandings, both because of its specificity and because of its ability to present interrelated wholes. As an example, the inclusion of photographs can make the familiar community questionnaire more comprehensive and the meanings of questions more precise; the nonverbal presentation can help to overcome problems of illiteracy and facilitate questioning across the language barrier in cross-cultural studies. Photographs offer the thought process a fluency of imagery in the projective interview, an opportunity that has just begun to find its place in the research of psychological and anthropological understanding. What Goldschmidt and Edgerton say of drawings as an interviewing tool is also true of photographs:

. . . they present all elements simultaneously, without differential emphasis, while a statement is, by the nature of language, lineal. [Also] the symbolic meanings of the artifacts are themselves significant, and . . . their significance is once removed when substituted for by verbal presentation (1961:44).

All varieties of cultural and psychological examinations which use photography exploit the stimulus of feedback. All rewards of interviewing with photographs stem from this phenomenon of the return of the informant to a familiar image of reality. All forms of self-expression are varieties of feedback. Our very intelligence depends on a constant renewal of awareness, and it is through feedback in painting, balladry, storytelling, and in modern man story reading and film viewing, that we acquire and retain our intelligence about ourselves and our life circumstances.

A creative photographer, Jim Goldberg, has developed an art form of photographic feedback. His technique developed out of a photographic study of the isolation and poverty of homeless people living in run-down residential hotels in San Francisco. Goldberg became concerned with the effects of their circumstances on the spirits of these castaways, and he fed back to them their portraits. He was not prepared for the depth of feeling that the photographs provoked; so fluent were their responses that he asked them to write down their thoughts directly on the prints. The people had discernment and refinement, reflected in statements of profound philosophical value inscribed on the photographs. This was, in effect, a form of photo-interviewing that stimulated his hotel friends thoughtfully to consider their lives.

It is unlikely that any social worker would have written the observations on human dignity and perspectives that Goldberg's photographs evoked. In writing on the photographs the subjects were talking not so much to the photographer as to their own reflected images, a dialogue with themselves.

The revelations of this experience challenged Goldberg to photograph affluence with the same projective approach. Again the photographs produced fluent responses, as the well-to-do inscribed observations on their own lives onto the portrait documents. When these were compared with those of the the hotel residents, Goldberg observed a subtle shifting of values in which the statements of the wealthy expressed unrecognized psychological deprivations compared to the poverty of the very poor. The hotel residents by comparison described unseen "wealth" in the hardships of their lives.

There is a history of projective revelations in and in response to imagery. Alexander H. Leighton of Harvard University made

some early explorations into the projective use of artwork which suggest the dimensions of this cultural experience. While making an anthropological study of Saint Lawrence Island in the Bering Straits, Leighton had several Eskimos draw pictures of the major events in their lives. One woman was outstanding for her capture of a whole range of human experience. A few years later during the Second World War, Dr. Leighton was sent for research purposes to the Japanese War Relocation Center at Poston in the Mojave Desert. The forced "relocation" of Japanese Americans created conditions of great stress. Dr. Leighton had a Japanese American artist make literal drawings of the major stress circumstances in the camp; the result was an intensely emotional feedback in watercolors depicting the conditions in the camp in their most serious light. "All emotions entered these pictures, rage, grief, the sense of injustice, and also humor, roaring laughter, and appreciation of the desert's beauty" (private communication).

Byron Harvey successfully used indigenous painting in an ethnomedical study of Hopi curing practices and ceremonies (discussion at Southwestern Anthropological Association meeting at Davis, California, 1966, and private communication). A major goal of using Hopi artists' material in interviewing was to form a linguistic bridge so his informants could explain with cultural accuracy the beliefs and practices of native therapy. The paintings offered his informants a positive scheme which would allow for a very involved explanation using the simplest vocabulary. A second objective was to use the painting to get into the mystique and the technology so that Harvey could ask intelligible questions. The accuracy of the paintings and Harvey's gleaned knowledge stimulated his informants to express fully knowledge that they might otherwise have glossed over.

The artists were all painters of kachinas (ceremonial wooden dolls elaborately carved and decorated to represent supernatural forces) and sophisticated in design and color as well as informed about Hopi mysticism. They had no trouble in moving from abstract kachina decorations to two-dimensional documentary paintings on paper. John McCaffrey accomplished this just as easily with a native calabash bowl painter in Australia, who moved without problem from making incised images on a gourd to watercolors on 16 by 20 in. paper (private communication).

While suggesting the subject, Harvey did not specifically structure the content of what the painters were to depict. "Now we are going to do a man with a broken arm." Harvey did encourage a sweep of content, to include more than one person and to show where the treatment was taking place.

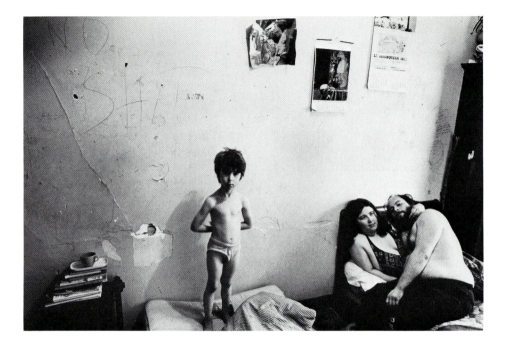

This picture says that WE are a very emotional & tight family, like the three Muskeeters.

Poverty sucks, but it brings us closer together.

Linda Bambo

Photographer Jim Goldberg urged people to write comments on their photographs in a unique form of informal feedback and interview. His initial work, as in this photograph, was with poverty-stricken people in San Francisco's Tenderloin district whose comments often produced profound viewpoints on their lives. (Photo by Jim Goldberg)

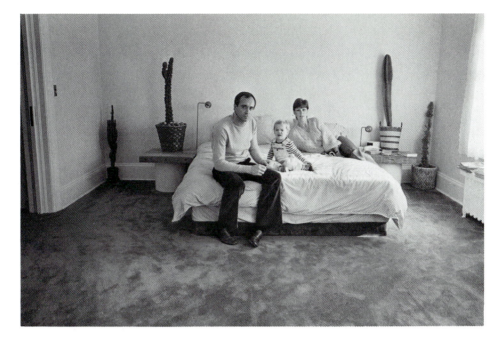

We are a contemporary family.
We don't want to be ~~part~~ of the masses.
We want to live with style!

JoAnn Roberts

Goldberg extended his photographic efforts to more affluent subjects. The wealthy were as responsive as the poor in projectively revealing the aspirations, joys, and psychological hardships of their lives. (Photo by Jim Goldberg)

Information was recovered on three levels. First, were the revelations in the paintings themselves; second, the painter's explanation of what the records meant; and third, check interviews with ten Hopis representing various tribal clans (including three of the artists who painted the series). By including artists in this final interview series Harvey obtained a comparable level of graphic as well as cultural sophistication. This series operated informally as a control over his data and gave Harvey a rewarding parallel reading of the paintings. All interviewing was unstructured: "Here's another one." Informants gave specific information and precise linguistic

identification but also told stories and made observations about what was going on. "Sometimes we use urine to treat sore eyes." Harvey also found out that these paintings were useful in exploring where sensitive magical areas lay; in his words, "See if they dodge." Graphic interview material often alerts the researcher to deliberate suppression that can in itself form a volume of important psychological insight.

The impact of photographs in interviewing is in the response to imagery reflective of the life experience of the informant. We believe that photographs, film, or video challenge the informant more than verbal feedback or artwork because the literal character of their images intercepts the very memory of the person. What is feedback? It is an essential personality process, continually in progress, when blocked its absence can provoke serious psychological consequence.

A study was carried out at Stanford University some years ago concerning the nature of brainwashing. It had been believed that lack of sleep was the key element, with exhaustion making the mind pliant to outer forces. Investigation proved this somewhat false. Not interruption of sleep but lack of dreaming was important. Theories now suggest that what we experience during the day is processed through dreams at night; when this continuity is broken we lose our psychological equilibrium and controls (John Adair, personal communication). Feedback can stimulate people to express multiple feelings about themselves and their culture. We can feed cultural material back to informants, allowing them to express their life feelings, or we can get the people to express themselves by manufacturing their own feedback, in paintings, drawings, storytelling, reenacting their lives for us, dramatically, or even producing their own photographic or motion images with the camera. This possibility raises rich and interesting avenues of exploration.

John Adair of San Francisco State College and Sol Worth of the Annenburg School of Communication carried out just such an experiment in 1966 by having Navajos make their own motion pictures. With minimal technical instruction on the use of three-turret Bell and Howell cameras they were told to make films of their own choosing and form. This ultimate experiment in projective examination allowed them to act out and produce images of their own conception of the world and their place in it. The results produced fascinating insights into a host of subjects, including Navajo cognition patterns, narrative style, an ordering of time and space (Worth and Adair 1972, private communications).

This experiment was a practical form of visual interviewing that could be repeated in both indigenous and modern urban societies.

A number of similar experiments have been carried out, although none with the same degree of organized research accompanying them. Sociologists have used the approach to investigate black urban culture with Black youth of Philadelphia scripting and acting out a film titled *It Happened on Wilson Street,* portraying the futility of gang warfare. In 1965 a social worker in Richmond, California, led Black teenagers to produce a number of films, including a fantasy entitled *The Dream Blowers.* These films, reflecting a depth of cultural refinement, were used primarily for viewing by the community. While there is no information on the results, other experiments suggest that such feedback has positive functions in terms of self-image.

Ron Rundstrom and Pat Rosa carried out similar efforts while employed by the Los Angeles County Parks and Recreation Department between 1970 and 1975. Working with Chicano youth groups in East L.A., they assisted these young people in making visual records of their lives. Products included documentation of trips to the desert, events and activities in the barrio, and several dramatic productions , including a love story. As with the films made earlier in Richmond, the main audience for these films and video tapes were the youth themselves, providing an outlet for expression of feelings, tensions, and creative drives. Some of the filming was done using Super-8 equipment, but the major focus of the project involved the use of video, housed in a mobile van (Ron Rundstrom and Pat Rosa, private communication).

Alexander Leighton has explored therapeutic feedback of film in the Maritimes of Canada. The situation involved an ingrown backwoods community that appeared to be developing a neurotically negative community self-image. The experiment involved three steps. First, the positive accomplishments of the community were documented and shown. Then a second film was made that had both positive and negative elements. Finally, a third film was made which showed things "as they were." The progressive viewing of these different films was used both to obtain insights from the residents and to help them define for themselves what they were and could be. Reportedly there were positive developments in community image and actions following the process (Leighton et al. 1972).

THE POSITION OF PHOTOGRAPHS IN THE SCALE OF PROJECTIVE TOOLS

When we speak of the projective use of photographs we are speaking of a distinctive experience. The TAT (Thematic Apperception Test) is one projective tool. Like the Rorschach cards, the TAT dredges for subjective responses. "What does this picture remind

you of?" The focus is on the internal feelings and values of the informant. When we interview with photographs we can have precisely the opposite experience, for the focus is on *what is in the photographs*. Such examinations can be like a personally conducted tour through the culture *depicted in the photographs*. Realistically, the interview return is a blend of precise reading of exact graphic content and projected attitudes. It is this reading fluency of photographs that makes the camera record a valuable recovery tool in anthropology. Hence, we must understand that responses to paintings and drawings are on another level of projection.

A field application of both drawings and photographs used projectively clearly gives us the character of the optically produced image. George and Louise Spindler of Stanford University have experimented with both media while interviewing the Blood Indians of Canada with a technique called the Instrumental Activities Inventory (1965). One question was, "Is it good to have white men's trading posts on the Blood reservation?" When they showed a *photograph* of a trading post on the reservation to an informant, the response was, "Why, that no good cheating trader McSmith! I'll never go in his post again; he's a mean, hard man." In another interview the informant was shown a *drawing* of a typical trading post, and the response this time was, "Yes, it's good to have a trading post on the reservation. Some traders can be real friends and help us Indians get the best deals. Bloods are not ready yet to run posts, and if a Blood was a trader, he'd give all the best deals to his family" (private communication). The Spindlers say:

> We want to avoid personalization, so that each respondent can project in to the instrumental activity his own values and cognitive organization. Photographs are too specific about places, persons, and objects for our purposes. The I. A. I. (Instrumental Activities Inventory) pictures are, however, not drawn with fuzzy lines or ambiguous detail. Each item in the picture must be technically correct or the respondent becomes so concerned about the technical mistake that he fails to project much of anything but this concern. And the respondent must know what instrumental activity is being pictured. But the I. A. I. pictures are depersonalized and decontextualized as far as specific personnel and locations are concerned (1965:11).

Projective materials that can create a feedback experience range from the Rorschach inkblot to the intimate photographic essay of a man's life. The projective response can be one of free association from deeply submerged feelings or can be highly structured and self-consciously factual. In the course of a study all these levels of

response might be drawn upon according to the needs of the research. We should select the most suitable projective tool. To do this, projective responses should be viewed in their proper order of abstraction, from imagery of the subconscious to factual explanation of realistic data. It is important to keep in mind that there is a direct relationship between our tool and the nature of the informant's response. The more abstract the projective shape the less predetermined the area of the response becomes. This is why the inkblot has proven so evocative of submerged feeling in psychological probings.

Here is an overview of the most frequently used projective tests:

Projective Testing Tool	Level of Expected Response

EXTREME ABSTRACTION

Rorschach Tests	Submerged feelings about self. Sexual emotions and fixations. Extremely free associations that dredge up thoughts passing through consciousness and subconsciousness.

SEMIABSTRACTION

Thematic Apperception Tests	Submerged feelings about self in relation to experiences in the real world. Free association about significances of circumstances which could take place in the real world.

GENERALIZED REPRESENTATIONS

Defined Line Drawings	Concrete sentiments about circumstantial reality. Free association about universal problems. Positive views about self with regard to the supernatural, universal or cultural values.

LOWEST LEVEL OF ABSTRACTION

Photographs of Familiar Circumstances	Precise descriptive reportage. Sweeping encyclopedic explanations. Precise identification of event or circumstance. Noticeable lack of submerged psychological responses. Noticeable lack of free association BUT Factual representation of critical areas of the informant's life can trigger emotional revelations other wise withheld, can release psychological explosions and powerful statements of values.

The TAT is the test most closely related to the possible use of photographs as projective stimuli in interviewing. This proximity suggests the use of photography to manufacture TAT material tailored for special uses. But if our purpose is to stimulate fantasy, substituting clear photographs for blurred TAT images will not work. Experimentally, we collaborated with a group at Cornell translating TAT pictures into photographs for a psychological study of projective responses. The results turned out to be entirely different from the TAT cards for, even at a glance, the testee would grasp and respond to the specific circumstances. The emphasis shifted away from imaginative storytelling to precise analysis of the photograph's documentary evidence.

Methodologically, the TAT concept could be modified to allow for significant projective responses using photographs. The shift would have to exploit the literal clear understanding of what was pictured in each circumstance. Instead of a multiple interpretation test you would have a projective questionnaire that could gauge an informant's attitudes and adjustments to structured experiences within his culture. It would be a valid testing tool in that you could confront any number of people in the same way with exactly the same probes of their attitudes about their culture. "How do you feel? What pleases you in your life? What upsets you?"

Projective tests made with photographs would have to operate on a very tangible level, where the informant would respond to a real circumstance, clearly recognizable. A possible example of this kind of projective testing might be a set of photographic cards showing classroom situations. These tests could be used to screen teachers for work among underprivileged children. Photographs could show rowdy students interrupting a class, a teacher shaking a Black child in anger, or in the reverse, a teacher physically comforting a weeping Black child. Scenes of this kind could be used to pretest a potential teacher's pattern of reaction, "How would you respond to these classroom situations?" Here the tangibility of the projective material would work in your favor.

In common with other culture-bound tests, one of the handicaps of the standard TAT is that it can fail to operate cross-culturally, simply because the visual triggers fall outside cultural familiarity. Could photography correct this fault? Only in part. Native-made drawings, as the Spindlers' work points out, may do this job better. On the other hand, photography can greatly assist in producing culturally correct drawings for projective testing.

Robert Edgerton used drawings with the Menominee of Wisconsin to elicit responses about values in relation to acculturation levels, using the Spindler sample of sociocultural categories (Gold-

schmidt and Edgerton 1961). But his experience with some of the drawings illustrates how important it is to have the cultural details correct. One of the test cards showed Menominees around a large drum, in a nativitistic gathering. The questions asked were about the values involved in these performances. Instead of giving relevant responses, informants asked, "What is that drum?" The artist had mistakenly drawn a picture of Indians in dancing costumes worn only at public "pow-wows" dancing around a sacred ceremonial drum. This so puzzled the informants that they could not answer the question.

The multiple choice opportunities offered by the ambiguous TAT images could be accomplished with photographs in a cross-cultural projective test if the judgments exploited the tangible record, in the same way as did the screening material for teachers. Material probed for would have to be specific rather than general. If the projective test were considered in this fashion, photography would certainly be the best way to assemble these examinations.

Changing sentiments of status in culture might be explored by this type of photographic projective test. Again highly tangible situations would be photographed and assembled in various kits. For example, to explore "Who has status in a changing culture?" test cards could show the roles and interaction of the contemporary cast of village characters, both native and alien, native priests of various sects, native leaders, men of various castes and professions, foreign traders and intruders, Peace Corps workers, Navy personnel, tourists, personnel from the various diplomatic missions, and so forth. "Which of these men are most important? Which of these men are least important? Which groups do you associate with? Which groups do you most fear?" Even free association about this cast of characters would trigger sentiments on the existing social structure. In this fashion many sentiments could be examined systematically.

In the circumstance of rapid acculturation, classical modes can shift, upsetting the speculations of anthropology. We constantly need a fresh look, for culture is always emerging. Some classical values remain stationary, but others change completely. Photographs provide a means of assessing such changes as well as fresh perspectives on old traditions.

An example of this occurred during one phase of Dr. Bernard J. Siegel's research at Picuris, a small Indian Pueblo in New Mexico. Siegel employed one of the authors (John Collier) to gather open-ended photographic records as part of a study of contemporary Picuris culture. The research period included the major saints day for the village during which a number of ceremonial activities took place, including an exquisite deer dance. At the request of the village

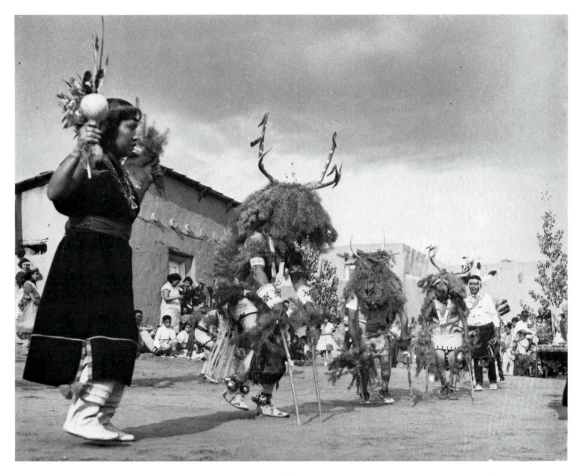

In a Stanford University study of Picuris Pueblo, both Dr. Bernard Siegel and John Collier assumed that this deer dance was the center of ceremonial activity at the summer fiesta. Interview responses using the photographs suggested otherwise.

governor both the deer dance and some foot races, involving mainly older men down by the river, were photographed. The field team considered themselves exceptionally lucky to be invited to photograph the deer dance, often considered to be the central ceremonial activity of this summer fiesta.

When Siegel carried out interviews using the photographs, to our amazement, only cursory comments were made on the deer dance; "We just do that for the Spanish people. . . ." But when the photographs showed the crowd moving down the hill to the foot race the interview tone changed; "Now the solemn time begins . . ." and intense commentary followed. Running was more of a central ceremonial mystique than the elaborate deer dance. This revelation suggested changes in classical beliefs regarding ceremonialism at

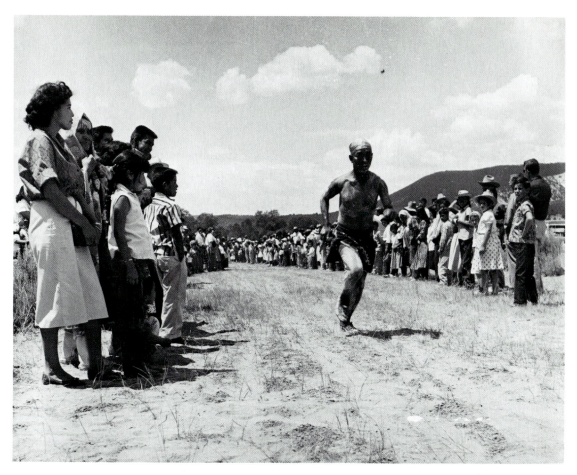

When Siegel used this photo in interviews, he was amazed to find that it was the foot race, not the elaborate deer dance that elicited the most intense responses and appeared to be the ceremonial center of the fiesta.

both Picuris and its larger neighbor, Taos Pueblo. Both had excelled, historically, in long-distance running, but it was the drama and pageantry of the deer dance that had always captivated the attention of outside observers in the past.

This example illustrates another point. Photographs by themselves do not necessarily provide information or insight. Without Siegel's disciplined use of the photographs nothing would have come of them. It was when the photographs were used in interviews that their value and significance was discovered. Only then, through the eyes and intelligence of a Picuris assistant, the photographs became anthropological evidence.

The value of projective responses to photography is the powerful persuasion of *realism*. Often we think of psychological explo-

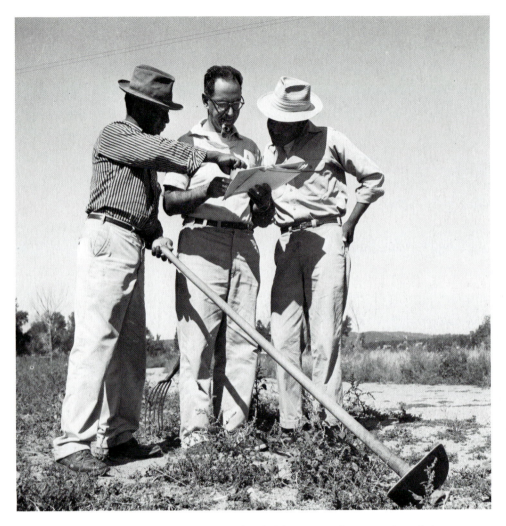

Dr. Bernard Siegel interviews in the field, using photographs of the fiesta. Note that the interview takes place around the the photographs, rather than centering on Siegel.

sions in terms of symbolism; realism can be even more provocative. Not just photographic realism, but any real evidence can have the most explosive effect upon the witness—the dagger used in the murder, the intimate possessions of the victim.

In the First World War, it is said, a German intelligence officer used the psychological pitfalls of realism to interrogate French officers on the Western Front. The trap for gaining intelligence was set by skilled hunters. A captured French officer would be treated with camaraderie: "We're all officers in the war together, comrades at arms in a deadly game. You're captured, so now relax. Let us drink together." The French officer was *not* questioned; instead he was invited down into a dugout to join a sumptuous meal, with

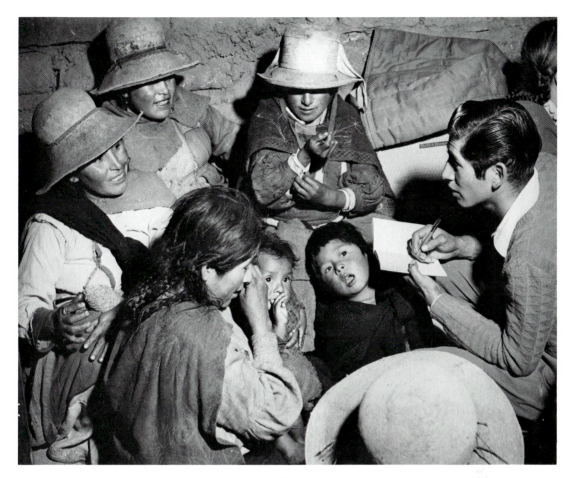

Interviewing with photographs is different from conventional verbal interviews. Note the effort of the investigator to communicate with informants. Verbal questioning can create a distance between interviewer and informants, whereas use of photographs can pull people together, as seen in the previous photo.

wine, cigars, and good cheer. *But* on the wall was a map of the Western Front, with the armies of both sides located with colored pins. Throughout the meal the French officer eyed this deadly evidence, and in some instances, before the evening was through he would step to the map and compulsively correct the location of the pins revealing his own army's precise position, and then with horror step back. We have a fascination with evidence we intimately know and a common compulsion to express our knowledge.

Photographs are charged with unexpected emotional material that triggers intense feeling and divulges truth. It is probably more difficult to lie about a photograph than to lie in answer to a verbal question, for photographic scenes can cause intense feelings that

are revealed by behavior, flushed faces, tense silence or verbal outbursts. The thematic qualities that can be found in photographic content, in intimate studies of the informant's life, evoke emotional statements of value—a positive "yes" and a positive "no." Using photographs projectively to reach these submerged areas requires tact and sensitivity to the emotions of the informant.

Many times photographs contain triggers which the interviewer never realized. The most innocent picture can create an explosion that changes the whole character of the interview. I (John Collier) once made a routine study of a pleasant village, which had once been a historical port. The file depicted old homes, docks, stores, scenes in the church and public school. The team interviewed a local minister with this photo study. He was steeped in tradition and gave us the classical view of the town—fine old families, old customs and values. The interview ran its perfunctory course till we showed him pictures of a pie supper. He became flushed, laid down the pictures without comment, and went on with his historical recitation. Then he picked up the pie supper pictures again and pointed to a smiling man holding up a pie for auction, "I shouldn't say this as a preacher, but I'd rather that man kill his wife than let her treat him the way she does! His wife is running with every loose man in the community . . . See that girl? She's pregnant. I know who the father is. . . ." After this emotional break, the interview changed completely, and in heated words the minister gave us a very disturbing image of this traditional community.

So in one sense, photographs *do* function like TAT cards, only the stories told are about *real circumstances* involving real people.

Chapter 10 Risks to Rapport in Photographic Probing

Photography can gain us a foothold in a community. But just as quickly and completely, photography can result in rejection if we are guilty of insensitive intrusion with the camera. It must be clear that when we start photographing the inner workings of social structure (as opposed to its outer institutionalized form) we leave the public domain and enter the confines of more private beliefs and behavior.

A community is encircled with cultural activities that range from wholly public, impersonal functions occuring in the public domain to the very personal and guarded activities of families and individuals. We may photograph freely in the outer rings of public gatherings and basic technologies, but as we move inward the ground becomes more treacherous, and we should accept the fact that there may be inner sanctums we never will be able to observe with the camera. We have these circumstances within our own culture, where photographing may be completely unacceptable, extremely dangerous, or literally impossible.

In many cultures, religious worship is one of the delicate functions of a community. The church, the temple, the Indian kiva are places where the deepest values are experienced. These sites and circumstances are steeped in protocol and are hypersensitive to strangers and to lack of respect. In many societies this sensitivity also involves covert or outspoken fears of magic danger.

Most Indian pueblos of the American Southwest prohibit photography of ceremonial dances. In Santo Domingo, koshares, the dancing clown-priests, will grab a tourist's camera, and without

breaking the dancing rhythm adroitly remove the film, expose it gracefully to the light, and return it to the photographer. Isolated Indian communities in the Oaxaca region of Mexico are so suspicious of "gringo" observers that some villages forbid photography altogether. In most indigenous cultures there are objects and locations that must not be seen by the camera.

Usually religious ceremony is a focus of prestige in a culture. It frequently involves important leaders, cloaked in social roles of caste and class. Most cultures offer ways in which you may present yourself to religious leaders and find a role that does not dishonor the ceremony. Beyond specific refinements, the approach must match dignity with dignity and respect with respect. You need not go among the Hopis to come upon this problem. You can experience it completely when you ask to photograph a friend's wedding or a service in the local synagogue.

I (John Collier) had just such a challenge in photographing the Amish farmers of Lancaster County, Pennsylvania, for the U.S. Department of Agriculture. Photography was met with great hostility, yet it was important to complete this study. I called on the local Amish bishop, an impressive farmer of great age. I explained my problem, outlined the worthy and honoring nature of my study, which was to record the richest culture of farming in America, as a record for history and research. The bishop was hospitable but adamant. "Don't misunderstand, son. We are not unfriendly to your work. It is just that we cannot help you make graven images of men—a sin against God. But it is obvious you are already lost with that camera machine, so we don't worry about your soul. Go right ahead, son. But when we see you we will duck!"

Unquestionably the bishop told his flock who I was and what I was doing. I found the Amish cordial, but they always ducked! With this understanding I photographed agricultural techniques and social interaction as well. When my camera was down, they smiled; when I raised my camera, if they saw me they turned their backs.

This problem of rapport can be examined on two levels—research in the public domain and photography of private sanctum. There are in each culture activities open to the general public and life circumstances that are considered completely personal. When a situation ceases to be public is a culturally determined circumstance. What you can do with a camera twenty feet from a man and what you can do five feet from a man can change dramatically from culture to culture. Each culture sets its distance. We can refer to Edward T. Hall's study *The Hidden Dimension* (1966) for a discussion of cultural distinctions in the use of space. Moving in on people with a camera

is subject to the same sensitivities as any other form of communication.

A seasoned fieldworker might question the feasibility of our suggestion that a newcomer should stand in front of a church and make a record of everyone entering or leaving. Certainly, if you went about this in an aggressive mechanical way, you would most likely be stopped. On the other hand, churches are prestige sites in most communities. People are proud of these structures; they represent the kind of locale where they would expect you to take a picture if you were a tourist. In a small community when services end there is a spontaneous gathering as folks leave the church. A couple of shots of the church which would include the congregation would be all you would need for a spot sample of who supports the church.

On the other hand, if you are recording who goes into bars, this is an entirely different matter. Studies of this kind have to be very sweeping street views that include the doorway of the bars, or the shots might have to be made on particular nights, when lots of people are on the streets, so that frequenters of the bars would be only one part of the sample. The key lies in whether or not the camera is felt to be a threat; a threat can be counted upon to arouse hostility.

The degree to which photography is percieved as a threat and therefore unwelcome can be affected by the behavior of the photographer. This is an issue particularly when working in public situations where it may not be possible to introduce yourself to all people who may come before your lens. Hurried and secretive shooting is certain to arouse suspicion regarding motives. In most situations it is best to move slowly and take time making shots, giving people time to know you are there and object if they wish. If, through your behavior, you convey a sense of respect and confidence in your role people are more likely to assume that your motives are good. Equally important, unhurried recording allows people time to adjust and to make contact with you. If through such contact individuals become accepting of your presence, that acceptance will be conveyed to others through *their* behavior, and your job will become easier.

What is public, what is personal, and what is threatening become acutely important when we consider the feedback of pictures of community interaction. Errors in taste as to what photographs you show to whom can cause more explosions than any other failure of protocol in the community study.

A critical example of improper feedback was the interview use of the photographs of a yacht club party which aptly illustrated class

structure (see Chapter 7). The fieldworker worked with local picture readers to cross-check the identification and position of participants at the yacht club dance. To his satisfaction, he had no problem obtaining rewarding interviews based on the photographs. In fact he was swamped with invitations, "Come and bring the yacht club photographs." Everyone in town wanted to see the pictures of this reportedly wild party. Then quite suddenly the flood of cordiality was turned to hostility, and the fieldworker and I as project photographer were bitterly criticized. We rapidly lost our investment of good will. It was clear we had made a blunder. Our mistake was obvious, for projective use of the party pictures had aided and abetted malicious gossips in the community. It had been a tactical error to show *any* of these photographs to the public. Probably the set as a whole should have been shown only to our one trusted key informant who, in the end, gave us the most complete reading of the event.

This experience suggests a safe rule-of-thumb protocol. Pictures made in the public domain can be fed back into the public domain. Pictures made in private circumstances should be shown *only to people in these circumstances*. Pictures of a family can with gratification be fed back to the family but should never be shown to other families no matter how good friends. A possible exception would be more or less formal portraits taken to represent the accepted public image.

In general, photographic notes should be handled in the same way as other field notes. Material given in confidence should be held in confidence: for a family to let you record their private life is an act of the greatest confidence.

Considering the retention of the subjects' good feeling as an integral part of ethical research procedure the anthropologist will, of course, pursue his research objectives with honor and discretion. We feel that it is an important professional accomplishment for fieldworkers to leave with doors open behind them, so that they can return with welcome as many times as may be necessary to complete their studies. Generally, the success of a field study is dependent upon the generosity of local people.

On one occasion we had the assignment of recording a Navajo sandpainting, but Navajo singers offered no cooperation to a White man with a camera. Trader Roman Hubbell of Ganado was amazed and amused at what we considered a dilemma. "Why don't you buy a ceremony? That's what a Navajo would do. Who have you been approaching? After all, you wouldn't expect one of your White friends to share his medical treatment with you." The solution was as simple as stated. We had no difficulty buying a sandpainting of our own, and once the deal was made, fear of magic dangers dwindled amaz-

ingly. With complete cooperation we photographed each step of the ceremony and were invited to record in detail the contents of the singer's medicine bundle. Most of the time there is a gracious way of carrying out your documentation.

Religious activities and objects can be sensitive subjects, but often there are appropriate ways to record them with respect. Medicine bundle of a Navajo singer, see page 136 for details.

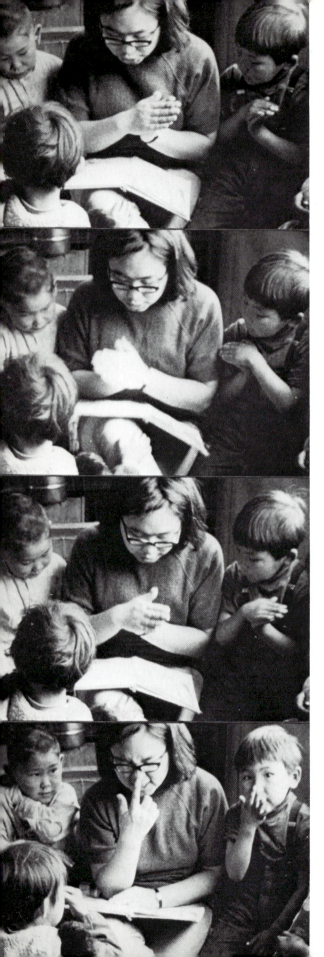

Frames from a Super-8 research film of a Head Start program, Kwethluk, Alaska. Sequences of still photographs can record what happened, but only the fluid imagery of film and video can reasonably convey the full emotional quality of human activity.

Chapter 11 Film and Video

Photographic action in visual anthropology has been increasingly drawn into film and video, for they have expanded nonverbal research with flowing records of culture and behavior through time and space. Film and video have become essential for the study of human behavior, as in investigations of interaction in city space or research of schoolroom culture.

The English photographer Muybridge, demonstrating the research use of still photographs taken at controlled intervals, unquestionably laid the basis for the research use of film. (Throughout this chapter "film" means movies.) His assignment in the 1870s was to settle a bet for Leland Stanford, railroad millionaire and governor of California, that at a gallop all four of a horse's hooves were off the ground at the same time. This brought about the first scientific recognition that the fleeting details of motion are not stopped by the eye. In 1877 a French astronomer, Jensen, and the French physiologist Marey perfected the first moving picture camera—not for entertainment, but strictly to study more than the eye could see.

The modern camera is closely related to this first invention which recorded an image ten or twelve times every second on a continuous spool of sensitized paper. Marey made high-speed studies of the flight of pigeons and the running of a horse, which were reported on in his book *Le Mouvement* in 1894 (Michaelis 1955). Since its development, the moving picture camera has been used extensively for scientific research from astronomy to zoology. In industry, film is the standard method for analyzing the technology of motion for efforts toward efficiency and industrial safety. For related rea-

sons, sports strategists have used film extensively for play-by-play analysis. Psychologists have used film in a similar way in the study of animal and human behavior. In all of these fields it is the flow of film and, more recently video, that is so desirable for time and motion analysis.

In anthropology, again it was Margaret Mead and Gregory Bateson who, together and independently, made the first effective use of film for analysis of cultural behavior (Bateson and Mead 1942; Mead and Macgregor 1951). Like Gesell's work in child development (1934, 1945) their work depended not only on the viewing of the film footage, but also on detailed examination and comparison of enlarged prints of single frames.

The past twenty years have seen considerable debate concerning the use of film and, more recently, video in anthropology and related fields. Actual usage has been uneven and falls into two broad categories. First, there has been great interest in "ethnographic" film, so that for many "visual anthropology" *is* the production of films which are then used in classrooms or in other audience settings. Second, there has been a wide range of research involving the use of film and video as *tools* to assist in the investigation of cultural phenomena.

What Happens When the Image Moves

When the image moves it *qualifies* the character of human behavior. Refinements of interpersonal behavior are suggested in still photographs, but conclusions must still rest on often projective impressions that "fill in" what the photograph does not contain. With moving records, however, the nature and significance of social behavior becomes easier to define with responsible detail, for it is the language of motion that defines love and hate, anger and delight, and other qualities of behavior. For this reason visual studies of behavior and communication tend to use film and video rather than the still camera.

Some of the reasons and rewards for the shift from still photography to motion pictures can be illustrated by our own movement to usage of film as a tool. In 1969, I (John Collier) joined a national research study of American Indian Education, under the U.S. Office of Education. The study was intended to examine the continuing historical failure of schooling for Indian children and was to be carried out wherever Indian children were in school. Dr. John Connelly of San Francisco State College had the responsibility of conducting the study of Native education in the Northwest Coast and Alaska, and I was appointed as a visual anthropologist to assist in

this investigation. Prior to the study I had been teaching courses dealing with problems of cross-cultural education, drawing on life-long contacts with Indians in the Southwest and in Latin America. Because I had observed that cultural problems in the classroom rested largely on issues related to communication and emotional well-being I shifted from still photography to film.

This decision was based on several experiences with film, two of which deserve particular mention. Some years earlier I had carried out an experiment involving the documentation of a family using 16–mm motion picture equipment. As part of this experiment a colleague, Richard W. Brooks, had paralleled my filming with superb still photographic coverage. Trials with the film and still photographs were made with different audiences, which demonstrated that the film could provide information and insight regarding emotional and communicational issues that could not be approached with the still photographs (Collier 1967: 132). The second crucial experience was a visit with Edward T. Hall in the summer of 1968. During the visit Hall showed us film that he had shot in New Mexico using Super-8 equipment. One portion of the footage, for example, recorded three families; one Anglo, one Tewa Indian, and one Spanish American, all enjoying strolls through a fair at a pueblo in northern New Mexico. The footage appeared mundane on first viewing, but as Hall projected the film for us in slow motion and frame by frame, it revealed in minute detail the contrasting non-verbal styles of each family, the fluid synchrony of movements within each, and the roughness or dissynchrony of movements in communications between people from different cultural backgrounds (Hall 1983: 142–48). Here was an ideal tool for the study of behavior and cross-cultural processes. So, prior to going to Alaska I purchased Super-8 equipment and film and arranged to have film shipped back to San Francisco for processing and examination by Malcolm Collier.

In Alaska I was one of a team who planned to carry out the major part of their investigation in a consolidated state-operated school in the regional center of Bethel. This center, at that time largely Yupik Eskimo in composition, drew its population from up and down the Kuskokwim River region of west-central Alaska. The Bethel school had classrooms from kindergarten through high school with primarily an Eskimo student body. Other members of the research team were to use structured educational "instruments", questionnaires, psychological tests, and copious interviewing. In contrast, I decided to work alone and film through a sequence of Eskimo schooling beginning in remote village schools, then in Bethel, and concluding with film coverage of Native children in the public schools of Anchorage where Indian and Eskimo children were a small mi-

nority in the classrooms. Additional footage would be shot in homes and around the communities. Methodologically, how should I proceed? What was I looking for? It was not curriculum but communication and emotional welfare, for I postulated that if these two factors broke down there would be no concrete education.

Having never filmed in a classroom before I began my research with some anxiety. Would my presence muddy the authenticity of classroom behavior? Teachers were, reasonably, suspicious of a stranger dropping down out of the sky with a movie camera, and I had first to develop rapport and understanding before I entered their classrooms. In the classroom I began by placing a running tape recorder in a central position and retired to one corner or another with tripod and camera. First I ran the camera "dry," with no film, allowing the class to absorb my presence, like the fisherman over a forest pool. "Fish" scuttled into the shadows but soon returned and, I placed the film cartridge into the camera and began to record. Certainly the teachers tried, at first, to monitor their teaching styles and the children were intrigued and distracted, but I saw that patterned behavior soon returned.

In retrospect I now surmise that teachers have developed styles which they feel comfortable with and the students have learned the behavior that satisfies that teacher. In time this becomes a cultural program that is reasserted every day and is not readily altered. This stability is particularly evident in the area of nonverbal behavior because people are frequently unaware of their nonverbal patterns. At the time, however, I had an additional worry: would the film reveal that data and understanding that I sought? The processed film was in San Francisco and not available for my viewing, but with time in the field I became more confident that I was indeed seeing and recording significant information.

I then rejoined the rest of the team and began filming in the Bethel school. Through the viewfinder the visual world of the school became engraved in my memory, and I began to recognize recurrent patterns of behavior. I shared these discoveries with my colleagues, and they responded with surprise, "Why, John, this correlates with our own evaluation!" We shared opinions but their's came from different data. The structured tests and interviews did indeed reveal similar patterns, but would my working analysis be substantiated by analysis of the film that lay waiting in San Francisco?

On return to San Francisco a collective research team of four people with experience in cross-cultural education and visual research was put together. The analysis (described in more detail in Chapter 15) recovered precise behavior information that correlated with ethnographic information and, later, with the findings of the

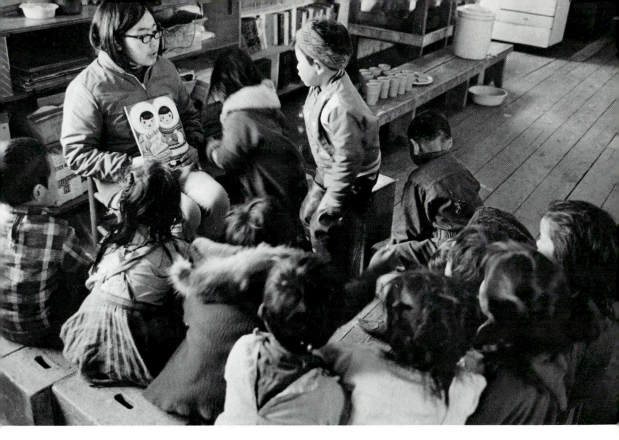

OEO Head Start class in Kwethluk, Alaska. Still photographs can capture the content and progression of classroom activities, but reliable recording of interpersonal relationships and emotional well-being is usually best done with film or video.

rest of the research team. The classrooms were found to be "cultural chasms" that swallowed up the educational efforts of both dedicated teachers and cooperative students. Eskimo children foundered in the open spaces common to many of the classrooms, where they either froze or bobbed around in unsynchronized manner like so many buoys in a tide rip. We made comparisons of film and photographic records of teachers' homes to homes and activities in the villages that defined the cultural isolation of teachers from villagers. The results of the film research could, in this case, be checked by the parallel investigation of the rest of the field research team. According to Ray Barnhardt, one of the field researchers, the structured instruments and interviews produced similar findings but *without the emotional and qualitative depth* that was reflected in the research reports from the film analysis (personal communication, emphasis added).

Still photography could have measured some of the proxemic or material aspects of these situations but would only have sug-

gested the psychological dimensions of White and Eskimo relationships. Nor could still photography have revealed the detailed workings of communication in the classroom (full report in Collier 1973; M. Collier 1979)

Only film or video can record the realism of time and motion or the psychological reality of varieties of interpersonal relations. As an example, it is hard to evaluate the character of love between children and parents from still photographs, whereas film can record the family tempo, the nature of touching, how long, how often, and the way an older sister might expresses fondness for a younger brother. The emotional chain is too broken in still photographs; its time slices are too far apart to trace accurately emotional flow and process.

In anthropology film or video is not only the complete way of recording choreography, but also the most direct way of analyzing communication, dance, or ceremony, where so many elements are in motion together. In this situation human memory and notebook recordings become wholly inadequate and highly impressionistic. The special value of film and video lies in their ability to record nuances of process, emotion, and other subtleties of behavior and communication that still images can only suggest. With the still photograph one can quantify human content, describe it in detail, measure distances, define spatial relationships. But with film or video it is possible to deal precisely with not just "what" but also "how" behavior happens, not only to see but also to understand the sparkle and character of an event, a place, a people.

Chapter 12　Film and Video in Field Research

Motion picture film and video are important research tools whose special promise is the record of motion, often with synchronized sound, and, in the case of video, the potential of rapid feedback and review of images. Above all it is their potential for unbroken recording of action or event that offers distinctive research possibilities.

Film and video *can* approximate still camera recordings, as in samples of houses on the village street, but analyzing such data from projected movie film can be exhausting. There is not the opportunity for repeated examination of enlarged photographs, or detailed study with a fine glass. Video and film are sequential records which are awkward to analyze in a comparative manner. Only one image can be looked at at a time. We can stop the projector to examine the single frame but we cannot compare this frame directly with another except by printed enlargements made from the single frames or through use of multiple projectors or monitors. This procedure does not compare favorably with viewing twenty or thirty photographs spread out on a table or floor, or pinned on the wall.

So when subjects can be analyzed as static images, record with the still camera whenever it will do the job. Where particularly saturated coverage is needed the robot camera with automatic time-sampling controls may be a compromise between stills and movies. A prime example of such a usage, involving the use of Super-8 equipment, is a study of small urban spaces carried out by William H. Whyte and associates (1980). Concerned with the question of why some open spaces in urban areas were heavily used while others

were not, they mounted Nizo cameras in strategic locations and made time lapse records of whole days. The resulting film records could be viewed with a projector at three frames a second, compressing a whole day into a few minutes. More detailed analysis was carried out through examination of single frames. The result was concise and readily applicable information about what types of spaces worked and why. Such a study would have been awkward and more expensive with a still camera and prohibitively costly using 16-mm equipment.

FIELD RECORDING WITH FILM AND VIDEO

In a general sense the methods we have described for use with still photography in the field are applicable to film and video, but their use raises some particular issues with regard to sampling and selection. Still cameras force the user to make selections of split seconds of reality; film, and even more so video, confront the field-worker with decisions regarding continuous time and space. How long is the camera to run? Should it run continuously? What is to be done with sound? Should the camera move or be stationary? What focal length is to be used, may it be changed while the camera is running? But as with still photography the ultimate question is how to ensure that the final product *has* information in a form that can be analyzed.

Field techniques with film and video vary greatly, as different approaches are developed in response to different circumstances and needs. These have ranged from use of continuously running, fixed-position cameras to hand-held, mobile camera work involving considerable in-camera selection and editing. Movies usually involve more in-camera selection than video, which has the potential for long unbroken runs with little increase in cost. Some understanding of issues in field recording may be gained by discussion of two studies of communication in cross-cultural classrooms, one by Frederick Erickson and Gerald Mohatt and the other by Malcolm Collier.

Erickson and Mohatt's study was a comparative examination of two teachers, one White and the other Native, working in the same school with similar groups of Odawa Indian students in Canada. Video was used and the recording was done by a member of the reservation community following instructions provided by the researchers. The camera was placed on a tripod, in a variety of locations on different days during the course of a year, and left to run continuously with a minimum of zooming and panning. Erickson and Mohatt were particularly concerned with transitions, so the community assistant was directed to turn on the cameras before

things started to happen and to allow them to run until things were over. Taping was periodic over the course of a school year, and, as might be expected, a considerable volume of video tape was obtained, totaling eleven hours of coverage of one teacher and thirteen of the other. Of these twenty-four hours, eighteen were used in the analysis (Erickson and Mohatt 1982: 132–74).

The result is an in-depth record of a small sample of teachers. Erickson and Mohatt were able to be precise and detailed about the style of each teacher and the manner in which they ran their classrooms. With records of many days in each classroom they could generalize about each teacher with confidence, producing rich statements of how two cross-cultural classrooms work and the variables that may have shaped them.

The study by Malcolm Collier (1983) used hand-held Super-8 motion picture equipment to record twelve classrooms in a Chinese bilingual program in California. Twelve teachers and fourteen aides are seen in the footage , together with a total of approximately 300 students. The film was shot by Malcolm Collier, using a Nizo camera with sync sound equipment. Each class was visited for one full day and film shot selectively resulting in twenty-five to thirty-five minutes of film on each class. There was considerable in-camera selection, in contrast to the Erickson and Mohatt study. The selection process was guided both by predefined categories of subject matter and by on-the-spot observations and decisions. In some classrooms considerable time-lapse footage was recorded that provided unbroken records of longer periods of time.

This approach produced a record of *many* classrooms, students, and teachers but without the depth on any one that characterized the Odawa study. The strength of this data lay in its comparative potential, making possible generalizations not about individual teachers but about different groups of teachers, aides, and students. The differences and similarities between American-born and foreign-born Chinese American staff and between Chinese American and Anglo (White) staff could be described with some confidence. Consistent patterns of behavior among the children could be identified as being more than the product of idiosyncrasies or a particular classroom and teacher. Precise statements could be made regarding proxemic and temporal variables affecting Chinese students as a group.

In comparing these two approaches it should be noted that in both many of the more important findings involved variables or issues that were not fully anticipated or even perceived prior to the analysis of the data. This is an indication that both approaches were successful as new information was discovered.

Had the Collier study been carried out using the Erickson and Mohatt approach the investigator would have been faced with at least 150 hours of video tape, far too large a quantity for one person to analyze intelligently. Conversely, had Erickson and Mohatt used the selective recording style of the Collier study to examine their two classrooms they would not have obtained the in-depth detail for their analysis which, in the actual study, balanced out the lack of larger comparative scope.

Film and video data are extremely time consuming to examine, and these two cases illustrate a general principle: the larger the scope of the sample the more selective the recording process may have to be if the researcher is not to be overwhelmed by the volume of data that is to be found in visual records.

One problem with continuous records made by stationary cameras is that they tend to have more waste sections in which little or no significant data are to be found and too often the visual data that are present is obscured by bad camera angle, lack of focus, or poor framing. This may not be an issue in controlled circumstances, but as we move out into the fluid activities of everyday cultural processes it can become serious. If video is used these difficulties will be aggravated by lower resolution. For these reasons many investigators working with continuous video records depend heavily on the sound content of the tape for their analysis, often with important findings, but important visual information is still lost. Some degree of control of the recording process by a person behind the camera is essential if rich visual data are to result. Use of locked on, stationary cameras would best be limited to controlled, clinical situations or to circumstances, as in the Erickson and Mohatt study, in which there is no skilled observer available to operate the camera.

More selective approaches allow for adjustments to changes in the situation. The camera can be panned to follow important behavior; closeups can be made of details that might otherwise be difficult to read, or wider shots can be made to record contextual details. The camera can be moved to record a clearer view or can be turned and aimed at unanticipated events or subjects. The chief danger in selective shooting is unintended cutting across the flow of events. This can be controlled by careful design of the recording process so that categories of subject matter are recorded, whether or not they appear to be significant at the time. Such a shooting guide can help provide a consistent and comparable record without unduly restricting the sensitivity of a skilled observer. As video becomes the more common media of recording, it may be better to err on the side of over documentation. This does not preclude moving the camera to obtain better coverage or turning it off when the

visible circumstances are clearly not within the scope of the investigation.

As with still photography, good video and film records for research are ultimately the product of observation that is organized and consistent. The equipment, except in specialized circumstances, cannot replace the observer.

This photograph was made in conjunction with an experimental, low-budget ethnographic film of an American family, Muir Beach, California. Well-made film that maintains contextual relationships should have the potential for both "ethnographic" and "research" usage. (Photograph by Richard W. Brooks)

Chapter 13 Ethnographic Film and Its Relationship to Film for Research

Ethnographic documentary films have become the most heavily funded visual studies in social science. Ideally, this swing to visual communication through a publicly distributed medium can be seen as an important development that may better share the human insights of anthropology with the general public. Another, unacknowledged reason might be that ethnographic films often bypass the scientific conventions that have frustrated ethnographic descriptions and suppressed the sensory observations of anthropologists. When anthropologists become filmmakers they often enthusiastically leave inhibiting research strictures behind and produce films that are far more artistic than scientific. This can be dynamic, provided cultural authenticity is retained. In the early flowering of cultural narration films, the concept of what constitute *ethnographic* film was undefined. Visual narration offered anthropologists more license than did the verbal treatises; if they wrote papers with the loose structure of much popular ethnographic film, they could be attacked in the scientific journals.

Recent ferment over the integrity of film in anthropology suggests that the scientific critics have now caught up with the ethnographic filmmakers. Regardless, audiences respond to the present genre of ethnographically focused films with more enthusiasm than to popular anthropological writing. If ethnographic film develops into a fluent support of behavioral science, it must develop structural formats that further the anthropological understanding of human diversity.

What *is* ethnographic film? A place to start building our definition is with the view of Sol Worth that "there is no such thing as ethnographic film. Or to put it another way, any film may or may not be an ethnographic film, depending on how it is used" (Worth 1981:83). This statement suggests that there is, as yet, no adequate structural framework for ethnographic film. Obviously ethnographic film is about cultural circumstance, but a simple filmic tracking of what takes place might not fulfill the format of an anthropological film essay that can be called an ethnographic film.

In content this genre of film should go beyond the documentary and be formed around a well-researched conceptual structure that contributes new understanding of cultural circumstance. But even productions with strong conceptual communication, in our eyes, can turn out to be something other than responsible ethnographic films. As an example, Robert Gardner's production *Dead Birds* (1963) is a powerful film about internal warfare among the Dani of West Irian, but the concept it presents apparently developed out of Robert Gardner's own feelings about war, rather than out of the Dani's practice of ritual warfare. It has been this variety of reflective interpretation of ethnography that has discredited much of the authenticity of anthropological film records.

The use of anthropological film can also define its form and content. Research film has defined characteristics in terms of content and structure. But research film is not made to spell out concepts about ethnography; it is made to contain relatively *undisturbed* process and behavior from which to develop information and concepts. Ethnographic film, in contrast, is usually edited to create a narrative selected by the filmmaker-producer. Hence, direct use of many ethnographic films for research purposes is difficult.

How does this editorialization affect the use of ethnographic film? The largest distribution of ethnographic film is for instruction in university classrooms. Teaching with film reveals the characteristics needed in educational ethnographic film. We have found the most fulfilling films are the ones that allow students to form their own conclusions from the approximated firsthand visual experience that the film provides. This suggests that film editing should not mangle researchable opportunity. It should offer students an informational experience not to be found in the campus library, an opportunity to make firsthand deductions about anthropological subjects.

This full educational opportunity is realized only when the informational integrity of ethnographic film records is preserved and exploited for its revelations. The less dramatic productions can be called "lecture films" because they confront the viewers with a closed visual and verbal thesis that invites no speculation. When the class-

room lights go on, students pick up their books and leave. Conversely some ethnographic films are so dramatized and so heightened with culture shock that they stifle questions, and after the lights come on students remain in their seats stunned. We have had little classroom success with epic cultural films such as *Dead Birds* (1963). Often we show only one reel of the more spectacular films, with the sound off, so that students must make their own deductive observations about the character of an unfamiliar culture. If research and education are not the functions of such ethnographic films, then what are they for? It appears that the more expansive (and expensive) ethnographic productions are generally a variety of art films for general audiences.

ARE ANTHROPOLOGICAL FILMS DISTORTED AND UNRELIABLE RECORDS?

Recently a number of anthropologists have questioned the informational integrity of film for anthropology. Their studies of film records by anthropologists point up distortions in observation created by "reflexivity," the changes brought about by the very presence of the observer, and "reflectivity," the personal values and biases of the filmmakers (Ruby et al. 1978). Illogically, some critics find this reflexivity and reflectivity particularly serious in film, failing to see that it must be just as serious in classical records of anthropology made by verbal recording.

My (John Collier) first contact with anthropology, forty years ago, revealed the consuming anxiety that "subjectivity," which seems to be much the same as reflectivity, would destroy the authenticity of anthropological data. I observed that discipline in field recording was directed to gathering "clean" information, "free" of the subjective responses of the observer. I began the development of photography for anthropology to achieve further and more dependable data. The present ferment over the unreliability of photographic evidence affects not only the development of ethnographic film but the credibility of visual anthropology as well.

The issue of reflexivity rests on the naive discovery that human perception is affected by the culture and values. This is so fundamental that the anxiety about it appears realistically to be a conflict between visual communication and the verbal record of anthropology. David MacDougall, a leading ethnographic filmmaker, made these observations:

> If anthropologists have consistently rejected film as an
> analytical medium, and if they have themselves
> relegated it to subordinate record-making and didactic
> roles, the reason may not be merely conservative

reluctance to employ a new technology but a shrewd judgment that the technology entails a shift in conceptualization (Nichols 1981:243).

Both visual communication and visual evidence confront the literacy-biased value system of modern Western society. We are compulsively verbal in both our communication and thought. Our memory image is codified and now computer-organized. There is small room in our literate society for *visualization*. We feel visual observation belongs to preliterate people and artists. Hence we distrust visual phenomena and look for written directions to guide our reasoning.

HOW IMPARTIAL IS THE ETHNOGRAPHIC RECORD?

Critics of anthropological film are sometimes more fastidious about the accuracy of the photographic record than they are about the authenticity of classical studies in anthropology, failing to recognize that distortion can be found in all cultural investigations and in many ethnographic writings. Condemning anthropological film records can obscure the issue, as is recognized by more experienced investigators of reflexivity. As pointed out by Jay Ruby following the symposium "Portrayal of Self, Profession, and Culture: Reflexive Perspectives in Anthropology" at the 1978 American Anthropological Association meetings, anthropological films simply provide clear examples of the manner by which all anthropological products are shaped by their producers. Unfortunately, not everyone is this sophisticated and many consider film records highly unreliable. Perhaps they are avoiding the impact of photography that they find most disturbing—the record of human sensitivity that is often omitted from ethnographic accounts? What is ethnographically real? The prejudice, culture shock, and bias of many fieldworkers and writers in anthropology are notorious, and many times these are reflected in print—sometimes spontaneously, but many times intentionally.

One classic case of variation in ethnographic description is to be found in the writings of Robert Redfield and Oscar Lewis on the Mexican village of Tepotzlan. Redfield's study (1930) was accepted as a classic ethnography of a peasant community. Two decades later Lewis's *Life in a Mexican Village: Tepotzlan Restudied* (1951) radically contradicted Redfield's characterization. When Redfield was challenged over this discrepancy, he answered philosophically, "I always believed the 'good life' took place in small organizations, and I went into anthropology expecting this to be true. Now, Oscar Lewis is a New Yorker and he dislikes small organizations. His *Tepotzlan* describes accurately all the negative experiences in a small community.

Read both books!" (paraphrased from a conversation with Gottfried Lang).

Where do we turn for cultural truth? To Zola, Dostoevski, Conrad, Faulkner, Garcia Marquez? Novelists can present the holistic human process which ethnographic filmmakers strive for. The novelists' process is creative. They are not searching for reality; they are inventing and reflecting life's authenticity through literary means. But when film-makers attempt similar invention, their dramatizations are no longer ethnographic. This raises the question, can film dramas, such as Flaherty's *Man of Aran* (1934), constitute an authentic cultural record? Are the contrivances and filmic reorganizations that critics challenge in ethnographic film the producers' efforts also to recreate an artistic reality?

A clear frame of reference for content and function would establish the format for authenticity in ethnographic film. But generally these references are vague, and the film code shifts back and forth between narrational Hollywood-drama film and the documentation of ethnography. Robert Gardner, one of the most dedicated and productive filmmakers in anthropology, is one of the few who have a clearly chosen frame of reference. Gardner is straightforward in sharing the motivation on which his films are based, and we are indebted to him for the candor with which he describes how he approached filming the Dani:

> I seized the opportunity of speaking to certain fundamental issues in human life. *The Dani were then less important to me than those issues.* In fact, the Dani, except for a few individuals . . . were important to me only because they provided such clear evidence upon which a judgment about, or at least certain reflections on, matters of some human urgency could arise. My responsibility was as much to my own situation as a thinking person as to the Dani as also thinking and behaving people. I never thought this reflective or value oriented approach was inconsistent either with my training as a social scientist or my goals as the author of a film (Heider 1972:34; emphasis added).

Is this a distortive approach to filmic ethnography? How different is it from many classic written ethnographies? The important issue is how does this affect the overview of Dani culture? These questions return us to some central questions regarding anthropology. David MacDougall comments that the ethnographic filmmaker frequently

> reaffirms the colonial origins of anthropology. It was once the European who decided what was worth

knowing about "primitive" peoples and what they in turn should be taught. The shadow of that attitude falls across observational film, giving it a distinctively Western parochialism. The traditions of science and narrative art combine in this instance to dehumanize the study of man. It is a form in which the observer and the observed exist in separate worlds, and which produces films that are monologues (Nichols 1981:266).

ALTERNATIVE MODELS

A number of ethnographic filmmakers are developing a genuine format for ethnographic film. Functional cultural structure in ethnographic film may achieve a dynamic balance between art and cultural authenticity through the creative intelligence of the filmmaker, who by sound research and conceptual discovery contributes to the understanding of anthropology.

Timothy Asch, now at the University of Southern California, taught with film for years at Brandeis University and used this experience to make fluent research and educational films. Asch's film *The Feast* (1968) has become an educational classic because of its effectual communication design. David MacDougall for years has been making films wholly founded on the authenticity of his field research (1972, 1973). Karl Heider has produced an "open-ended" film showing Dani building a pig sty from footage not used in *Dead Birds*. Some of John Marshall's short films (for example *Bitter Melons* 1971 and *Men Bathing* 1973) also fall into this category of films with no message that, when screened, allow students to write copious personal insights about people and activities in the films.

Hubert Smith has made in-depth ethnographic films of modern Mayan survival, experimentally including in his filming the interactions arising from the presence of himself and his film crew and the manner in which their presence affected activities (*Living Maya* 1983). While the technique has some difficulties, his filmic concern appears dedicated to making a bond of understanding between general audiences and the Mayan people that does not obscure the impact of the film crew.

Leonard Kamerling and Sarah Elder, based in Alaska with the Alaska Native Heritage Project, have made a series of films on contemporary Native communities that reflects the successful development of what may be described as collaborative ethnographic films (*From the First People* (1977), *On Spring Ice* (1975), and other titles). The films are the joint product and property of the project and the communities, with selection of subject matter and editing of final prints shaped by shared decisions of the film team and the

communities. The films are characterized by a lack of any overt message, a leisurely pacing that allows cultural processes to unfold at their own rate, and an episodic structure in which there is often no clear beginning or end. The films produce rich discussions when used in the classroom because their open structure allows students to work with the visual content without any overriding conclusions to color their discussions.

How Can Films be Made from the Inside Out?

Most ethnographic film is made by outsiders looking in, which promotes the reflectivity for which it is criticized. Franz Boas sought the inside view when he developed the process of working intensively with key informants, which gave anthropology its first views based on native intelligence. In film John Adair and Sol Worth experimented to discover the visual inside view by placing Bell and Howell three-turret 16-mm cameras directly in the hands of seven Navajo men and women (see Chapter 9). Through the films they made, these Navajos were able, for the first time, to share visually their own perceptions of their processes and their world. The films, described in *Through Navajo Eyes* (Worth and Adair 1972), were genuinely ethnographic films—a revolutionary development of emic understanding.

In another attempt to get the inside view, Don and Ron Rundstrom used direct techniques of visual anthropology. They photographed students of the Japanese Tea Ceremony performing the ritual and then interviewed their master teacher with the still photographs. Then they used the insights from these interviews, plus continuing collaborative feedback, to create *The Path* (1971), a film record that is accepted as authentic by Japanese audiences. This film is a rare example of an ethnographic film structured directly on visual research that preceded the filming.

The previously described work of Leonard Kamerling and Sarah Elder also reflects an organized attempt at obtaining an inside view. These films can best be perceived as dialogues between filmmakers and the community in which the views of both are reflected.

Yet it is significant that these successful experiments are rarely repeated and their methods have not been incorporated into other ethnographic film productions. Is it that most film producers are not themselves anthropologists? Or that anthropologist filmmakers are too conservative to appreciate the possibilities inherent in these methods? Perhaps there is a more human and ethnocentric reason: that only in theory are "we" willing to let "the native" have authoritative judgment!

Visual anthropology can help bring clarity to the meaning and function of ethnographic film. Where lies the integrity of ethnographic film? In part it rests on the viewers' ability to experience holistically and authentically the cultural circumstances presented in film. This in turn depends upon maintenance of cultural relationships within the film. Even though ethnographic film, like all film, succeeds structurally by its organic artistry, this artistry is only a means, for the end is cultural authenticity. This suggests that the criterion for strength of an ethnographic film record lies in its research background and the retention, through production, of this research authenticity.

Research methods in visual anthropology define the content and structure of researchable data, and these criteria offer guidelines for producing researchable and readable ethnographic film. Anthropologists making film should be well acquainted with these needs, for they are essentially the same as for all data gathering for research: identification of the source of phenomena, and undisturbed spatial and temporal order of objects and occurrences. If filmmakers find these requirements too restraining, Robert Redfield, in *The Little Community* (1955), offers a series of approaches that would allow them to retain researchable content systematically. Redfield stresses the value of building an organic model of cultural circumstance so that parts can be considered as units of the whole. Ethnographic interpretation requires an artistic synthesizing that can qualify and link together otherwise isolated cultural parts into organic wholes. But montaging cultural episodes only for artistic effect can destroy the organic structure of an ethnographic film. Resistance to a structural approach to cultural processes suggests a misunderstanding of artistic development itself, which is the ability to assemble organically complete form.

Visual research could support the orientation and planning phase of making an ethnographic film. Conventionally the anthropologist consultant or film director may have made extensive field studies in the area of the proposed film, but this research is usually predominantly verbal and may omit many visual relationships significant to filmmaking. This handicaps the direction of a film in which information is primarily visual. Primary photographic surveying of environs visually unfamiliar to the investigator, and surveying of the visual shape and sequence of a proposed film could offer essential information for film planning. A month's intensive field photography, followed up by photographic interviewing, can give film planners extensive and accurate information on geography, cere-

mony, social structure, and the technology of survival on a visual level. Local assistants can identify and validate any unfamiliar visual information. Photographs from such a survey can be incorporated directly into the planning and storyboard of a proposed film. This can be done in the field prior to actually exposing film. A major value of such rapid visual orientation is that the filming can begin with an *open process* that invites otherwise unknown visual circumstances to influence the theme and content. This approach could deflect prestructuring, which might warp the authenticity of a film. The feedback of orientation photographs can also be a fluent communication bridge that allows native participation in filmmaking decisions, just as collaboration through interviewing with photographs created the authenticity of the Rundstroms' film ethnography of the Japanese Tea Ceremony.

Robert Flaherty attempted to use an open process with what he called "the roving camera," seeking themes directly in his rushes. He had faith that the realism of the film image could catch insights unavailable even to his own observations. But he did not involve *native eyes* in this filmic searching. Visual anthropology also exploits the hidden dimensions of the photographic image which can be uncovered through disciplined research, particularly with the assistance of native photographic readers. This could help maintain cultural continuity in time and space.

Preserving cultural continuity can be essential in ethnographic film for two basic reasons. First, continuity through space and time retains the research value of film. And second, visual continuity is essential to nonverbal comprehension. In visual narrative each still photograph or scene is, figuratively, a word in a sentence or a unit of paragraphic meaning. When images in film are moved out of order, the visual message can be radically changed or can seriously distort the order of understanding. Strictly artistic image-scrambling may create a work of art, but it can destroy the documentary and conceptual message. When ethnographic footage is cut and montaged for the wrong reasons, authentic communication can be lost, and the film may only express the bias of the producer. A sound visual research base could help decide what and where cuts and montages can be made.

FILMMAKERS AND ANTHROPOLOGISTS

Anthropologists frequently need the assistance of professional filmmakers; conversely film professionals often feel the need of working with anthropologists. What does this mutuality of need indicate? Does film professionalism add depth and communication

to ethnographic film? Certainly in still photography the ability to record under all conditions, mastery of negative exposure, sharp focus, and the skill to record the peak of significance for visual communication all extend the scope of photographic evidence. Is this as true in filmmaking? The motion picture camera with synchronized sound is far more complex than the 35-mm snapshot camera. Film is a consuming technology. For this reason an increasing number of ethnographic films are made by professional cameramen and assembled by professional editors.

As anthropologists move from data film to commercially distributed educational film, the technology of modern film production takes the camera away from the anthropologist and gives it to the professional filmmaker. This shifting control can disastrously change the character of film for anthropology. The communication structure of professional filmmaking is often in conflict with the conceptual structure needed in film for anthropology. We agree with Sol Worth that

> learning how to make films as films, with an emphasis
> on the technical or artistic aspects of the medium, is not
> relevant to anthropology. Learning how to study about
> films in relation to some specific anthropological
> problem is relevant. At the present time this kind of
> study (about ethnographic film making) is almost non-
> existent (Worth 1981:83–84).

This truth raises a dilemma and requires a new approach to mastering the professional technology of ethnographic film making. In this context Hubert Smith has a cogent comment:

> Filmmakers make films that viewers attend to.
> Anthropologists make films that are informed. When
> one learns the skills of the other, chances for good filmic
> ethnography improve. It is as unproductive to make an
> un-viewable film as it is to publish an unreadable book.
> It is as undefensible to make a misleading filmic
> utterance as it is to make a written one (personal
> communication).

Anthropologists as filmmakers should, first of all, retain their role as ethnographers and not surrender their film to media. Surely anthropologists must learn the technology of filmmaking, but at the same time they must retain their vital roles as cultural researchers and educators. Sound ethnographic film that is more than mere illustration of existing ideas needs to be based on sound visual research.

Chapter 14 Principles of Visual Research

Where do we begin? What do we do? How do we conclude? These are challenging questions in studying human societies. Along with anthropologists, photographers can follow the late Robert Redfield's advice to begin anywhere, and then move methodically from one relationship to another.

> In moving to understand the systematic character of the life of a community the student cannot begin everywhere; he must begin at some point. Commonly the beginning is made with things immediately visible. . . . [Speaking of his study of Chan Com] I began where it happened to be convenient to begin. I went along with a man to the field he had cleared in the forest for the planting of his maize. I watched him cut poles and with them build a small altar in the field. I saw him mix ground maize with water and sprinkle it in the four directions, and then kneel in prayer. I watched him move across the field, punching holes in the shallow soil with a pointed stick and dropping a few grains of maize in each hole (Redfield 1955:19).

From the cornfield Redfield followed the farmer home along trails that became roads and finally converged in the village, and then through streets that ended at the farmer's home where his wife and children lived. This simple journey tied together a multitude of tangible details into one systematic relationship from which the formal study of Chan Com began.

Redfield's concept of the research progression is that one must keep pulling in the cultural rope that ties one circumstance into the next. If you pull in all the rope, you will observe the complete process of a community. He suggests various journeys through the culture, each of which would define a reflection of the whole through a process that preserves the contextual order of all circumstance. Dr. Redfield urges the fieldworker to establish the enveloping context of a cultural organization. We believe all methodologies should be directed to this end.

In preceding chapters we have described examples of procedures for photographic exploration in the field, and in the chapters that follow we present approaches to the analysis of the visual data recorded in the field. But if these efforts are to produce the complete journey described by Redfield they must be organized into a coherent plan in which one element is related and supportive of another, allowing us to complete our efforts with rich and responsible conclusions. This coherent plan is our research design, which is based on an understanding of the principles of visual research.

Basic Considerations in Visual Research

An elementary reality is that total documentation is almost always impossible, and if such saturated recording were attempted we would become engulfed in an overload of complex details from which it might be impossible to reconstruct a contextual view. A whole view is the product of a breadth of samples that allows us comprehend the whole through systematic analysis of those carefully selected parts. A good selection process provides a sufficient reflection of cultural circumstance from which to establish a reliable perspective. Analysis may also require sampling within the data if we are not to be overwhelmed with the mass of detail and complexities often present in visual records.

Therefore, we plan fieldwork to achieve systematic selectivity through a definition of how and in what order we will record environment, behavior, and other cultural phenomena. Such definitions or shooting guides should not be confused with the more familiar "shooting scripts" often used in the photographic and film world. *These* are directed at production of narrative-based communication—"stories"—and not research.

Field shooting or observation guides are concerned with defining procedure, structure, and categories for recording that produce data on which later research analysis and summations are built. They answer questions like "how many photographs are to be made? At what time intervals, in what places?" They may define categories

of subject matter but rarely define specific photographs. The research photographer is faced with the challenge of gathering a semblance of the whole circumstance in a compressed sample of items and events observed in time and space. These photographs must be made in a consistent manner that preserves the opportunity for comparative analysis. The photographer also needs to master the skill of representational recording of the peaks and key points of particular activity. The whole view can only be observed and recorded in the form of a responsible, selective composite. Only in clinically controlled situations, not in the outer world, is it possible to approach total documentation.

RESEARCHABLE VISUAL DATA

The most beautiful and technically superb photograph is useless in visual research if it does not conform to the needs of systematized observation. For this reason we need to review what can be seen and researched in photographs.

We can responsibly analyze only visual evidence that is contextually complete and sequentially organized. No matter how rich our photographic material is, quantitative use of evidence is limited to that which is countable, measurable, comparable, or in some other way is scalable in quantitative forms. We can reliably read out of photographs the identity of material items like tools, furniture, clothing, and other artifacts. We can analyze behavior in those circumstances where we have adequate control of contextual information, including the identity of participants. Further control of insight can be achieved through repetitive recording of social circumstance that by their repetition stabilize our understanding. Additional data can be obtained through use of photographs in interviews.

The significance of what we find in analysis is shaped by the context established by systematic recording during fieldwork. As an example, a study could be made of family structure in a confining class or caste-defined society. A systematized recording of family gatherings throughout the social organization in comparable circumstances (meals, ceremonials, work, etc.) could supply a profile of family structure through comparison of family behavior in comparable situations. We would be careful to obtain records of the same range of phenomena in each circumstance, such as proxemic relationships, the functional identity of all participants, physical setting, the temporal sequences of behavior and events, as well as a variety of other categories of information.

An unusable study of the same subject would contain family scenes in which visual identity and spatial relationships would be

unclear and temporal order jumbled. Imagery might be obscured by shadows, soft focus, and angles of view that miss crucial information or are inconsistent from situation to situation. Such a collection of data would be as limited in value as a mass of archeological artifacts dumped on the floor of a lab with no information regarding the locations in which they were found. Like misplaced artifacts, these images might still be aesthetically satisfying but they would not be a reliable source of knowledge. This criticism should not discourage "extra sensory" or "artistic" recordings made to gather the overtones of cultural circumstance, but it should emphasize that such records be made within the setting of a larger research process that can provide the necessary contextual relationships to allow photographs to become meaningful.

Impressionistic and ragged recording is not the only danger of unsystematized field observation. A conscientious fieldworker might attempt mechanistically to record every detail of environment and cultural content, creating a further form of uncomputable data in which we would become overloaded with disorganized detail. The danger of this approach is illustrated by Mark Twain's description of a river pilot cursed with an unselective memory in which trivial detail overwhelmed the more important elements: "Such a memory as that is a great misfortune. To it, all occurrences are of the same size. Its possessor cannot distinguish an interesting circumstance from an uninteresting one (Twain 1917: 112)." The purpose of systematic fieldwork and analysis is to provide the researcher with information that is significant and exclude that which is not. In this manner the complexity of the real world is put into a form from which meaningful conclusions can be made.

THE RANGE OF PHOTOGRAPHIC OBSERVATION

The question raised in making intelligible observations is how fluent should be your sense of evidence in order to gather meaningful data? There are a number of elements to consider.

First is the dynamic possibility that a less rigid approach to recording can draw upon the unexpected and spontaneous happening. A overly structured approach could edit out holistic and

Opposite page: Comparisons are often key to discovery of cultural patterns. Family meals could provide a basis for comparisons that could help define relationships within families in different cultures as well as details of custom and etiquette. Top: evening meal in a home in Vicos, Peru. Center: supper in a Spanish American home, New Mexico. Bottom: breakfast in the home of an advertising executive's family in Westport, Conn.

circumstantial relationships of great importance. An example comes from the work of Samuel Barrett, who produced a series of film records of California Indian technology. Barrett's film crew included anthropology students whose ethnographic interests went beyond the reconstruction of traditional craft methods. Eventually there was a conflict over Barrett's structured approach. This confrontation took place in an empty lot in Santa Rosa, California, where an elderly Pomo woman demonstrated basketmaking. In the background were junked cars, political posters, and urban mess. The students tried to include this modern context, but Barrett refused to shift the camera focus from the details of basket manufacture. In the perceptions of the young anthropologists, the ethnographic significance was that Pomo baskets were still being made, even in a cluttered city lot. In the students' eyes, Barrett was framing out this significant data (Robert Wharton and David Peri, personal communication).

Secondly there *are* defined needs in photographic data. The incident in Santa Rosa illustrates one requirement: framing to preserve the context. A further requirement is suggested by Barrett's selectivity: we *also* need the details of process as well as the contextual setting. Photographically we need the detailed foreground as well as the wide vista.

Cultural phenomena take place in time, which defines another requirement of recording, the need for sequential records. The single snapshot has only identification value, we need the sequential context of process through time. Even when we do not understand what is happening, sequential exposures can later reveal the developing pattern of technology or human interaction.

By what process do we make *significant* photographs? Paul Byers, anthropologist-photographer, reports a sound scheme that can give the photographer the role of extended vision in a research project. The plan comes out of the craft of photo-reportage in which photographers, knowing they cannot document everything, tend to work in prescribed areas with an informal but structured list of objectives to ensure holistic coverage. Byers worked intensely with the scientist for whom he was going to observe, absorbing the objectives of the study and the needs of data. Then, out of these insights he formed a frame of reference, which we would call a shooting guide, and took "hundreds of still photographs around these points of significance." This meant he observed intensely with the goals of the study in mind. Subsequently, he assembled the field photographs into orderly structures, also built around the frame of study. Finally, the scientist studied this data and coordinated the nonverbal evidence with his developing research.

Such an assignment might record a microculture or the scope

of a geographic region—a day's photography or 2,000 to 6,000 negatives made over a year's field period. Describing Byers's work, Margaret Mead pointed out, "The success of this approach depends more on the understanding of the researcher's framework and the translation of some part of this to still photographic recording than on the improvement or elaboration of photographic techniques per se" (Mead 1963:178–79).

The Organization of Research

Research with photography is a journey that begins in the field, continues into laboratory analysis, and ends with conclusions and the communication of those summations. In the field we must decide what is to be recorded with the camera and then record it: in analysis we must discover what those records may tell us. In the communication of findings we must attempt to define what it all means in a form that can be understood by our colleagues and the public. A successful research design should help lead us through these different steps in a manner that makes full use of the potential of visual recording in research.

Such a plan defines the shape and focus of inquiry, specifies anticipated informational needs, and functions to narrow the field of selectivity, directing us to circumstances that should provide the relevant information that our fieldwork seeks. We suggest that research be seen as a circular journey, beginning with open ended processes, evolving into various stages of structured observation and analysis, and concluding again with open speculation as we translate our findings into conclusions. This is a dynamic form that allows creative perceptions in fieldwork and analysis without sacrificing the specificity and responsibility of scientific study.

The Significance of Open Observation

Open observation, recording, and analysis are essential for the discovery of the new and unforeseen. Edward T. Hall has noted that closed processes in the early or introductory phases of both fieldwork and analysis can foster the very distortions that scientific method attempts to avoid—the distortions of projection of personal bias into the record. For this reason he urges film analysts, for example, to start simply by exposing themselves to the film record until they "hear" (see) the authentic voice of the visual record (Hall, personal communication). Robert Redfield suggests in his text *The Little Community*, "The time to write a book about the national character of a people other than one's own is in the first few weeks of

the first acquaintance with them. Never again does one have so vivid an impression of them . . . (Redfield, 1955:18)." Redfield is describing the phenomenon that in early periods of the field experience we often do not know enough to structure and limit our perceptions, consequently we respond to the overwhelming whole. Any research design should include a plan to record carefully *all* first impressions as irreplaceable insights. (Redfield *also* points out that, however compelling the first impression, "scientific training and a sense of responsibility" lead to a search for more particular knowledge and understanding. As will be discussed, this is true in visual research as well.)

Ideally, the open phase of fieldwork and analysis exposes us intuitively and intellectually to the organic form of our research subject. It should provide us with a whole *context* within which we can sample for details and trench through for discrete information as needed to complete our research. Equally important, it can provide us with new *questions* and avenues for investigation during succeeding phases of our investigation. These more spontaneous insights and subjects of investigation quite commonly provide the most important findings of any research.

The first look is often a period of saturated "first impressions," an intuitive response that assails our senses. Our approach at this point should be one that considers all possibilities. Lord Dunsany describes this approach in a short story set in the Pyrenees in ancient times. A knight arrives at a mountain inn of dubious reputation. After his dinner he is led to his room, realizing that he is entering a realm of danger. Alone, he considers his safety; from where might danger strike? Should he barricade the door? Unsheathe his sword and peer under the bed? As a man of action he realized that the greatest danger lies in believing that he *knows* where the intruder might enter so he rumples the bed clothes into a dummy and lies down on the floor to observe the unexpected. As night deepens, a trap door opens in the ceiling and a dwarf slides down a rope with poniard raised. The knight rises, slays the intruder, and achieves a sound rest.

STRUCTURED RESEARCH

The movement to more structured and detailed recording is a necessary step in both fieldwork and analysis. If investigation continues without entering a phase of disciplined observation the research is likely to be overcome by the disorganized complexity of the many details that we are certain to encounter as we become more familiar with the place, the people, and our own data. The

research needs to shift from open processes to systematized observations that ensure we do indeed have the information necessary to complete our research. Any investigation in science involves a consolidation of the focus of data gathering and analytic activities.

Fieldwork is different from analysis at this stage. An analytic process can be repeated in a different form if it fails to yield insights. But frequently we cannot return to the field, so a picture missed is a picture gone, a visual memory that offers little assistance to our investigation. Much of research design for photographic fieldwork is therefore directed toward maximizing the field photographic opportunity. Previous chapters have presented examples of how this may be done for specific subjects.

ANALYSIS

A well-executed field study does not ensure a satisfactory research conclusion. There still remains the challenge of interpreting the complexity of the field data, which can be more difficult than the fieldwork itself. Many brilliant field investigators fail to take their work to conclusion and the information gathered in the field remains obscure and unknown.

Both art and science face the challenge of abstracting new insights and experience from the visible shape of reality. This creative process goes beyond documentation for discovery is an act of creation, and reality must pass through an alchemy in which the documentary record becomes new knowledge that creates a new reality. Such creation is at the core of scientific discovery just as it is at the core of art. Just as a fine artist leads us to see things in new perspective, so Einstein led scientists to see a new reality in time and space.

All analysis involves a movement from raw data to refined conclusions, a process that is a form of reduction. This reduction process has its dangers, for there is a risk that micro-analysis of parts can obscure the patterns and structure of the whole. Photographic analysis is not immune to this danger, but the character of well-made photographic data can be exploited to minimize the danger through a return to larger relationships in the visual records.

The analysis of photographs includes the decoding of visual components into verbal (usually written) forms and communication. No analysis of photographs can ignore this crucial translation process, although it may be that some research insight and knowledge cannot be fully transferred to verbal forms. Decoding or translation serves as a bridge between the visual, which in Western culture we associate with intuition, art, and implicit knowledge, and the verbal,

which we have come to associate with reason, fact, and objective information. The promise of systematic visual research is that it may provide a means of combining these different sources of intelligence in a responsible manner that overcomes our cultural separation of the visual from written records. In visual anthropology, until we move our knowledge over this gap we fail to exploit the potential of photography and other visual records as tools of documentation and research. The main reason that anthropology has not made good use of visual records is that researchers have not, generally, been able to make this transfer between the visual and the verbal.

The function of this decoding process is more than simply a means of getting photographic evidence into scientific literature. It involves abstraction of visual evidence so that we can intellectually define what we have recorded and what the visual evidence reveals. It frees the photographs from their limitation as *documents or illustration* and allows them to become the basis for *systematic knowledge*. As we deepen our understanding of the photographic evidence through analysis, its character as primary evidence gives the imagery an independent life. This aspect of photographs as primary experience separates the records from the theoretical procedures of analysis. Film, in particular, can take on an organic life of its own, which is why fine film editors stress the importance of fully experiencing film on its own terms before cutting.

It is this independent authority of the visual data that makes photographs, film, and video so valuable in behavioral research. A function of open procedures during analysis is to provide opportunity to encounter all the potential insights and information that this characteristic provides. This authenticity can be obscured by the exclusive use of reductionist, codified approaches. When we break up the fluency of the visual record we destroy its conceptual stimulus, for if we do not transcend the details we can lose the contextual perspective of our investigation. When we ignore or lose the exploratory function of visual evidence the photographs become mere *illustrations* with little research value. It is important to discriminate between photographs as part of the research analysis and photographs as illustrations. The photographs may often have no place in the final product of the research, except as occasional illustrations.

This separation of the image from the ultimate product may be a wrench to many photographers, whose professional concern is with the image as the product. Certainly it was a shock to one of the authors when during his first anthropological research project he was told by Alexander Leighton: "You know, John, when you

formally publish the results of your investigation probably the article will carry no photographs."

In our classes a rude beginning to analysis is experienced when students are presented with a strewn pile of beach pebbles on a white sheet of paper. Faced with the assignment "analyze this data, this pebble community," students tend to take one or the other of two extreme approaches. One is to observe the pebbles as a cosmology, the second is to reorganize the pebbles in orderly categories of color, size, shape. What can be learned from each approach? What conclusions might each support? We begin our discussion of research design in analysis with this example.

A cosmological approach would reveal the distribution pattern formed by the pebbles. Smaller and more mobile pebbles might be strewn at a greater distance than the large, less mobile ones. The distribution might then be seen as a function of the characteristics of different pebbles. *Mapping* the location of the pebbles might be an act that could clarify the precise position of each "artifact."

A typological approach that breaks the pebbles into different categories would reveal statistical content about the pebble "community" with no visually patterned relationships. It would tell us what was there but not how. Once the pebbles have been removed from their authentic position the contextual order would be lost and the associational relationships could not be considered. Similar confusions can occur in handling photographic data when the contextual information and spatial/temporal relationships are lost.

Like good fieldwork, analysis also should include a phase of free discovery. As already noted, open-ended viewing may yield important findings or at least define new, unanticipated directions for more structured analysis. In this phase we yield ourselves to the reality of our data. Photographic data are the closest approximation to primary experience that we can gather, and we want to carry this photographic authenticity from the field into analysis. Frequently, the analysis of visual records is a dialogue between researcher and images, a two way communication similar to fieldwork.

But as in fieldwork if we do not have a cumulative scheme that directs our analytic explorations we can become locked into endless circles of confusing detail from which we may never emerge. Sometimes these disorganized processes can be traced to inadequacies in the field recording, but usually the cause lies in a lack of coherent command of research procedure and techniques during analysis.

Just as in fieldwork we must move from open response to directed activities, so in analysis we must move from visual impressions to systematized procedures for handling visual data.

The ideal analysis process allows the data to lead to its own conclusions through a dynamic interplay between open and structured procedures. As one example, we can begin the analysis of a home inventory with an immersion in the images of the home environment that can give a sense of direct interaction with the details and functions of the habitation. These first impressions reflect all the skills of intuitive discovery and intellectual speculation and can also help us develop *categories* for more structured counting, measuring, and comparing procedures. These are often in the form of questions: "How does this home serve as place of relaxation and renewal? How does the home serve as a place for socializing? As a place of retreat?" The photographs can be inventoried to provide specific information on these questions. If the sample is large, this process will produce statistical findings that may lead us to define better our initial perceptions or, equally possible, to decide where they are faulty.

In this manner analysis involves a two-part question: "What do I see?" and "How do I know?" or better "What can be seen and identified in the visual record that gives me that impression?" Deliberate combinations of open and structured procedures during analysis enable us to discover with our full capacities of perception while defining and checking those perceptions through careful reference to specific visual evidence. In some respects this is an art process, but it is guarded from remaining impressionistic by scientific procedures.

It is photographic content that supports or denies the authenticity of our research conclusions. This is often true in artistic uses of visual records as well. Gunvor Nelson, film artist and teacher, states that the greatest block to organically creative film editing is that students have often composed their films in their heads before beginning to edit the footage. This is destructive because it blinds them to the true content and character of their film and the circumstances portrayed within it. The resulting finished product is often dull, inauthentic, even *unartistic* because there is no discovery (personal communication). Gunvor Nelson is saying something regarding art film that is similar to what Edward T. Hall says about analyzing research film. Both are saying "don't tell the film (photograph) what it means, let the film tell you."

These principles suggest a basic design sequence for analysis of all visual records, including film and video as well as photographs. You begin by looking at the film or photographs repeatedly until their character is clear. In this stage film and video are viewed uncut in proper chronological order. Photographs are arranged in temporal or spatial orders that approximate the original circumstance in which they were made. The open immersion may take weeks.

The next stage will usually involve some sort of inventory or logging process in which the content of scenes or photographs is broken into categories of behavior, actions, material content, and spatial arrangement that are then noted in some standardized form or code. The purpose is one of becoming familiar with even the mundane content of the visual records and identifying the location of data within the total sample.

After this step it is common to engage in focused analysis, shaped by initial research questions and new propositions discovered during earlier stages of the analysis. At this point one might carefully compare one living room with another, measure the distance between participants in different interactions, count how many times the teacher looks at a particular child, track people through time, or carry out other specific analytic activities. It is now that one might do micro-analysis, examining every frame of film in a particular sequence, counting every item in every photograph of every room. The detailed information that is gathered in this stage is useful because it fits within a larger framework.

In the end you must formulate conclusions. We have found that dynamic conclusions are usually best produced through a final review of all the film or all the photographs. This clears your mind of minutiae and places important details in their larger context, preserving the lively character of photographic evidence that is the most important aspect of visual anthropology.

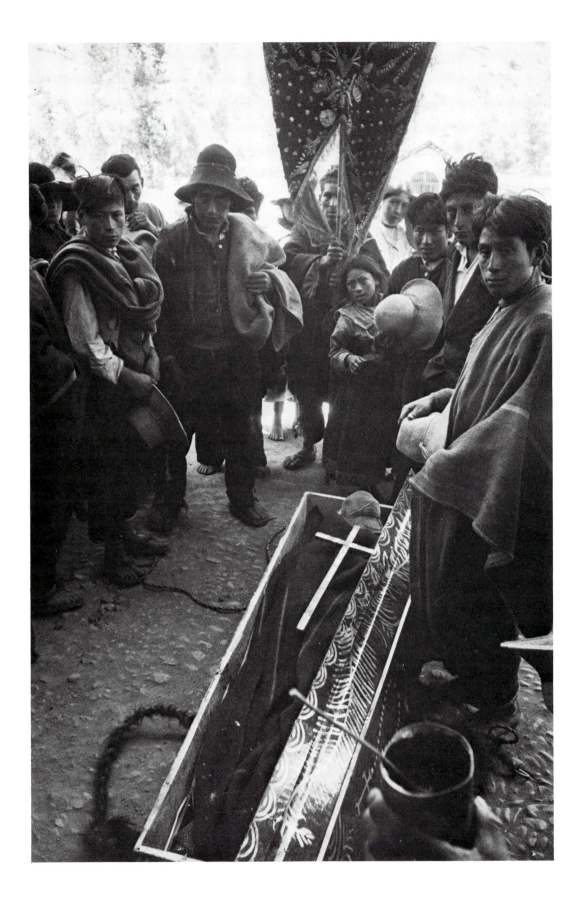

Chapter 15 Analysis of Still and Moving Images

Analysis begins when we start to use our visual records as a source of primary insight and information. It entails a variety of activities within the framework of the general research principles described in Chapter 14 and ends, ideally, with summation of what has been learned.

Our initial experience in visual analysis was in still photography that focused on the specific needs of the larger projects with which we were affiliated. In this setting we developed specialized forms of analysis to gain insight into problems and processes of social upheaval caused by rapid technological and social change. Analysis of mapping and community survey photographs yielded a wealth of demographic, social, and economic information. Detailed studies of fishing and lumbering technologies revealed the technological changes related to social change and anxiety. Data gained in photo-interviews provided insights into stress resulting from shifting values. The basic techniques of analysis involved counting, measuring, and comparing information to be seen within the static images of the still photographs. When we used the camera to track people's behavior through time our activities began to merge with those

In Vicos, illness and short life spans tragically made funerals the most common shared ceremony in which social relationships, formal ceremony, and shifting ceremonial customs could be recorded. Photographs could be examined for information on social-support networks, the mix of indigenous and European customs, and relationships to the larger society. Here, the coffin rests for blessing with holy water by the priest.

associated with film analysis. Our shift to comprehensive film and video investigations led to new possibilities of visual research and analysis. While we discovered that the foundations of film and, later, video analysis rested in the basic procedures and variables of still photographic analysis we also encountered challenges, difficulties, and promises that necessitated different approaches to analysis. More recently we have realized that many of these new approaches can in turn provide a richer analysis of still photographs.

Because moving images are the most comprehensive visual records, we will use our initial film research as a basis from which to begin our discussion of the process of analysis. Film and, to a lesser degree, video are supersaturated forms of information and present further opportunity and difficulty in analysis. The primary challenge is volume; a film sequence of several hundred frames often covers the same subject that might be recorded in two or three photographs. Photographs can be pinned on the wall or spread on a table sequentially for intensive overview and study, but the complexity and volume of film or video make such overviews difficult. Certainly the film can be screened in an unbroken viewing, but such an overview deals only with patterns of behavioral flow. If we wish to carry out the detailed study that grasps the internal dynamic, we usually must begin some form of microanalysis, *and this takes time.* What if we are faced with twenty hours of film or tape? How are we to know which segments deserve detailed attention and which do not? An approach based solely on detailed examination could take years to accomplish with no guarantee that the results will produce meaningful, comprehensive conclusions.

The particular promise of film and video is its potential for qualifying information. The motion of film and the added dimension of sound, as with video, can give us not only the content but also the emotional flavor of human activities. Recovery of this qualitative insight is not necessarily supplied by microanalysis, although details can help define qualitative evidence once they have been discovered.

These were some of the issues that we encountered at the conclusion of the fieldwork examination of Native education in Alaska, described in Chapter 11. After the fieldwork was completed we were faced with twenty hours of film and a one-year deadline for the final report to the National Study of American Indian Education (see J. Collier 1973). Existing analytic models were primarily based on microanalysis, clearly impossible with the amount of film that we had.

The film was organized on the basis of village, school, grade, and classroom. This mass of data could not be handled by one person, so a research team was formed. Our goals were speedy analysis, comprehensive insights, and responsible observations.

After an unstructured team viewing of most of the footage we knew that it would be necessary to make judgments on the welfare of Eskimo children in White-run schools. How could these judgments be made? We decided to concentrate on *communication* as the significant variable in the classrooms, and we agreed on an assumption: "Education is a *communicative* process—from teacher to student, from student to teacher, between student and student, *and between the student and himself."* A corollary to this assumption was: "From viewing the film *we cannot tell whether education is taking place,* but we might be able to tell circumstantially *if* education *could take place,* and be reasonably sure of the circumstances in which education *is not taking place"* (J. Collier 1973:53).

A survey sheet was developed to guide team members in their analysis of the film. The sheet defined categories of communication and listed several questions that required specific evaluations of communication in the classroom. The sheet was intended to provide some standardization of viewing of the films as well as information that could be codified for further evaluation. Survey viewing was done individually.

We met periodically to discuss the progress of the analysis. During these sessions we read each other's survey sheets, looked at footage together, and questioned each other on our findings. Film would be stopped, reversed, discussed as individuals desired. Some portions might be viewed over and over again. These discussions clarified details, raised important questions, and defined conclusions, and the interplay of ideas sharpened our examination of the evidence and the precision of our analysis. On a conceptual level these joint viewings were the most productive stages of the research.

When all the film had been viewed, information from survey sheets was coded and entered on punch cards, which provided statistical profiles of each classroom and of the sample as a whole. Written summaries of these profiles were prepared and discussed by the team, who then wrote individual summations of their analysis and findings.

All these materials were then gathered together by John Collier, who as chief investigator had the responsibility of writing the final report. His initial attempts to write the conclusions directly from the detailed research findings proved frustrating, for reasons that are detailed in our final chapter on making conclusions (Chapter 19). To resolve these difficulties he rescreened *all* the research footage; only then was it possible to make productive use of the detailed findings of the team and write a final report.

In retrospect, it is evident that we had pragmatically found our way into a basic, dynamic approach to visual research. First we

organized our film file, then we looked at the film together in an unstructured manner, searching for basic patterns and hypotheses. We followed unstructured viewing with a detailed, structured examination of the data, and finally we returned again to an open immersion in the visual record for production of an integrated conclusion. This sequence in conjunction with the general principles described in Chapter 14 suggests a basic model for analysis of photographs, film, or video. This model would have wide applicability, but details would have to be adjusted to particular needs and circumstances.

A Basic Model for Analysis

First stage

Observe the data as a whole, look at and "listen" to all its overtones and subtleties, discover the connecting and contrasting patterns.

Trust your feelings and impressions, but be sure also to make careful note of them, including what portions of the data they are in response to.

Write down all questions that the data bring to your mind: these will often provide important direction for more detailed analysis.

See and respond to the photographs (or film, etc.) as statements of cultural drama, and let these characterizations form a context that can become the container within which to place the remainder of your research.

Second stage

Inventory or log the evidence so that you know completely its general content.

Do not make this just an inventory of numerical content but inventory in the context of your research.

What are you trying to find out? Design your inventory around *categories* that reflect and assist your research goals.

Third stage

Structured analysis.

Go through the evidence with specific questions that direct your attention to specific informational needs.

It is here that you measure distance, count heads, compare movements.

The information is often statistical in character and can be plotted on graphs, listed in tables, or entered into a computer and subjected to statistical analysis.

Detailed descriptions may also be made in this stage which abstract one situation for ready comparison to another.

Fourth stage

Search for the overtones and significance of the details by returning to the complete field record.

Try again to respond to the data in an open manner so that the details that you have been immersed in can be placed in a more complete context that defines the significance of their patterns.

Reestablish context, lay out the photographs, view the film in entirety, and then write your conclusions as influenced by this final exposure to the full context.

We have found that just as techniques developed for the analysis of still photographs enrich the micro analysis of film, so too techniques of film analysis have provided new ways to analyze still photographs. For this reason in our discussion of analysis we freely mix examples drawn from film, video, and still photography that can contribute to any visual research. Through the remainder of this chapter we review the more general procedures of visual research analysis, and in the subsequent chapters we examine more specific activities and problems that may be encountered.

Organizing the Data

Analysis often confronts us with a mass of images that leaves us wondering where to begin. The first act of *any* visual analysis is to put all records together in sequential order, either temporal or spatial as appropriate, and marked so that they can readily be returned to their proper relationship. Disorganized visual data are comparable to the shuffled pages of a manuscript. If the pages are numbered it is easy to reassemble the pages into a readable message. But if pages are not numbered, reassembly becomes a painfully slow process of detective work. Hence, the first activity of analysis is to establish visual chronology and order. This is relatively easy if the fieldworker has kept good notes and properly labeled negatives, film, prints, or tapes as they were produced, and otherwise maintained a good data file.

But what if there are no contact sheets, no film slates, no notes or other tangible way to reconstruct the order of recording? What could we do? This problem is one we frequently face with students in artistic and creative photography. Photographs often arrive in class with no clear order. "Have you put up these photographs in any particular order?" "No, they are just as they came out of the box." "Can you rearrange them?" "Well, I'll try."

This is a fundamental first step in any visual interpretation, an "individual" reading of the general character of photographs. Art students frequently say "I'm making photographs to find out who I am," a general artistic search. But this search can remain in their heads, for often they cannot coherently read the language of their

images. This can happen in visual anthropology as well, when the student or investigator attempts to project impressions onto visual evidence without first defining contextual relationships and searching for the true character of the photographs or moving image. We suggest that if you keep shuffling the photographs an order may emerge. We can treat this disorganized imagery as we would shuffled, unnumbered pages of a manuscript. In each photograph we search for clues that define larger order. When students can find and read a narrational form in their photographs they often say, "Now I see what I was trying to find."

The ability to look at the full expanse of a visual coverage becomes increasingly difficult as the volume of images grows. For this reason open-ended study needs to be a unit within a larger analytic process. An unstructured, intuitive overview may result in a significant hypothesis that can carry you dynamically through your research, but unless these insights are rigorously tested they can lead to mistaken observations and false conclusions. Although open viewing and even shuffling of photographic records can be productive, such projective use of images can be hazardous unless done with images whose true context and origins are known.

Sometimes reconstructive ordering of photographs can inadvertently confuse the actual sequence of occurrence, resulting instead in a projective revelation of the "way it is supposed to be." An example was a set of photographs that a student in Asian American Studies made of social interactions at a church retreat. The photographs arrived in class, fresh from the drugstore, and the student was asked to arrange and number them in the chronological order of the interactions.

Later inspection of the negatives revealed that some of the photographs were not in actual chronological order but in logical order. The student had sequenced them in a way that "made sense" in terms of their content, subtly redefining the relationships among people. This re-recording might be of research value in projective, psychological investigations when photographs serve somewhat as Q-sort cards, but that is a process separate from direct photographic analysis.

Such examples from still photography demonstrate the importance of maintaining spatial and temporal order, without which the analytic process becomes confused. Film and video also need proper organization. Film rolls need to be spliced together in temporal or geographic order, as appropriate, and reels of film or cassettes of tape all need proper identification so that their place in the larger collection of data is preserved. A basic rule is never to edit or cut up the original but always to work with prints or copies. Only after

all our data have been properly identified and ordered can we safely move on to other stages of analysis.

OPEN VIEWING PROCEDURES

Almost any analysis of visual images can benefit from a period of free, unstructured examination. But this process should not be casual. Images, whether still photographs, video, or film, should be carefully arranged and viewed in their authentic relationships.

With still photographs, it is best to put all the photographs out together. This can be done on top of a table, on the floor, on the wall. The assembled photographs can then be viewed as a consolidated experience, and the researcher can move back and forth through the coverage at will. With film or video the same effect can be achieved by viewing the records in sequential blocks, preferably as a sustained effort during consecutive days.

If the collection is large it may be necessary to break it into components of related subject matter. In this manner all the photos of one home are looked at together, all of the next and then the next. All the photographs of homes would be looked at before looking at those of surrounding environments; such groupings will be easy to arrange *if* proper organizational steps have been made. Similar procedures should be followed with film and video.

If the photographs are taken with a larger format camera, say $2^1/_4$ by $2^1/_4$ in. or larger, the whole file can be studied on contact sheets, but with small 35-mm contact images other solutions may be needed. It may not be realistic to enlarge all of the photographs, but it is possible to examine the contact sheets with a high-powered magnifying glass, although this is not totally satisfactory. Alternatively, some photographs can be enlarged and mounted together with frames from a duplicate set of contact prints. Some other solutions and technical issues are discussed in Chapter 19.

Open viewing is an unstructured immersion in the visual record, a repeated viewing of all the material that allows you to respond to the images as they *are* and not simply as you expect them to be. With still photographs you will simply let your eye wander backward and forward through the file. Film or video are viewed in motion to begin with. Later it may be appropriate to carry out other analytic activities, including some manipulation of the images. In a study of multiethnic classrooms in the San Francisco Bay Area, John Collier and Marilyn Laatsch (1983) viewed much of their film footage in slow motion during their open analysis. Slow motion viewing is a key process in analysis; unstructured slow viewing will often reveal unforeseen elements that may otherwise be missed at normal speed.

Film and video can be screened at high speeds if you have the proper equipment. High-speed viewing exaggerates activities and motion, which can be as effective as slow motion in discovering new patterns. It can be helpful to use a viewer; this allows you to skim through sections, examine others at a more leisurely pace, and run backward and forward with ease through particular sequences. In this manner you can look at many different portions of your data record in one day.

Preliminary unstructured viewing is a crucial stage of analysis, and careful notes should be kept that record not only what is seen but where it is seen and what questions it may provoke. These notes become an important basis for further analysis.

STRUCTURED ANALYSIS

The movement from unstructured viewing to structured analysis occurs when you start asking specific questions. This structured phase can be initiated in a number of ways. John Collier and Marilyn Laatsch interviewed each other regarding what they had seen in the films during an extensive period of unstructured viewing. They probed for total reactions and insights as well as factual observations (1983). This provided a transition into focused analysis by defining a range of questions and issues.

It is possible to carry out structured examinations of large collections of film, videotape, or photographs by using directed or focused questions as was done in the Alaskan study. As such questions become more specific the process moves in the direction of microanalysis. In a study of Chinese bilingual classrooms by Malcolm Collier, initial questions included: "What is the structure of activities? What is the character of student-to-student interactions? What is the character of instructor-to-student interactions?" Later, as the analysis moved to greater detail, questions became: "What is the minimum distance between teachers and students? What is the greatest distance between children? How long did this interaction last (M. Collier 1983)?" When we arrive at this degree of specificity we have become involved with microanalysis, a refined form of structured analysis.

MICROANALYSIS

Detailed or microanalysis is done to define refined insights. Ray Birdwhistell, Gregory Bateson, and others used this approach to help define the psychiatric concept of the "double bind" from analysis of film of a disturbed mother and child. Saturated microanalysis has developed into an important tool for clinical research that in-

Microanalysis can provide refined insights. The Asian boy in the foreground sets a stance that is fluid, and balanced in contrast to the angular, harsh position of the boy to the left. These differences may reflect not only levels of skill but also culturally different kinesic styles and attitudes toward the discipline. (Photo by Robert A. Isaacs)

cludes examination not only of visual evidence but also of the relationships between sound and nonverbal behavior. Microanalysis has its basis in the unique requirements of clinical research and is a reductionist approach in which understanding of the whole is sought through study of its small components.

But anthropology is generally not a clinical science in which examination of parts can meaningfully describe the whole. Photographs, film, or video are time fragments selected from the flow of culture which we use to attempt a reconstruction of the human context. This is why open viewing of our images is so important. What, then, is the role of microanalysis in visual research?

Typically, microanalysis is the measuring, tracking, describing of particular phenomena or behavior. It includes repeated, careful examination of single images and sequences until detailed understanding is achieved. Erickson and Mohatt, for example, carefully tracked the movement of teachers around classrooms and the time they spent in different activities. This information was used to produce diagrams and graphs that provided the details of how an Odawa teacher differed from a White teacher (1982). Generally, microanalysis has the function of providing the details of patterns already perceived at other stages of analysis. In Collier and Laatsch's urban classroom study, microanalysis included slow-motion and frame-for-frame examination of sequences that had evoked previous findings and questions. The detailed examination did not produce new findings, per se, but made it possible to be explicit about the components of already recognized patterns (1983).

The results of microanalysis may be detailed description or statistical data that can be translated into comparative profiles, tables, or statistical analysis of larger patterns. Some specific procedures of microanalysis are discussed in the next chapter. Because it is time-consuming, micro or detailed analysis is best left to that stage of research when the important sequences in the data record have already been identified. In this manner it can be carried out with precision and economy.

There is an interesting interplay between analysis and field recording. For example, microanalysis of film has influenced our recording process in still photography. The enriched understanding of behavior gained from microanalysis stimulated a new acuteness in looking at and recording behavior with a still camera. Now we observe somewhat as if looking at film, anticipating with more accuracy and selecting our time cuts with more care, saturating specific moments with multiple exposures, our eyes disciplined and sharpened from detailed study of film.

In all successful research, the structured stage of analysis is followed by the preparation of conclusions which define the significance of the findings. This critical process has its own dynamic that requires a chapter of its own, but first we examine some specific procedures and issues encountered in analysis.

Chapter 16 Practical Procedures in Analysis

This chapter presents practical procedures that can be helpful in visual analysis. Most are applicable to the examination of any visual records, although some may be specific to still photography, film, or video. They are presented in approximately the order that they might be used in actual analysis.

ORGANIZING MAPPING AND SURVEY PHOTOGRAPHS

Analysis of mapping and survey photographs requires care in organizing the images for both open analysis and more detailed study. The full value of a panoramic study is seen only when the photographs are enlarged and mounted or arranged in a sequence that approximates the original circumstance. Then you can really see the spatial and functional organization.

When you arrange or mount photographs together you are creating a visual model. A panoramic montage is a two-dimensional model that offers conceptual insights no single landscape photograph could afford. Linking many images together also allows for *comparability*. Panoramas made from a promontory overlooking an agricultural area can offer exacting comparison of land use, from far pastures to urban gardens. Added depth can be derived from comparison of photographs taken through seasonal cycles that can give a temporal depth to agricultural activities. If photographs can be obtained from years in the past then comparisons can provide historical and social insights, as described in Chapter 4.

What graphically conceptual insights could be made overlooking a small Mexican village? Lorenzo (Zo) Avila, a student in visual anthropology, built a photographic model of his father's ancestral village in Zacatecas, Mexico, to probe this question. Zo made three 360° panoramic vistas from the tower of the church: one at eye level, another at 30° down, a third at 60° down, which included the feet of the photographer. This was only the first step in constructing the model, for by nature of perspective these circular panoramas were concave, with each montage appreciably smaller. How could this ultimate photographic map be viewed? Zo solved the problem by joining the panoramas in the form of a large bowl that fitted the concave imagery of this multidimensional map. This concave model allowed the viewer to "stand" indefinitely in the church tower studying this saturated view of environment. In the circular model was seen the shape of the village itself; the interior patios, the streets, and the grid of roads leading beyond into the countryside. It was as complete a documentary model of village environment as could be made.

What could be learned from this model, this circular mind's-eye view of the village world? The first practical recovery could be photo-interviewing. What interview stimuli this bowl model could be! This model could contain the shapes of all demographic information. The interviewer could walk with his collaborator down the streets, stopping at relatives' homes and frequented stores. The walk would continue out into the countryside to the agricultural lands. It would be like literally sitting in the church tower, asking about the structure and ways of the village.

Direct analysis could investigate the structural forms of village architecture reflective of change and history, detailed sociometric observations could be made, based on the notes as to the hour or day of the week in which the panoramas were made, people identified and counted on streets, pedestrian communication patterns studied. Students concerned with planning and land use could observe how the village enters the open space of agriculture. This model literally gives us a bird's-eye-view of village culture.

Survey and ground-level tracking records present a somewhat different analytic challenge than panoramic studies. Here pictures are not made from one spot but reflect a journey through space. It can be quite effective to mount these photographs in a geographical relationship to each other. We can consider a photo survey of an urban street as an example.

Photographs could be mounted on a series of connected 11 by 14 in. boards. Wide shots would be mounted on the bottom of the board in geographic sequence. Detailed or close-up shots of partic-

ular buildings, stores, displays could be mounted on a second level. On the top level would be placed photographs of people or the interiors of buildings. All of these would be mounted adjacent to the wide views of the locale in which they were taken, maintaining the proxemic context so the viewer can experience the street as a unit. The opposite side of the street would be mounted on a separate set of boards; the two sides could be laid out parallel to each other, and the viewer could walk down the street between them. If mount board sheets are properly hinged, the final product can be looked at as a large book as well as spread out on the floor. Alternatively, the photos can be mounted on long rolls of paper, but these are more difficult to handle.

INVENTORIES AND SOCIAL PROCESS

We have discussed how photographs of environment may be organized for analysis in some detail because they illustrate the relationship between how photographs are ordered and the information that can be obtained from them. Photographs of cultural inventories, social interactions, technical process, ceremonies, or any other subject that occupies time and space can be laid out similarly, structured either in terms of spatial relationships or temporal order. Students have experimented making cardboard models of homes with photographs of interiors mounted on the walls of this three-dimensional diagram. Looking down into this model-diagram invites a functional interpretation of the home. Less elaborate arrangements have the images laid flat but in proper proxemic relationships on a large, graphic drawing of the floor plan of the home.

Photos of social interactions, ceremonial processes, or technical procedures that have sequential order can be mounted or arranged so that they approximate the temporal relationships. Temporal order is established by sequence, and temporal distance can be indicated by spacing between images. A small distance can indicate a short time, a larger one more time. The photographs can be mounted on folding mounts that open out like an accordion so that the whole can be spread on the floor or pinned on the wall to be seen as a whole, or folded together and opened as sequential spreads of a book.

Mounting photographs on temporal diagrams or building proxemic models are all means of broadening the scope of analysis by helping us to *see* larger patterns. When photographs of a street, a home, a landscape, or a social process are properly laid out we can then respond to them as a reconstruction of the undisturbed circumstance rather than as individual photographs.

Americanization in a Spanish American school. What is the educational message of this bulletin board? This display on the wall of the school in Cebolla, New Mexico, shows only one element of Spanish American culture. What is the long range effect of such cultural disassociation? Inventories of schools, like homes, can help define the character of educational philosophy in the school.

LOGGING FILM AND VIDEO

A common first step in structured analysis of film or video is to make a log of the record. With film, this is best done using a viewer with a frame counter so that concrete reference points can be noted. Video equipment has footage counters that can serve the same purpose. Some researchers have time marks put onto their tapes with character generators, these are useful in logging and even more essential in micro-analysis. Still photographs can also be logged with profit to the analysis, often this is done during fieldwork as the film is processed.

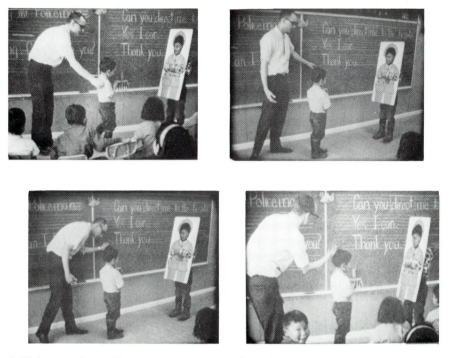

Still frames from film sequences can aid analysis. English as a Second Language (ESL) session in Kwethluk, Alaska.

Logs should contain descriptive information as a matter of course and may also include coded information regarding specific categories of data. The logs in Collier and Laatsch's urban classroom study included information on occurrences of student communication with the teacher, with each other, and with the camera person, and peaks of excitement. This was used to derive statistical comparisons of classes and to locate film for micro-analysis. At a minimum a log should be a good index of the visual content and the duration of different activities.

It can be useful to make visual logs of film by making selected still photographic records from the projected images. This technique was used by Patricia Ferrero when working on John Collier's film study of a Navajo school (Collier and Laatsch 1975). Frustrated with trying to write from the sequential moving images, she made 35-mm copies of projected images and enlarged them to 4 by 5 in. She found that these stimulated a new and productive level of inquiry on which to build her subsequent writing. This shifting of moving images to stills demonstrated that still images have a value that can be lost in the sequential format of film. The results suggested the idea of a visual log, which we have incorporated into subsequent film analysis.

Still copies of film are made by projecting the image onto high-quality, white bristol board. The projected image is then photographed with a single-lens-reflex camera. A projector that can be stopped on a single frame is a necessity, and you may need to build a special mount for your camera. Exposure can be determined with the built-in meter of many cameras, but some experimentation with exposure and developing time is required to arrive at optimum contrast. For logging purposes the negatives can be simply contact printed, although in a later study we enlarged the negatives twelve frames at a time to a size of 2 by 3 in., using a glass carrier in a large-format enlarger.

The value of these still images goes beyond their function as a visual index. They provide ready comparisons of different situations and are a check on memory of details. A set of such photographs can be an important aid at the end of research, forming a conceptual base to organize the review of your footage and its distillation into written and visual conclusions. They are also a source of illustrations for publications.

COUNTING AND MEASURING

Counting and measuring are the major activities of micro-analysis and are basic procedures in all visual analysis. Typically the researcher identifies phenomena that are considered potentially important on a statistical or detailed level. Quantitative information regarding these phenomena is then extracted through close examination of individual photographs or sequences of film and tape. Counting, measuring, and other forms of detailed analysis provide the details we need to give credibility and substance to our findings.

The first step is to create a list of categories of information that are needed and can be counted, measured, or in other ways reduced to a statistical base. We can count the number of objects, people, and rooms, or the number of instances of interpersonal synchrony. We can measure the distance between people, objects, fields, buildings or make statements as to size. We can make measurements of time and the beat or pace of people's movements. These all have real, measurable characterstics. We can also derive other statistical patterns. For example, we can note the presence or absence of particular people, objects, activities, and these can become the basis of statistical statements.

In this manner, an analysis of film carried out by Malcolm Collier involved looking at each sequence of activity and recording the following categories of information, as excerpted from a larger analysis sheet (partial list, from M. Collier 1983).

a) Class ID number
b) Teacher ID number
c) Aide ID number
d) Teacher background code
e) Number of students in group
f) Ethnic mix of students
g) Interpersonal distance between staff and students in feet
h) Interpersonal distance between students in feet

When information in these and other categories of data was obtained for some 157 different sequences it was possible to carry out a statistical analysis of different variables using a small computer. This analysis revealed that student attention and involvement dropped when the distance between children increased from one foot to more than two feet. The analysis also defined clear associations between use of Cantonese and smaller interpersonal distance between people in the classroom. Teachers often unwittingly created proxemic relationships in the classroom that stifled the very participation and involvement they wished to encourage. Open analysis had suggested these possibilities, but detailed measurements made it possible to define these patterns with precision.

MASS FILES

Photographic fieldwork often produces vast quantities of visual evidence, particularly when there is detailed analysis or use of film and video. The saturated photographic study at Vicos resulted in a file of seven thousand negatives, made during a year of fieldwork. How can a researcher use such masses of information? Only highly systematized analysis can solidify such mass information. The examination of such saturated still records merges with the systematized analysis of film research; both can benefit from tools, such as sort cards or computers, that assist in the storage and handling of large amounts of detailed information. An essential difference is that film is locked together by unbroken film records, while still imagery rests in thousands of separated images. This lack of locked-in order is both a disadvantage and an advantage. Meticulous record keeping is required so that the correct relationships are known and preserved, but, on the other hand, still photographs can easily be moved around for easy visual comparisons. Unlike film or video, photographs can be arranged to simulate real proxemic relationships and they can be viewed simultaneously in groups rather than simply sequentially.

An example of both the challenge and the possibilities of masses of images is a photographic coverage of a three-day protest march by leftist Salvadorans from San Jose to San Francisco made by Celeste Greco, a visual anthropology student. Greco laid enlargements out on tables in our classroom. We recognized that the patterns of repetitive behavior were confused by the temporal order. On closer examination, the patterned behavior—cheering, shouting through bull horns, holding aloft signs—was seen to come at various peaks, divided by subtle breaks. These exuberant peaks appeared related to the urban landscape through which the marches were passing. Could this be concretely confirmed?

We suggested Greco create a wall-length geographical and temporal diagram that contained exact geographic locations and time passage of the march. The sequential enlargements were mounted *above* this diagram. The highs and lows of marching activity now could be observed in distinct relationships to the towns passed in the march as well as the passage of time. A crescendo was reached with final arrival at Mission Dolores in San Francisco.

The data contained police and pedestrian audience behavior as well. These records were mounted *below* the geographic diagram, so that police and audience response could be correlated with the marchers' projectivity. A graphic line, or series of graph lines, could now be drawn through this wall length diagram: a line for energy output, another for nonverbal signals of fatigue, a third for audience response, a fourth for police vexation. In effect, this was a *visual model* of an extended event that defined relationships and invited objective analysis and writing.

This example shows how mass information might be handled on a relatively open level. But what if we need to carry out detailed analysis as well? This is the problem faced by Rafael Cake of the Universidad de las Americas in a study of the proxemic and social organization of a Mexican city of 45,000 inhabitants (personal communication). The city is a growing transportation, trade, and industrial center in the state of Puebla with a busy town center dating to colonial times and numerous new *colonias* developing on its periphery. Cake made careful photographs of every block of every street in the city, amassing a collection of thousands of photographs. These are only part of a larger field effort that also included interviews and archival work. An understanding of the organization of the city would have to rest not only on an open evaluation of the photographs but also on analysis of details and a correlation of those visual details to other data.

In discussing this study (still in progress in 1984) with Cake, we made a number of suggestions and he has developed some

approaches of his own. First, with regard to more open-ended stages of analysis, we suggested that he treat the photographic file not as still photographs but rather as film. The contact sheets could be organized in proper geographical order and viewed rapidly under a large magnifying glass. This would approximate a compressed journey though the whole city that could be repeated at will.

For detailed study Cake developed a series of data categories that could be coded onto pin sort cards, with one card for each block. Photographs of each block were studied and the appropriate information punched onto the card. Cards can then be sorted in various combinations and statistical information derived. Cake will be able to pull all the cards for one barrio, extract a statistical profile of that barrio and then compare those results to the profile of another barrio.

The extracted data of such an approach could be handled on a small computer, but the sort cards have the advantage of providing a base on which photographs or photocopies of photos can be mounted. We suggested he mount key images on cards, providing the potential for additional analysis. He could, for example, use the pin sort cards to identify and pull out all the blocks with small stores and examine not only the range of specific information already encoded but the images associated with them for additional, as yet uncoded information. Creative use of sort cards in combination with mounted images makes it possible to move fluidly from open, visual analysis to the detailed approach of micro-analysis. In the near future it may be possible to carry out the same process with computer programs that combine written and visual data.

SOUND AND IMAGES

The relationship between sound and image is often dealt with on a level of micro-analysis. In the past, the poor resolution of video often required heavy reliance on the sound track as a primary data while looking at the visual track as an adjunct. Now that the quality of video images have improved these techniques can be even more productive with the increase in visual information. It is particularly useful to examine the relationship between pacing and peaks of verbal communication and the beat and peaking of nonverbal behavior. Frederick Erickson and others have demonstrated a close synchrony between verbal and nonverbal behavior in interactions among people engaged in normal communication and a frequent absence of such synchrony in cases of cross-cultural miscommunication (Byers and Byers 1972, Erickson 1979).

The analysis of the Alaskan film demonstrated the value of team analysis when working with film. It can be equally productive with still photographs. Margaret Mead used this approach in a comparative study of child development during the 1950s. The research team sat around a conference table which was covered with a large number of photographs of a specialized area of the research. The photographs provided a saturated stream of information. The team would express their impressions , informed and stimulated by the multiple evidence, and often new concepts and correlations would be born (Mead, personal communication).

Photo or film interviews are closely related to team analysis. These may be with people actually seen in the film or with others (see Chapters 8 and 9). In the previously mentioned film study of Chinese American bilingual education, film interviews were carried out with key teachers, who watched themselves on film and commented on what they saw. Initial questions were open ended, in an effort to catch their own, undirected reactions to the film. As the interviews progressed questions then became more focused (M. Collier 1983).

Ideally, most analysis should include team efforts. Only with teams can we exploit a key value of visual records: the ability for many people to examine and discuss precisely the same slice of reality. Team analysis is taken further when individuals participate in analysis of records of their own activities. Such collaboration can include informal projective group interviews. As an example, John Collier made a photo survey of an Acadian community surrounding a clam-packing plant. A date was made to share this with the plant manager. On our arrival all the packers joined in "to look over the pictures." Spontaneously a group interview took place, with each person competing with the next to tell all she knew of the community. In a short evening we gained an in-depth demographic record of this community of thirty homes.

These procedures are but a few of the means by which it is possible to facilitate obtaining information from visual records. They do not define what to look for nor do they exhaust the range of techniques that can be used. In the next chapter we explore the ways by which the investigator can find patterns within the evidence and move on toward insights and conclusions.

Chapter 17 Finding Patterns and Meaning

Most photographic analysis is a search for patterns and the definition of their significance. What are *patterns* in anthropology? They appear to be the relationship among parts and the manner in which they are related to the whole structure, as conceptualized by Ruth Benedict (1934). Some patterns can be statistically defined, but in visual work these are not always clear nor is it always possible to define overall patterns through statistical details. Even a set of photographs thrown on a table with no order to them may exhibit patterned information that we perceive impressionistically from the impact of the images. It is more productive to look first for patterns in the whole scope of the data and then seek detailed or statistical confirmation. The purpose of a good research design and of different procedures applied within it is to facilitate the discovery and definition of patterns.

Artists and writers often operate on an impressionistic level, sometimes presenting rich and authentic versions of social and cultural circumstance. Well-organized visual analysis usually combines structured, detailed study with such impressionistic processes as a means of seeking new insight. The structured activities of analysis can provide the order and control that offer a functional place for such open-ended impressions in the responsible framework of research. The procedures and activities described in preceding chapters can assist in this effort. The primary importance of unstructured analysis is that the eye is freed to see larger designs within the data. There are, however, additional analytic procedures that also can help in the search for larger patterns.

The camera can capture all the material and human complexity of a cultural circumstance, as in this market scene from Cholula, Mexico. But it is analysis that defines the significance of such records.

MAKING COMPARISONS

A primary purpose of organizing data and laying it out in spatial or temporal order is to assist in making intelligent comparisons. The comparative process is one of the most productive techniques of analysis and is employed at all stages. We can make totally open comparisons of whole files by laying out photographs side by side, and we can make comparisons during the most fine-grained micro-analysis by examining details within two different or similar sets of images.

Consider a study of family relationships and child development in different societies. We could make photographic sequences of a tribal family and lay them out above the photographs of a suburban family engaged in similar activities. Subtleties of behavior will be visible at once through the juxtaposition of contrasting styles of behavior. These might take much longer to define if the photographs were examined separately from each other. Paul Ekman has en-

countered the same phenomena using video in psychological research and in his work frequently edits tapes into contrasting sequences that define emotional signals that might otherwise be missed (personal communication).

The fastest way to define the character of a home or neighborhood is to wander in and out of an organized set of photographs of two different homes or neighborhoods. Soon we would begin to see what is unique and what shared in each. For greater refinement we can pull categories of photographs from each and put them side by side, comparing the details of window displays or the contents of kitchens to extract the specific content that provides the meat of any analysis.

Photographic comparisons can be a powerful measure of change, as when we take photographs of a place, subject, or activity from the past and put them together with photographs from the present. Such a comparative examination was the motivation for the extensive home cultural inventory in Vicos although the work was not completed with a later follow-up study. The potential for comparative analysis is a rich dimension of a long-term research project.

We can employ comparative processes to uncover information regarding nonverbal behavior and communication. Malcolm Collier compared film sequences of language instruction in English and Cantonese by editing out and screening them in close association with each other. These comparisons revealed major differences in the structuring of lesson time in English as contrasted with Cantonese. This information in turn shaped further analysis that defined important cultural patterns operating in the classrooms (M. Collier 1983).

Comparisons can be of various types. We can compare similar situations or contrast different ones. Photographs can be shuffled to provide semirandom juxtaposition of diverse elements that may assist in defining what we are looking at. Comparative examination of different photographs or film through photo-interviewing can also sharpen comparative findings.

Creative and Artistic Approaches

Many students in visual anthropology at San Francisco State University have come from various areas of the arts. These students are often unusually successful in visual research, possibly reflecting the use of different cognitive processes from those used by students from the social sciences. Certainly their formal training has been different. Modern anthropology students, like students from other scholarly disciplines, are primarily library trained to share the in-

sights of leading contributors in their field. Doctoral candidates in anthropology frequently find themselves reading a book every three days, and this literary focus is reflected, to a lesser degree, at other levels (Don Rundstrom, personal communication).

Students in the arts are not as rigorously trained to glean insights from books. Their accomplishments are more directed to mastering creative processes, and their distillations tend to be *visual* and creative. Perhaps for this reason they develop conclusions more swiftly and with more organization than library-trained social science students. This phenomenon is of great importance in discussing analysis in visual research.

Our experience suggests that artists use a broader base of reasoning than our anthropology students. An incident in the classroom demonstrates this characteristic. A woman student had completed a field study of a company lumber town in Mendocino County, California. The field recording had been made with discipline, based on a well-drawn village plan.Her saturated photographs should have supported a holistic summation.

A clear visual model was developed, but weeks went by without a summation. Finally, with some desperation, she was urged to write a *poem* expressing her *feelings* about the company town. The student responded with alarm, "Are you kidding? Write a poem about my photographs?" She was assured she should explore a further dimension of reason, by switching to another system of cognition. Dutifully, the student wrote a poem and the next week pinned it on the wall by her photographs. Students moved forward, read the poem and looked over the photographs, some nodding their heads. Knowingly, the student reread her poem and, as if for the first time, reviewed her photographs. She turned away in an air of relief. The poem had broken the deadlock by creating a new hypothetical scheme that gave consolidated meaning to her data and stimulated her to write a conclusion.

No amount of well-organized information assures the production of a sound research conclusion. The discovery necessary for the conclusion often lies beyond the last outpost of data, forming a gulf between the researcher and conclusions. The challenge is now to cross this gulf! We suggest the chasm can be spanned only by *creativity;* we need to *fly* over undocumented space in order to command scientific discovery.

However, while art processes are often a means to creative discovery they can be dangerous if not combined with an organized and responsible sense of scientific "craft" that moves beyond individual feelings and intuitions. The temptations of an artistic ap-

proach in visual anthropology can lead people to be sloppy about the details of fieldwork and analytic procedures. Consequently they cannot always tie their findings to concrete visual evidence. This tendency is partly a reflection of an aspect of modern Western artistic culture which does not always place a premium on precision craft skill. In visual anthropology this can be unfortunate. When creative processes are combined with meticulous field and analysis craft the results can be astounding.

A successful combination of these elements was work by Naomi Togashi, a student in our visual anthropology courses at San Francisco State University (Togashi 1983). Naomi was an art major with artistic training in Japan prior to arrival in the United States. Her own art productions were experimental avant-garde forms. She had no photographic experience but readily mastered the field and laboratory procedures because she approached them as a systematic craft process.

After her first semester in the course, she decided to make an investigation of core Japanese aesthetics through a photographic study of home styles of first-, second-, and third-generation Japanese American homes. These data were to be supplemented with photographs of homes in Japan that she arranged to be made by a friend. Naomi's purpose was "to study how Japanese people in San Francisco carry their background of Japanese culture in their home styles." She was curious to see how home styles changed from generation to generation and hoped that identification of key continuities in the homes would define the essential aesthetic elements that reflected Japanese culture.

Sixteen homes were photographed, nine in San Francisco and seven in Japan. She made carefully framed studies of every room in every house, with particular attention to: (1) the way space was used in the homes, (2) the nature of "shrines" (this category was not limited to religious shrines), and (3) the range of Japanese artifacts. Naomi initially expected that shrines and artifacts would be the most revealing, but after examination of the first photographs with Malcolm Collier she revised her assessment and paid particular attention to proxemic variables. This reflected an artistic recognition that there were common elements of style relating to space that operated even when the contents of the homes were different.

The photographs taken in Japan provided comparative depth. Naomi made hundreds of 5 by 7 in. prints, which she arranged room by room and home by home as they were produced. From a relatively unstructured examination of these she developed ideas concerning the relationship of proxemic variables to other aspects

of home style. She could make generalized statements about how space was used by each generation and how this was related to changing cultural circumstances.

On one level the study was already complete, but Naomi carried it further. She made a detailed examination of her records, as she had intended all along. An analysis sheet with 108 different variables was designed. These variables included details of room type, the nature of its spatial arrangement, types of objects in it, and the function of the room. The resulting information was entered on pin sort cards. Naomi then photocopied a key photograph of each room and mounted this copy on the associated sort card. In this manner both the abstracted information and key elements of the visual information were held together on the card.

The cards were used to derive statistical information which was combined with earlier findings to produce a five-volume, twenty-pound report. It included enlarged photographs arranged by room and home, carefully annotated, *plus* a careful presentation of the analysis. Photographs were meticulously mounted in ascending order of evolution and acculturation. A final volume distilled the key findings into a compact, illustrated set of conclusions, artistically mounted on handmade Japanese paper. When Naomi presented these to our classes, students looked around at each other as if in silent question, "Can we match this ultimate presentation?" Naomi's attitude was "Here it is," and she was silent about any further analytic or written refinement. We poured over the volumes as ultimate fulfillment, visually tracking her hypothesis through to a third-generation apartment in San Francisco. Now a true scientist, she declined to generalize beyond her data and wrote that her findings could only be applied to Japanese in San Francsico!

Her analysis only touched upon the full potential of her fieldwork because of time restrictions, but this effort remains an unusual example of coordinated artistic and scientific procedures. Her success rested on two foundations. First, she started with a fairly well-developed hypothesis that provided a structure for her fieldwork and her analysis. Second, she was systematic about *both* her art and her scientific processes: each was carried step by step through to completion. This was related to her concept of the relationship of craft skill to creative production. She did not see meticulous attention to procedural details as inhibiting to her creative processes, unlike some American art students. Instead, craft skill was seen as a vehicle to creative production, whether in art or science. Consequently, she was thorough in her activities and did not become bored by the tedium of either artistic or photographic processing and visual analysis.

So far we have discussed the contribution of artistic processes to visual anthropology, but what about the contributions of visual anthropological processes to art? Naomi had no intention of becoming a visual anthropologist, so she was asked, "how do the things you have done and learned in the course relate to your creative activities?" She replied "Before, if I thought something was beautiful I might not really know why, now I know how to look at it again to discover what it is that makes me think it's beautiful. That helps me in my art" (paraphrased from conversation). This discovery underscores our introductory statement that visual anthropology is essentially involved with observation, not technology.

These procedures and examples should be seen as suggestive and not conclusive. Ultimately, analysis is a form of experimentation with the data until they make sense. The key elements of good visual analysis are an exploitation of all the potentials of visual records and a systematic, careful follow-through of all procedures.

Photographs can trigger intense involvement and study of a subject. Here, two students in an Asian American Studies class at San Francisco State University re-examine a photographic map of a Chinese American community prior to preparing conclusions from an analysis of the photographs. (Photograph by Malcolm Collier)

Chapter 18 Making Conclusions

Analysis is completed by reaching and articulating your conclusions. At this stage we face again the reality that documentation is never complete, that there is no statistical process that will responsibly bridge the gap between known details and the inventive needs of our conclusions. We need a process that offers us the freedom for full creative conceptualization to achieve further understanding. We have already suggested that this requires a return to an unstructured review of all the photographs, film, or tape. The importance of repeating the unstructured viewing cannot be overstated. The reasons are illustrated by two cases from our own work with film.

The first is the analysis of the film from the Alaskan Eskimo education study described in Chapter 16. When John Collier attempted to write the final report from the detailed research findings, problems developed. As the time to write drew closer I (J. Collier) became increasingly anxious. The work of the team was done, profiles had been prepared, and the written survey sheets provided a fluent record of the insights of each team member. But this balanced information did not prepare me to write, despite our hopes that a report could be scientifically written directly from the abstracted findings of the research team. The coded information and survey sheets appeared to defeat the very end that they were designed for, the presentation of information that would supply a concise and factual *overview*. Indeed it was a comprehensive overview that I felt I lacked; in spite of my field experience I was still unable to write fluently from the team's findings. I felt the desire to return to Alaska for a "second" look and, functionally, that is what I finally did by

immersing myself again in the films as a running reflection of the original reality.

This difficulty with the detailed analysis of the team should not be interpreted as a negative comment on the value of structured analysis but rather as evidence that we had not effectively programmed how to organize our efforts and how to utilize our codified information. We did not know how the different pieces of the analysis should be incorporated with each other to produce a fluent conclusion. Subtly, the details of analysis had obscured the larger context of Eskimo school experience. What I needed was a context in which to place the codified information. In response to this need I rescreened every classroom, allowing the abstracted information to be integrated with the larger character and context of each classroom. When I turned to the film before final writing I inadvertently allowed the primary imagery of the field experience, recorded on film, to translate the detailed findings of the analysis back into the larger cultural context. *Now* I could write a report, which later became a book (*Alaskan Eskimo Education: A Film Analysis of Cultural Confrontation in the Schools*, 1973). To the best of our knowledge, this was the only individual case study that was published from the entire National Study of American Indian Education, perhaps because the final report was written from the organic relationships of the film records themselves.

At the time we did not appreciate the significance of this final review in reaching conclusions. Following the Alaska study John Collier took on an investigation of a community-operated school on the Navajo reservation. This was a search for positive experiences in American Indian education through exploration of the response of Indian students to a bilingual, culturally determined program. Field methods were similar to those used in Alaska. Again, analysis included a team approach and code sheets. Again, an attempt was made to write conclusions directly from the abstracted findings of the analysis, which were both detailed and rich, and a lengthy, detailed text was prepared, but it had no cohesion.

This text was reviewed by Edward T. Hall, who pointed out, "John, you have destroyed the most important element of your research by ignoring the authoritative presence of your films" (personal communication). Indeed, the difficulty was more severe in this case because the analysis was both larger in quantity and more refined in detail. As the results became more specific, the production of comprehensible overall conclusions was more difficult. Again, it became necessary to return to the film itself to write a coherent report and conclusion.

This example illustrates the statement of Leonardo da Vinci:

"The more minutely you describe something, the more you will confuse the reader's mind and the further you will remove him from knowledge of the thing described" (*Profiles* 1985:17). The purpose of a return to the overview is to rise above the minutiae of detailed data that obscure the discoveries that can lead to conclusions.

This final overview will be different from initial unstructured viewing. Now the images will be seen in the context of intense analysis; they are no longer strangers which you seek to know but friends whom you understand in depth. The purpose is now to place these elements together and reduce mass information to its essence. Achieving a research conclusion is essentially a creative undertaking with which we attempt to reveal our study in its full perspective. We return to an overview of our primary data in search of an organic form that will allow us to transcend the limitations of specifics without necessarily losing scientific responsibility.

In the previous chapter we described shifting cognitive processes from the scientific to the artistic as means to reaching a unified insight. In our instructional experience we have had scientific students shift to the more open cognition processes of the arts, and we have had arts students shift their cognitive processes to the systematized processes of science in order to accomplish successful visual research. These shifts suggest an important relationship between art and science which may be particularly important in anthropology where pure, systematized data are often difficult to obtain.

How did Naomi Togashi move from her initial ideas about Japanese American home aesthetics to her successful conclusion? By just such a combination of cognitive processes. How did Albert Einstein form his early scientific theories? Certainly he used a form of reasoning different than that he used in following years to define and attempt to prove the theories. Dr. Junius Bird, archeologist, started a major exploration based on a few fluted stone points found in the Panama Canal Zone. If he could have found a campsite, a fire pit with charcoal, in association with such points, then he would have been able to make a major statement about early hunters of big game in the isthmus. Bird died before completing his search, but his creative achievement stands; all it took was one fluted point, and scientific *imagination* could conceive the possibility of a whole world. Discovery is an act of creation.

It is this opportunity for combination of creative and scientific approaches that is the particular promise of visual anthropology. From this combination can come understanding and knowledge based on a more complete application of human intelligence and observation to the problems and promises of our times.

Sometimes complex circumstances require refined application of
photographic technology. This photograph of an oil camp bunkhouse in
the Canadian Arctic required multiple flash bulbs. The sync cable for
one of the bulbs is visible in the bottom center of the picture.

Chapter 19 Technical Considerations in
 Visual Anthropology

Does mastery of the technology of photography, film, or video ensure success in visual anthropology? How good a technician do you need to be to use the camera for research? How professional does your equipment have to be? Neither expensive equipment nor technological skill guarantees success. When teaching courses in visual anthropology, we have always minimized the technology of photography in favor of the development of systematic observational skills, sound research designs, and the analysis of nonverbal evidence, for only these can ensure a successful effort. Some students who have produced brilliant visual research projects had never used a camera prior to their investigations for the class. Conversely, a number of professionally trained photographers have accomplished only mediocre studies. Mastery of optics and of the camera have little relationship to skilled observation. Ideally, visual anthropology should not rest on photography, although the camera is a crucial aid to recording and research. Still photography, film, and video should instead sharpen our vision, so that with or without the camera, we become skilled and knowledgeable observers of our surroundings. Whether one makes use of visual records or works only through direct observation, insight is a product of acuity of human perception. Read this chapter with discretion, looking for the supportive technology essential to your research.

Skill and the quality of data are related. The scope of information can be enhanced by skillful use of equipment, but technology should not master and intimidate you. Basic data are available for every level of photographic skill, from the novice with the disc camera to

the perfectionist with an 8 by 10 in. view camera or a multilens Nikon. The skilled cameraman certainly can glean data that is out of reach of the learning amateur, yet very important observations can be made with the amateurishly operated snapshot camera. Some varieties of sociometric tracking can be done as well with an instamatic as with a professional camera. Extreme sharpness is not essential in counting riders at a street car stop, or school children milling around in the play yard. Simple counting and rudimentary identification can be made from technically unsophisticated records.

Camera skill does *not* ensure gathering readable data. The expert observer will gather more significant material with a box camera than the visually blind super-technician with a five-hundred-dollar camera. The challenge is *to observe with significance.* With this view, rudimentary technique and an adequate camera are all any anthropological student needs.

The relatively greater significance of visual awareness, as compared with technical skill, was demonstrated by a group photographic study made by two anthropologist couples, Bernard and Rella Cohn and Jack and Shirley Planalp, working for their doctorates in a small village near Banaras, India, on one of the Cornell Community Study Programs in the 1950s. Others were carried out in Japan, Thailand, Nova Scotia, and on the Navajo Reservation in the American Southwest. Bernard Cohn and Shirley Planalp decided a few weeks before departing for India to use photography for ethnographic recording. Neither had done photography before or owned anything more than a snapshot camera. To meet their needs, serviceable 2¼ by 2¼ in. twin-lens reflex cameras and light meters were ordered, and the team had time left for just four exercises in basic camera technique. (This was in the 1950s, prior to the development of 35-mm cameras with built-in meters.)

Our first stipulation was that they write down all the technical data for each exposure in the four short lessons so that they could learn completely from the examples of each developed roll of film. This is a most important procedure in mastering technique rapidly. Taking a few rolls of film systematically and writing down the exposures can teach anyone the rudiments in a few days of study.

The first lesson was how to expose film with the aid of the light meter. The students were cautioned that they could expect their meters to break or deteriorate in tropical field conditions, and, when they arrived in India, to make careful light studies of all recording conditions, writing the data down for future reference. The students carefully exposed film, noting meter readings and camera settings, working light values through from bright landscapes to deep shade and home interiors. This procedure would be appropriate even with

today's automatic cameras because you have to assume that the metering system may give out in circumstances where it cannot be fixed.

We developed the film together in the Cornell lab so that they would have a follow-through view of the process and see at once their successes and mistakes.

The second lesson was in controlling the focus of the lens by working through from infinity to three-foot close-ups. The third lesson was photographing a model carrying through a process, making each step visually clear. The fourth lesson was photographing artifacts, using natural light to sharpen detail, and the camera ground glass for sharp focus and sensible framing.

Dr. Cohn's recall of this crash training highlights what probably is most important in the orientation of the anthropologist who goes to the field with a camera.

> The points I remember about the experience were:
> (1) Your ability to relax me regarding the technical aspects of photography by driving home the relative simplicity, especially with a reflex camera, of the operation.
> (2) Your insistence that one should see the picture before one took it rather than hope for the best.
> (3) The necessity to take a lot of pictures and in sequence.
> (4) Your 'eye' in seeing how a picture would look when enlarged or cropped (private communication).

Our lessons stopped here. They were urged not to process their own film, though they carried equipment to do so, except for emergency checking of their field results. Instead it was suggested that they find a reliable film processor in Banaras, give him several rolls of film shot at a variety of film speeds, check for the best exposure, note the film rating, and expose everything at that speed for the whole film period, being very careful always to have the same man develop the film as nearly as possible in the same way.

Their supplementary camera equipment included K-2 filters for screening out the white glare of dusty tropical skies, light-weight tripods for careful close-ups, lens tissue, and dust-off brushes. The cameras were in ever-ready cases, with instructions to keep these cases closed at all times except when working, for *dust* is the wrecker of cameras. They were instructed to store their film in *cool places,* with bulk storage of film in iceboxes whenever possible to avoid deterioration of the film.

We did not see this field team for a year and a half. I was full of anxiety and anticipation, for in letters they had reported a very

exhaustive film coverage. When we saw their 1,000 contact prints we both were heartened and amazed. Despite their limited instructions the team returned with an outstanding visual ethnography.

Various elements had worked for their success. The even brilliance of their negatives was the result of good synchronization between exposing and processing and their regularity of getting their film to the lab in Banaras quickly so that they avoided the general fogging that is the hazard of film deterioration in hot countries. Another element was their good judgment not to force the lighting conditions. Recording was done whenever possible in the stable light hours of the day.

Still another basis of their success was thoughtful planning. Shirley Planalp and Rella Cohn concentrated on the women's world within the home compounds, where few men are allowed to go, while Bernard Cohn and Jack Planalp worked solely in the men's world. Having cameras in both these domains greatly enriched the research files. But beyond these technical points we must credit their success to their excellent training in the cultural significance of circumstances and artifacts, which they had received from Dr. Morris Opler in the year preceding their expedition in the field. Opler had bombarded his students with photographs of roles in Indian society in the region where the study was made. This training was unquestionably the key to their success, for it gave them sharp recognition and triggered their cameras at the right moment.

In an effort to carry this thoughtful study through to its visual conclusion, the Cohns and Planalps made a generous selection of their more important negatives, and we shipped the negatives to COMPO, one of the finest professional photographic laboratories in New York where many magazine photo-essayists have their work processed. The lab returned 8 by 10 in. prints and to the satisfaction of the photographers, the technical and visual content of their study could match any professional study made in India. It is apparent that the eye makes the picture. Fine observation is fine photography.

SOME CRUCIAL FACTORS

What *is* a good ethnographic photograph? The answer changes with the nature of the subject; good photography of ceramics is observationally less complex than records of events or behavior. Good recording of ceramics, carvings, statuary, and other material objects may require skills in lighting, exposure, and focus to enhance detail. Records of ceremonies, events, and interactions require skill

in observation as well as camera handling. The context must be established, relating details to surrounding place and events, and the choice of the moment of each photograph is crucial. These demands suggest making both close and distant photographs that may increase the scope of contextual information. Ideally, we would not depend on a single image but rather on sequences that established the temporal flow and peaks of the circumstance. In all cases our goal would be to produce researchable records. Within this frame of reference there *are* some critical technical factors.

As an example, in refined studies of cultural inventories a soft-focus negative is of little value, for precise reading is impossible. Critical focus or image resolution involves three factors: the nature of the lens, lack of camera movement, and proper adjustment of the point of optical focus. If you are paying $200 for a camera you should check out the lens. Even costly lenses can be defective, for the sharpness of a lens depends as much upon how its elements are mounted as on the optical formulae. Modern computerized designs appear to ensure "adequate" lenses, but a critically sharp lens is no easier to find than it was twenty years ago.

Always examine *with a magnifying glass* the back surface of your lens. *The slightest marring on the back surface may make the lens soft focus.* So will fungus between the elements of the lens. Fungus looks almost like etching on the surface of the elements. Scratches on the front of the lens are of negligible importance. *See that all elements are screwed together tightly.* The slightest movement of elements will change the focus of a lens.

Check your lens by making two tests. Photograph a newspaper with black type at the closest point of camera focus with the lens aperture wide open, and then again stopped down. Make a second test at infinity, ideally showing sharp building lines, signs, or electric wires. Again expose film with the lens wide open, and then stopped down. These tests should be made with the camera on a tripod or other form of support so that camera vibration or shaky hands will not be a variable. The results of these tests will tell you whether or not your lens is flat field and sharp to the edges. They will tell you whether your lens is critically sharp wide open, and your view of infinity will check out the resolving power of your lens. Infinity is the extreme test of a lens.

Zoom lenses are becoming more common with 35-mm cameras. Some of these, those that feature a wide focal length, may be useful to the fieldworker. They allow changing the coverage of the frame without either changing lens or moving around and may be an assistance in certain types of studies of behavior and social inter-

action. However, while their quality is steadily improving, they still remain less consistently sharp in focus than standard lens. More important, except at great cost and weight, they are not as "fast," meaning that they cannot let as much light through to the film. This defeats one of the primary advantages of modern 35-mm cameras, their ability to be used in low-light situations.

If you have a good lens and still get blurred images, study how you hold your camera. Make tests and find out how slow a shutter speed you can hold without blur. The calm individual can make a sharp negative easily at a $1/25$ and even $1/10$ of a second. The nervous type can't hold an exposure slower than $1/60$. If this is a problem, lean against a wall when you shoot necessarily slow exposures in very dim light, or use a tripod. Photographing motion requires a fast shutter. You can stop a running horse at $1/500$, and many craft processes at $1/125$ of a second.

If you get blur with a fast shutter speed, check on your footage scale and the working of your range finder. Range finders can jar and give you a false plane of focus, instead of focusing at five, feet the camera may actually be focusing at ten feet. With single lens reflex (SLR) cameras (the most common variety today), focus can be thrown off by minor breakdowns in the positioning of the mirror that reflects the image to the viewfinder. This occurs most commonly when the camera is held in other than a horizontal position.

To check your focus and test the accuracy of footage scale and range finder, put your camera on a tripod, open the camera, place a strip of wax or tracing paper in place of the film, throw a dark cloth over your head and the back of the camera, and examine the exact point of sharpness through the lens. The image will be accurately reflected on the wax or tracing paper. If there is a discrepancy between the point of focus using your viewfinder and that looking at the tissue paper then there may be something wrong with the camera, and it should be checked by a technician. You can also make a rough check by comparing the reading on the footage scale of the lens (after focusing through the viewfinder) with the distance to the subject as determined with a tape measure. Should such a problem develop in the field, with no opportunity for skilled repair, it may be possible to calibrate the camera using these approaches. Then you can set the camera's focus using the footage scale on the lens rather than by looking through the viewfinder.

Consistent problems with focus do not always reflect a faulty camera; some people who use glasses can have difficulty focusing accurately with 35-mm single lens reflex cameras. It may not be possible to obtain camera attachments to compensate for this par-

ticular difficulty, and if you wear glasses and encounter consistent focusing problems it would be well to develop a good sense of distance so that you can check your focusing by reference to the footage scale. If there is a gross discrepancy between your perception of the distance and the point you focused on through the viewfinder you can then refocus or set the focus using the footage scale. Given the depth of field of normal and wide-angle lenses in 35-mm, a consciousness of the problem and a little care will usually take care of difficulties.

Sensible framing of the camera image is a second skill that adds considerably to the research value of a photograph. Framing means adequate coverage. Counting and measuring are not possible if the whole view is not available for study. See that all of the research subject is covered. If this is impossible in one frame, mount together as many frames as necessary to obtain a complete record. The whole view is the scientific view, the composition that gets the most relationships and dimensions. In large operations such as sawmills or shipyards, you want to make very wide-view exposures so that all the complex relationships of the industry can be studied. The wide view is equally important for tracking the positions of the workers, ideally to see them in their various roles through the changing phases of manufacture. The same is true when tracking social interactions; details or close-ups are only useful when you have a record of the larger context. Hence a wide-angle lens is a practical necessity.

Of all your lens equipment, you will probably find your wide-angle lens is your most valuable. Many anthropologists and documentary photographers use wide-angle equipment almost exclusively. To be sure, the telephoto lens offers still another refinement of study. On occasion the sociometric study benefits greatly by the long lens, but in general it is not as valuable as your wide angle. You can always enlarge up a part of a sharp frame, but there is no way of stretching the borders of a confining negative. Equally important, long lenses tend to put you at some distance from the subject. Most of the time an increase in distance is a disadvantage as it means that you are not as "tuned in" as you might otherwise be. You will have difficulty in anticipating what will happen next, and the quality of your records will suffer.

Proper timing of photographs also adds to their research value. As in all photography, the anthropologist is a hunter who raises his camera at the right instant, at the most clarifying part of the process, or at the peak of nonverbal expression of the human subject. There is no formula for this success; rather it is a clarity that comes to the photographer through practice and astute observation.

Beyond these technical achievements, fine photography for anthropology is as much the result of good human relations as it is of camera manipulation. An open, expressive portrait of the native certainly holds more opportunity for study than a stiff expressionless one; here is a basic reflection of the relationship between the native and the anthropologist. Photographs that hold intense human significance and communication have often been made by novices with the camera, for the secret of such records lies in the nature of rapport, not in photographic technique.

Aggressive technical mastery can interfere with rapport and produce photographs that have no human content, looking like pictures taken through a glass door. This is one of the problems with long lenses, particularly long zoom lenses. Their very appearance is menacing, like a gun barrel, and the photographer or film-maker has no technical incentive to come closer to the people in front of the camera. Jean Rouch, the French ethnographic filmmaker, when asked "What is the value of zoom lens?" replied furiously, "I take the zoom lens away from my students . . . it is good that they have to run back and forth, you should be able to smell the people you film."

In like manner, former Farm Security Administration (FSA) photographer Russell Lee, when teaching photography at the University of Texas, would often take the long lenses away from his students and force them to go onto the street with 35-mm Pentax cameras and normal-length lenses, with the assignment to "get close pictures of people" (personal communication). The fieldworker must become comfortable in the role of photographer, this cannot happen if too great a distance is placed between subject and camera. You would not expect to carry on an extended conversation with someone at fifteen to twenty feet, likewise the photographer must come closer if a human connection is to be made.

Fine ethnographic and research photography is like fine interviewing, an attempt to get closer to the view from the inside. The fieldworker should learn to work simply and directly. Building two-way empathy and communication with people is the basic skill. Getting the inside view may ultimately mean turning the camera over to the informant: "Here, you photograph yourselves as you are." Or less extreme: "Show me what I should photograph." In any case, close communication with people is essential. Beyond anthropology, this is the key to all fine humanistic photography, even the fine art of portraiture is the result of a human bridge over which imagery is formed.

What cameras are best for research? Field photography has involved many innovations since early ethnographers made formal records of indigenous peoples. Historically *all* cameras were view cameras with a ground glass back for full viewing and focusing, and all cameras were large—8 by 10 in., 5 by 7 in., or 4 by 5 in. Work was rarely enlarged, and a large contact print was a prerequisite of the field record. The truly miniature cameras, the 2¼ by 2 ¼ in., and the 35-mm, were not in common use until the 1930s. Only in the last twenty-five years has the 35mm camera been developed into the all-purpose tool that it is today. Modern lenses, improved film, and chemicals for processing have made the twin-lens Rolleiflex and its imitators, and the 35-mm single lens reflex (SLR) cameras the most widely used cameras in both laboratory and field studies.

Historical archeological records were all done with the 11 by 14 in. or more popular 8 by 10 in. view camera. The large contact print rendered exquisite detail and remained popular with many eminent archeologists. Paul Martin, curator of anthropology of the Field Museum of Chicago, commonly logged all his Southwest digs with an 8 by 10 in. camera mounted on a specially constructed movable steel platform ten feet high. We are no longer held to this enormously large film for critical details. Improved lenses allow the 4 by 5 in. camera to offer the archeologist comparable renderings. The issue is no longer sharp images, but rather corrected and carefully framed images. In the field of museum and architectural photography or in recording ruins the 4 by 5 in. view camera remains the most professional tool. It allows for critical correction of distortions in perspective through its system of tilts, swings, and rising and falling lens adjustments. One drawback to this equipment is that it requires a skilled operator.

Many early records in anthropology were made with a 4 by 5 in. or 3¼ by 4¼ in. Graflex; though cumbersome its reflex system allowed for critical study of the camera image within seconds of the exposure. This first "candid" camera has given way to the small twin reflexes and the single-lens 35-mm reflexes which, owing to their extreme depth of field, accomplish recording of this character as well if not better than the larger equipment.

The 2¼ by 2¼ in. twin-lens reflex remains a happy and durable compromise between the large and the very small. Its negative is large enough to allow for comprehensive study, yet the camera is small enough for quick candid recording, and its lens is short enough for a great depth of sharp focus. The full negative-size ground glass allows for precise focusing and framing. Similar to the twin lens

reflexes, if also more expensive, are a variety of modern single lens reflex cameras that use the same 120 size film. Under the names of Hasselblad, Mamiya 645, Pentax 6 by 7, and others, these have interchangeable lenses and a variety of special attachments, being the tools of various branches of commercial photography. The negative format varies but all are larger than 35mm negatives.

While cameras such as twin lens reflexes continue to have a place in fieldwork, particularly when there is a need to work with contact prints, the major equipment of fieldworkers today is the 35-mm single lens reflex (SLR) camera. It is not just convenience that recommends the 35-mm camera but also its functional design that invites spontaneous and inconspicuous recording. This characteristic revolutionized humanistic photography. The reflex 35-mm camera allows for complete viewing in a ground-glass viewfinder which means that extreme closeups can be made with precision focusing and framing. Thirty-five millimeter slides are the most popular size for educational use, and anthropologists, who almost invariably teach, often carry the 35-mm loaded with color for precisely this reason. Modern lenses, film, and processing allow the 35 mm to produce very sharp 11 by 14 in. prints. Modern photojournalism and documentary photography were founded on the 35-mm format, first in rangefinder cameras such as the Leica and today with the many SLR's, so there is a large professional craft behind the use of 35-mm.

Beyond its ability to synchronize the eye's vision through the camera with flowing human and natural process, the most outstanding feature of 35-mm cameras is the lenses, which allow a wide range of framing choices. Most important are the short focal-length lenses (wide angle) that, with proper lighting, can have almost universal focus from two feet to the horizon over a very wide angle of view. These can become invaluable tools in the capture of context. The 28–mm focal-length lens is the most useful of these wide lenses. It is not so wide as to distort the image and makes a fine working lens for the student of technology, social gatherings, and regional ecology. The SLR camera is almost always also equipped with a 50-mm or 55-mm lens, the "normal" lens because it reproduces spatial relationships within the frame in the manner closest to that which we ourselves behold. These lenses are commonly the fastest lenses as well, allowing the maximum amount of light through to the film; thus they are extremely useful in low-light situations. Beyond the 28-mm and 55-mm focal-lengths there are infinite variations of lenses, the most useful which for the fieldworker might be a 90-mm or 100-mm lens, good for portraits and detail shots of interactions, and of street scenes. Of the zoom lenses mentioned earlier, the most

useful are those in the 28–80-mm or 35–90-mm range. Super wide-angle lenses, including the "fish-eye lens," are also available. These all distort to one degree or another, but when the aim is to photograph complete relationships, distortion may not be of significance.

An additional feature of 35-mm camera lenses crucial to the fieldworker is their speed. Normal lenses (50-mm) with apertures of f/1.4 are readily available and even faster lenses are made for some cameras. Together with highly sensitive modern films, these lenses make it possible to photograph in almost any illumination.

Another value of the 35-mm format is the long film wind of thirty-six exposures, with bulk cartridges available for some cameras that allow for up to a hundred exposures. This bulk is not just convenience; coupled with rapid film transport, including auto winders, it is possible to make rapid sequential records. An additional feature is that the film is edge numbered, securely establishing the true chronological order of shots that the memory may otherwise reorder. Film can be bought in bulk, loaded by the fieldworker into reusable cartridges, and the costs per exposure are far below those of any other format.

A wide range of film types (emulsions) are sold in 35-mm, ranging from fine-grain, slow-speed films to fast, super-sensitive films for low-light use. The sensitivity of color films has jumped in recent years to as high as 1600 ASA for both negative and slide films. Black-and-white films are also sold with ASA figures as high as 1600, and Ilford makes a unique black and white film (XP-1) that produces almost grainless negatives at 1000 ASA. In 35-mm, if you can see it, you can probably photograph it. In addition to these fast films there are small but quite powerful electronic flash units manufactured for use with 35-mm cameras for those situations in which supplemental light is necessary.

Historically, black-and-white film was used for most data gathering, with color transparencies shot selectively when color records were needed. The cost differential between color and black and white was a major determinant of this use pattern. Color transparencies were shot instead of negatives because the color fidelity was more dependable and the slides could be used directly in teaching with no additional processing. When prints were needed in color, they could be made selectively from the slides through an internegative process.

While black and white remains a more economical medium than color if fieldworkers do their own processing, the choice between color and black and white and between slides and color negatives is less clear than it used to be. If processing is to be done by a commercial lab it is often cheaper to work in 35-mm color today

than in black-and-white, when the film is developed by discount processors oriented to the general public. While the quality of color prints so produced is uneven and the prints small, the flexibility of the color negative has invited many students in visual anthropology to bypass both black-and-white and color slides in favor of drugstore color prints. They can then work with the images on their kitchen tables with no need for projectors, or darkroom skills. Initial costs are slightly higher than with color slides, but duplicates are cheaper and prints can be more easily handled and analyzed, in most cases, than slides. Also, the cheap reprints can be given to informants with corresponding improvements in rapport. For the fieldworker with processing skills it should be noted that color printing is relatively easy today and that color negatives can be used to produce black-and-white prints using photographic papers such as Kodak's Panalure and normal black-and-white chemicals and procedures.

The cost of reproducing color photographs in publications is high *if* they are reproduced in color. But this should not be basis for deciding against the use of color in fieldwork since color negatives (and slides through an internegative) can be used to produce fine black-and-white prints, as noted above.

One step smaller than the standard 35-mm camera is the half-frame 35, which is literally half the size of the 35-mm. This miniature exposure was first developed for robot cameras that made an exposure automatically every second in time and motion studies. In the last twenty years, a number of half-frame cameras have come on the market. Professionally, they are used in filmstrip production and by cameramen who want the advantage of seventy-two exposures on a standard thirty-six frame roll of 35-mm film. The focal length of the lens is even shorter than the standard 35-mm lens and, therefore, has nearly universal focus. With great care in exposure and development, print detail can be gained that compares well with the standard 35-mm camera.

When we move to still smaller cameras, the Minox or the 16–mm Minolta, we can no longer produce professionally clear prints. The 16 mm is one quarter the size of the 35 mm. The contact print is useless for studying, and so far the negative does not produce a critically sharp enlargement. Such a small camera may fill a personal psychological need rather than a realistic documentary one. We are also prejudiced against hiding cameras, which is the popular appeal of the Minox. Rarely is it good protocol to work in this way. The main values of the 35-mm camera are depth of field, speed of operation, and bulk of film. The Minox does not expand these values.

On the other hand, serious observers have used the Minox, including Edward T. Hall. Some of the illustrations in *The Hidden*

Dimension (1966) were made with this tiny camera. It is considered a romantic spy camera and would fit nicely up the sleeve of James Bond.

MOTION PICTURE CAMERAS

The methods of visual anthropology were developed primarily in still photography, more research can be done with still cameras than is done. However, much contemporary research work is done either with motion picture film or video. This shift of technology was and is a recognition of the fluid characteristics of behavior and many cultural processes which only a motion record can adequately record and define.

Ethnographic recording and research first began in 16 mm, and commercial anthropological films are still shot in 16 mm. This may change in the near future, with increasingly sophisticated video technology. The cost of 16-mm equipment, film, and processing tends to discourage spontaneous field recording and blocks comprehensive film investigations of culture in motion. This type of fieldwork and analysis has been done primarily with Super-8 and video, although some specialized, narrowly directed research has been done in 16 mm. Our discussion of motion picture cameras for the field, therefore, is directed at Super-8. We present Super-8 solely as a data gathering tool, not as a means of producing satisfactory release film for audiences. Although some fine audience-intended work has been done in Super-8 (often with television as an intended outlet), if we wished to work to that end it would usually be more satisfactory and sometimes even cheaper to work in 16 mm.

SUPER-8 EQUIPMENT FOR FIELD RESEARCH

The main features of a good Super-8 field camera are a sharp, reasonably wide-angle zoom lens and dependability. The work-horses of much of the field research in Super-8 have been Nizo cameras, German products with a reputation for durability. Many Japanese cameras also have fine reputations for field use.

All manufacturers make optically sharp cameras but all models can also be woefully soft focus. Because of miniaturization there is less tolerance for maladjustment in Super-8, and, additionally, almost all Super-8's are equipped with complex zoom lenses. These are usually sharp in their medium-to-telephoto positions but are too often soft in the wide-angle position that is *most* important in research because it records context. Soft focus is usually the result of minor maladjustments at the back element of the lens; unfortunately there are few or no technicians who can correct this problem. The

problem cannot be detected by looking through the reflex viewfinder found on most Super-8 cameras because most take the image for the viewfinder from a "beam-splitter" that is located *in front* of the back element. It is crucial, therefore, to shoot test footage on any camera you are considering for purchase to determine if the camera is indeed sharp at all focal lengths. The procedure is the same as for testing still camera lenses and can be carried out in the store itself, prior to purchase.

You can shoot synchronized sound in Super-8, either "single system" (the sound is recorded directly onto a magnetic strip on the film during filming) or "double system" (sound is recorded on a separate recorder with a sync pulse for later synchronization, as in 16 mm). Double system involves more equipment and more skill, and often more people, so there are more things to go wrong. It also involves either considerable equipment expense or laboratory fees. Single system, providing good microphones are used, produces sound as good as that heard on most 16-mm optical sound tracks and is considerably less bother in the field (Scott Andrews, personal communication). Useful, semisync sound can be shot with silent Super-8 cameras using a cassette recorder that is turned on and off by the camera shutter trigger, or, alternatively, that puts a pulse on a second track of a small stereo cassette recorder.

Some Super-8 cameras are equipped with "intervalometers" that make it possible to shoot time-lapse exposures from six frames a second to one frame every minute. This feature can be very useful in the field as it allows for recording of long sequences or periods without extreme film costs. Time lapse with Super-8 can also be used for extended sociometric studies, in place of still cameras, as was done by William H. Whyte and associates in their study of urban spaces (Whyte 1980).

Anyone working with Super-8 will also have to buy a viewer (sometimes called an editor) and a projector. The viewer is used to piece rolls of film together, log film, and do basic analysis and editing. Most viewers have a small frensel screen on which the film is visible as you advance the film by hand. Some also come with frame counters, essential for good analysis and editing, and sound heads for reading sound strips. Projectors come in silent and sound versions with many variations within each category. The projector is used both in analysis and for teaching and general viewing purposes. Good silent projectors come with variable speed adjustments that allow you to view the film in slow motion and sometimes in fast motion; unfortunately almost no sound projectors have this essential capability for research and analysis. Because analysis of film involves hours and hours of viewing, the projector is the unit

most likely to break down, and an allowance for this fact should be built into any long-term budgeting of a project involving film.

Video Equipment

This discussion of video must begin with a caution. Video is in a state of rapid technological development and many statements made here may soon be obsolete. The past five years have seen both a dramatic increase in quality of small video and a decrease in costs.

Video comes in number of formats, but for the fieldworker the choice will be $1/2$ in. or 8-mm cassette formats. There are two $1/2$ in. formats, "Beta" and "VHS." Beta equipment is slightly smaller but VHS is more widely used and available. The latest video format uses 8-mm cassettes, these are much smaller and the equipment is correspondingly more compact. Tapes shot in one format cannot be played back on a machine designed for another format, although one can make copies from one to another electronically. The fieldworker will have to choose one, and we suggest that the choice be based on compatibility with whatever equipment is used at the institutions one may be affiliated with. This way you will have more equipment available for your use and can show tapes at school without hauling in your own equipment.

Video, even with falling prices, involves a fairly high capitol investment compared to still and Super-8 equipment. At a minimum you will need a portable recorder, a camera, and a monitor on which to view the recorded tape. It is possible to play back onto regular color TV sets via "RF" adaptors, and this is the most common means of doing so. Image quality will be better if the playback is through a monitor designed for direct cable connection to the video recorder. More expensive monitors tend to have better image resolution; this can be crucial in analysis of data.

In order to record in the field the researcher will need a portable video recorder and camera that operate on rechargeable batteries. Most video manufacturers make portable units; the higher the price the more features they will have and, to some degree, the higher the quality. If you are intending to do any kind of analysis of the video recordings it will be well worth the extra expense to purchase a video recorder that allows "noiseless" slow motion and freeze frames. These features allow you to view the images in slow motion or in single images without the obstruction of the "noise" bars that would otherwise obscure the image.

Particular attention should be paid to the video camera. We would suggest one with an electronic rather than optical finder, with low-light sensitivity, and a fairly wide, sharp lens. Video lenses are

subject to the same problems as Super-8 lenses in the wide end of the zoom range, so different cameras should be tried out until a sharp one is found. Another feature to consider in video equipment is the amount of electrical current required to run them. In the field you will usually be running on battery power, so the less power the units consume the better. A tripod with a smooth panning head is also very useful in video work. In long-term budgeting, allowance has to be made for relatively high maintenance costs for video equipment.

Video has increasing promise and flexibility. Very fine records have been made with small video. In theory, the more sensitive video cameras can now record in lighting as low as 10 lux or approximately 1 footcandle; this is about the same level of lighting as can be photographed with 35-mm film at 1600 ASA. Peter Yaple, a student at San Francisco State University, used small, ultralight JVC equipment to make superb documentary and research records of Vietnamese refugees in San Francisco. Some of these records were shot in lighting conditions so dim that Peter was pushing the black-and-white film for his still photography, yet the color and images in the video were relatively sharp and clean. Generally, as light levels drop video loses its color saturation and images become monochrome, usable for research but not always satisfactory for audience purposes.

Technical Issues in Panoramic Studies

In the study of homes or in geographic records of communities, the major challenge to the photographer is whole coverage. The research value of photography recedes when we cannot appraise all four sides of a room or the full sweep of a community. The more elements we *can* relate, count, or qualify, the richer becomes our understanding.

Use of the wide-angle lens can solve much of this problem. So desirable is this lens that fieldworkers refer to it as "the anthropologist's lens." Getting space photographically, getting whole coverage, becomes the consuming effort.

The standard wide-angle lenses are not wide enough for 180° panoramas, let alone the 360° view which records the complete circle of the landscape. The only way we can obtain such vistas is by multiple exposures, a rough effort which can be accomplished in overlapping shots—from three or four for a 90° sweep to a dozen or more for the full circle. These exposures can be spliced or morticed together in an uninterrupted view of a room or a town, and the results can be satisfying source of dependable information.

The problem is that unless the camera is *perfectly level*, the horizon line will be zigzagged or curved up and down, when the foreground is accurately morticed. And if the camera does not turn *on the exact axis* of the middle of the lens, foreground and background can never be accurately spliced.

Once you have mastered these optical problems, there is the challenge of variable exposure. As you pan from the light-over-your-shoulder to the left or right, or as you pan in a circle directly into the sun, your negative will get increasingly thin in the shadows, and overexposed in the heavens. To equalize this, you must take light readings for all your camera directions and decide which is more important, perfect skies or readable ground detail.

While a sharp, wide angle lens is invaluable in many mapping and panoramic studies it is not always the best lens to use. For one thing it makes distant subjects look smaller and farther away than they are relative to subjects in the foreground. This may make it harder to read the photographs or cause some distortion in the reading of spatial relationships. If a reasonably precise record of spatial depth is required then you will need to use a "normal" focal length lens (50–55 mm in the 35-mm format). If you use a longer focal length the reverse happens, distant objects appear closer than they really are. This can be helpful when it is necessary to read detail but requires many more photographs to record the same subject.

An exciting way to study a 360° panorama is to enlarge all the frames 8 by 10 in., mount them in a continuous band, fold this strip in a circle *print side in*, suspend this panoramic circle at an eye level, and view the image from *inside*. Every detail will now appear in its natural position.

PROBLEMS OF PORTRAITURE

The camera has from the start been used enthusiastically for portraiture and to record physical types. Despite the great technological advance of photography, early camera records of native people are often superior to the studies made today. The reason for this is a commentary on photographic technique and the art of photography. Two factors, both of which could be thought of as disadvantages, actually contributed to this early superiority: the customarily long focal-length lenses and the very slow film. Early lenses were little more than pinholes, and they had to be of long focal length in order to cover the negative. Wide-angle lenses are the result of modern optical formulas perfected only in recent years. But the long lenses meant that portraits were beautifully corrected. The lenses

of Brady's day forced the photographer to be at least six to eight feet from his subject. This meant that noses and ears were rendered in their true proportions.

The other factor of success, slow film, challenges the refinements that have gone into making modern film emulsions, sensitive materials that allow us to shoot fast in poor light without the blur of very long exposures. The very slow film of eighty year ago *required* that the camera be used on the tripod, and *required* that the subject sit before the lens in a controlled manner, or the image would have been blurred out of all recognition. The inadvertent result of these technological hardships was that portraits were very carefully taken years ago. Ethnic materials were carefully arranged, the subject was given the opportunity of composure, and the rapport between the photographer and the subject tended to be more complete than the communication between today's snap-shooter and the surprised subject. Of course, there is a compensation in the development of fast film and fast cameras. Now we have the genuinely candid portrait of people who are oblivious to the photographer. Such records might be essential in recording how people appear undisturbed in their cultural roles, at their work, or in social interactions. But this approach must be clearly separated from just one of snapping pictures of the passing subject, where the record too often reflects self-conscious "cheese" grins, bewilderment, or open hostility. Ideally, portraits should be taken with care, and communication between the subject and the photographer should be clear. There are many more factors involved in a fine ethnographic portrait than just a framed head. Take your time, and give your subject the opportunity to communicate.

Distortion that can make records useless to physical anthropology comes from the extreme angle between the lens and the subject when the camera is too close. If you are using a wide-angle lens, *stand back.* Long lenses modify this, because a full portrait head can be framed at six feet or farther. At this distance the photograph appears less distorted than the same angle at three feet. Many 35-mm cameras have interchangeable long lenses that can be used to make well corrected portraits. The 80-mm to 100-mm focal-length lenses are beautifully suited for this purpose while still allowing the photographer to be close enough to make good contact with the subject.

Through-the-lens reflex cameras invite eye-to-eye portraits, which offer maximum correction for the lens used, but waist-level reflexes are a threat. Portrait after portrait is made with these cameras taken from the belly button, with the eyes of the subjects staring aimlessly overhead. Actually, they may be looking straight across at the pho-

tographer, but the camera's eye is looking up. This can be easily corrected. All waist-level reflex cameras have direct view finders that allow you to photograph the subject eye-to-eye. Sometimes, a low-angle shot is what you need. But make this a matter of choice rather than default.

SOUND WITH STILL PHOTOGRAPHS

Synchronized sound in motion picture recording can become a major expense in terms of film costs, duplication, and equipment. It is, however, possible to make quite useful sound records in conjunction with still photographs using small audio cassette recorders. The tape and equipment are relatively cheap and no laboratory work is needed.

Peter Bella, a doctoral student in anthropology, planned a film doctoral dissertation in Africa. The film was to be divided into separate sections, one dealing with traditional activities of herding and hunting and the other with adaptations to European-introduced farming techniques and economy. He was particularly interested in interactions among tribal members who were engaged in different ways of life. His grant money did not materialize, so Bella collaborated with a professional photographer who made still photographs while Bella made closely coordinated sound recordings. The moment when each photograph was shot was marked on the sound tape so that a close degree of synchronization of images and sound was possible. The tape was translated immediately into English and a "sync" sound film produced from tape and photographs. Use of still photography does not force the fieldworker to forego the important elements of sound in ethnographic recording.

TECHNOLOGY IN ACTION

Single images of technical processes have little research value beyond illustration of moment and place. Almost all activities, including technological ones, must be photographed sequentially if we are to gain any analytic insight. Within this context there are a number of technical considerations in making records of technological and other processes.

To blur or not to blur! Many technological circumstances should be sharp. Hands twine fibers, the textile craftsman throws his shuttle through the loom, the farmer drops four kernels of corn in a hole, and fisherman draws a cod from the sea; we can study these techniques clearly if the motion is sharp, without blur that can disguise the way it is done. One blurs intentionally only when it is important

to record the character of movements themselves as in the contrast between rapidly moving hands and a still body.

Most of the time blur results from the photographer arbitrarily failing to shoot at a shutter speed fast enough to stop the action. But blur can come also from the body movement of the photographer. If light is so poor that you must shoot at speeds slower than $1/30$ of a second, use a tripod, hold your breath, lean against a wall, or rest your camera on a chair.

It must be remembered, the closer you are to the action the more the blur. You can photograph a horse trotting by a hundred feet away at $1/125$ of a second, but if you are ten feet from the trotting horse you need a shutter speed of $1/500$ of a second. If action is coming toward you or going directly away from you, a galloping horse can be stopped at $1/125$ of a second, whereas if this horse runs across your camera view it would be blurred at $1/500$ of a second.

Most crafts can be photographed at $1/125$ of a second, but if there is swift action, advance your shutter to $1/250$. If you want to count the kernels of corn dropping in the ground, use $1/250$ of a second exposure. If you are photographing a rodeo, use $1/500$ or $1/1000$. If you are photographing fishing on the high seas, use 1/500 of a second exposure, or even faster—you can't control the motion of the boat.

Should you *always* stop the motion? Paul Ekman, director of the Nonverbal Research Center at Langley Porter Clinic, exploited blur so he could record motion (private communication). One camera was used to *stop* motion and get all details sharp, while a second camera was set at a slow shutter speed to record the presence of motion. One part of the subject's body might be sharp, while the hands or shoulders would be blurred from movement. By the same technique, a slow-shutter-speed series on group interaction would reveal who moved fastest. Nervous hand gestures would be recorded which might seem insignificant in a frozen-image record.

Photographing with Little Light or No Light

Photographing in low-light situations can present serious problems. There are a number of solutions, falling into two categories, those that involve supplementary light and those that do not. Ideally, one does not add light if it can be avoided, the presumption being that the quality of light present is a feature of the setting which is important to record. With the extremely sensitive 35-mm films now available it is much easier to achieve this ideal than in the past.

The basic solution is to use a film that has increased sensitivity, which is indicated by the film having a higher ASA rating (today

this is sometimes called an ISO speed). One should also use a "fast" lens, one with an maximum aperture of 1.8 or lower. Color negative and transparency films are available with ASA ratings up to 1600. These are fine films, but the fieldworker should be aware that the high ASA ratings reflect very little margin for error in the direction of underexposure. For this reason, if working in a setting with many shadows it may be advantageous to set one's meter at a slightly lower ASA setting than that suggested by the manufacturer. Most high speed-color emulsions have more tolerance for overexposure than underexposure. Slide films can be "pushed" with some success. Pushing involves overdeveloping the film and modern slide films can successfully be pushed to twice their rated ASA. In this manner it is possible to shoot an ASA 400 slide film at 800 ASA and get usable images by having the film specially processed.

Black-and-white photography has considerable flexibility. So-called recording films are sold with ASA ratings of 1600; these have large but not unpleasant grain. Ilford has recently introduced a black and white negative film (XP-1) which uses color dyes and can be rated at 400 to 1200 ASA. Developed normally it will then produce usable if, somewhat contrasty, images in low-light situations. Better results can be achieved by pushing; the film has virtually no grain and can be used to make fine 16 by 20 in. prints of low light subjects. An interesting feature of this film is that it is very difficult to overexpose. This film must be developed in color chemicals, not with regular black and white developers.

Low-light situations have more traditionaly been met in black and white by using high-speed films, such as Kodak Tri-X or Ilford HP-5, and exposing them at higher-than-normal ASA settings. The film is then pushed in development with a theoretical gain of 100 percent ASA for a 50 percent in development. In practice they cannot be pushed much higher, although manufacturers of chemicals have claimed for years that speeds of up to 3600 ASA were possible. Beyond a 150% increase in ASA rating there is a rapid fall off in shadow detail, making the records of little use for analysis.

Sometimes the natural light is not enough or does not provide the type of lighting needed. For example, if great depth of field is needed it will be impossible to use wide-open apertures and additional light will be needed. Light can be added to a situation in a number of ways.

In the Andes at high altitudes, there is little or no light to photograph with under the portals and in the rooms of Indian homes. How can you record? Here you must work with reflected or artificial light. The simplest and most available supplementary light is reflection. Take a five-foot square of white cloth, stretch it on two

crossed sticks, and you have a reflector that will flood an Indian's portal with adequate light. If this is not feasible, you have a number of other choices. Within the range of electric circuits you can often boost light level by simply replacing the bulbs in the building with more powerful ones. This is particularly useful when you do not wish to change the relative quality of the lighting. If this is not practical or more light is needed you can use photo-flood bulbs. In the field you must either use flash bulbs or electronic flash (sometimes called strobe).

After flash bulbs took the place of powder flash, for three decades most news pictures were made with flash bulbs. They came in a great many varieties and sizes, some as small as peanuts. But each bulb was good for only one shot, a large supply was too bulky to carry, and changing the bulbs every time you took a picture consumed a lot of time. Shots had to be carefully set up, except for those that used a single flash unit.

The strobe light, which came into general use in the late 1940s, has eliminated the necessity of bulbs. The strobe unit produces an electronic flash of very high illumination at a very fast speed within a sealed tube. It can be fired again and again with a brief recycling period, one second to a minute (depending on the equipment), between shots. Modern electronic flash is often automatic, calculating the length and intensity of the flash for the photographer. This feature is very useful when using bounce flash.

When using flash, two elements should be considered—enough light, and the right kind of light. When the flash unit is right on the camera, it is called flat flash, simply because the flash eliminates all shadows. This is fine for investigating murders, but not very revealing in photographing technology and social process. Without shadows we lose all sculptural detail and delineation of planes. Also, as every amateur knows, faces near the camera always appear like floured-faced actors in a minstrel show, whereas people in the near background cannot be seen except as shadows. The only way we can defeat this harshness of lighting is to get the light away from the camera. You can hold the flash reflector in your hand, clamp the light on the wall focusing down at an angle to the subject, or you can flash the light up on the ceiling, if there is one, and *bounce* the light back on the subject. The angle lighting gives hard shadows, but shows good detail in technology. The bounced light gives a more rounded well-modified light over the room area and is less intrusive and more generally useful.

In the days of flashbulbs fine lighting could be achieved through the use of multiple bulbs, all attached to the same sync cable. In this manner the photographer could fill in shadows and give a good

sense of depth. The same effects can achieved with multiple "slave" electronic flash units triggered by the flash of the main unit. These are common in advertising photography but probably represent too specialized a technique for most field investigators.

How Reliable is Flash?

Flash units go off as the shutter is tripped and are fired by batteries. Some strobes use batteries that can be recharged from a wall socket; they are worth the added investment. If the batteries are weak or if the synchronization within the shutter gets faulty the exposure is off. Both these failures are common. A frequent source of sync problems is a loose connection between the camera and the flash unit. With 35-mm SLR's, flash pictures that have a portion of the frame grossly underexposed and the rest properly exposed are almost certainly the product of improper shutter speed or bad synchronization. Most SLR cameras have focal plane shutters that cannot sync with a flash unit unless the shutter speed is set at a $1/60$ of a second.

In the field you can resort to one sure technique with flash. Open the shutter, fire your flash bulbs or strobe, close the shutter, and you *know* you have the picture. This is known as "open flash" photography, and uses the shutter setting "B," which stands for bulb—the old rubber bulb photographers used to squeeze and release to open and close the shutter. With faster films this technique will work only if the natural lighting is almost nonexistent; otherwise you may get double images.

Strobe has a rewarding character in that the light is so fast—$1/1000$ of a second and faster—that people often never really see the light flash. When a powerful strobe is used as a bounce light, it is very hard to detect even in a dimly lighted room, so instantaneous is the light duration. Strobe is far superior to flash bulbs. We used a strobe unit in the Andes for six months before a rainstorm shorted the unit. The battery gave two thousand trouble-free exposures.

The answer for all kinds of artificial lighting is to practice using it extensively *before* your expedition. Work the bugs out; learn your technique at home so you can work with confidence in the field.

Problems of Heat and Cold

Extreme cold, as in the Arctic, can paralyze photographic equipment. Shutters may freeze up in as little as ten minutes at twenty degrees below zero, and modern battery-powered cameras are even more susceptible to cold than more traditional spring-driven cameras. Not only do batteries lose power in the cold but shutters and

other moving parts drag, requiring more power than at moderate temperatures. With still cameras, it is best not to use equipment that is dependent on batteries. Motion picture and video equipment will need heated covers to operate dependably. In Alaska, John Collier improvised by sewing an insulated cover for his Super-8 Nizo that had pockets in which sports hand warmers were placed. This ended the cold problem. It is also possible to run equipment from separate battery packs that are kept inside one's coat.

Once film or equipment has become thoroughly chilled it must be warmed up gradually to avoid condensation on the film and in the interior of the equipment. Do not bring a cold camera abruptly into a very warm room. With still cameras this problem can be avoided by keeping them inside your coat except at the exact moment when you take pictures. This way they never become thoroughly chilled.

Tropical heat and humidity can also destroy batteries, damage film, and wreak havoc with equipment. These problems recently led one ethnographic filmmaker with a small budget to take only spring-driven Bolex movie cameras with her in the Peruvian Amazon (Diane Kitchen, personal communication). Most video equipment is sensitive to heat of over 100 degrees; the tape stretches and "snow" and other "noise" may appear in the image. With any electronic equipment heat and humidity can hasten corrosion and cause electrical connections to fail.

Heat and humidity can injure film, reducing the sensitivity to light and altering the color balance in color films. These effects become accelerated after the film has been exposed. Heat and moisture are a problem with black-and-white film but can be deadly with color film, which must be handled with more care. In humid conditions film should be stored in sealed containers with silica gel. Bulk film should be refrigerated, if possible, and when removed from refrigeration it should be allowed to sit several hours before opening containers to avoid problems with condensation.

PHOTOGRAPHIC PROCESSING IN THE FIELD

Should anthropologists develop and print their own material? Modern commercial processing has removed this laborious necessity. In past times it was extremely difficult to get professionally adequate commercial developing and printing. Today only a few photo-journalists do their own laboratory finishing; the vast majority let trained specialists do it for them.

Our advice to the anthropologist in the field would be: develop film *only* when essential, either to avoid deterioration, to check

equipment, or to get immediate feedback. Even in this latter case, the Polaroid camera, in many instances, will do the service for you. Even in rural India, Bernard Cohn and Shirley Planalp got excellent results by giving their film to a local processer; though his laboratory was not one to inspire great confidence, he probably did a more dependable job than they could have done in the limitations of their field surroundings.

Nevertheless there are circumstances when processing in the field is essential. On a long field assignment how can you be sure your camera is working properly and whether you are making correct exposures? If you can't get your film to a local processor, then periodically, if possible, you should develop a test roll of film.

To meet this problem the field photographer should carry a compact emergency developing kit: a film tank, thermometer, plastic graduate, and packets of developer and fixer to mix just one tank-full at a time. Eastman Kodak makes small packets of chemicals that can be used for this purpose; these are currently called "Hobby Packs" and contain all you will need for small-scale developing of film and even, if you wish, printing. Your darkroom is a light-proof bag with elastic-bound sleeves to get your arms inside—a "changing bag." This is an important article for the times when film gets jammed inside a camera, and it also allows you to load your exposed film into the developing tank. The remainder of the process can be carried out in a lighted room. The film you develop as a test should be exposed as a test; do not risk valuable data. After clearing in the fixer the test film can be washed briefly in a basin of water and dried for careful inspection. Even lightly washed film will last weeks or even months, so on a water-scarce location you can avoid the laborious problem of fully washing film for a half-hour.

A second circumstance where a field laboratory could be necessary is on an extended study. Working with your camera records in the field can be of great research value, and sending the film out of the bush or the mountains for processing can be perilous as well as consuming weeks or even months. Setting up a field laboratory where there are houses and a temperate climate is no great problem, but if your locale is tropical and very humid, and if there are no houses, a field laboratory is best forgotten. Even with four walls tropical heat can make processing nearly impossible and will inevitably destroy film.

If you do set up a lab, the requisites for processing film are the darkness of a changing bag, an adequate supply of clean water (it is nice but not absolutely necessary to have it "running"), and a dust-free room for drying negatives. Minimal equipment would include four film tanks for 120 film or two double-reel tanks for 35

mm, a one liter and two 500 cc plastic beakers, two thermometers (you will break one), and a plastic bottle for storing fixer. Use "one-shot" developer formulas that are thrown out after use so that you minimize the risk of failures caused by age-weakened developer. You will also need acetic acid or some other form of stop bath and fixer. Fixers can be bought in dry packs for mixing in the field, but acetic acid is only available in wet form. You can carry potassium chrome alum powder to use for a film stop bath, but there is no substitute for an acetic acid stop bath between developing and fixing prints. An extremely useful chemical in the field is a "hypo eliminator" or "washing aid"; these help remove the fixer from the print or negative and greatly reduce the amount of water and time needed for washing. While somewhat optional in places with abundant running water they are essential in areas without running water or with water shortages. In warm areas they will also reduce the opportunity for softened negatives to get scratched.

Prints can be made in the field by two methods. Without chemicals you can make printing-out proofs, the familiar red-tinted portrait proofs, which are printed by exposing paper and negative in a print frame to the light of the sun; these are only proofs and turn black fairly quickly if exposed to strong daylight. Obviously these are not fit feedback material. The second method is to print your negatives on regular contact paper which requires developing; this necessitates a darkroom, and a "safe-light," a filter of a specified color over a light so you can see well enough to put negative and paper securely into the print frame before you turn on your exposing light. Translated to a darkroom without electricity, this means a safe-light filter secured over a hole in the wall. Printing by daylight calls for a slow contact paper; simply open the door of your darkroom, and close it again quickly. With testing and practice you can print your negatives quite professionally. Ideally you should use an 8 by 10 in. print frame so that you can proof or print a complete roll of film at one time. Added equipment for contact printing would then be a filter to make a safe light, a print frame, three 8 by 10 in. developing trays, photographic paper, and plastic bottles to store chemicals in. The chemicals include developer, acetic acid, and additional fixer. Developer and fixer can be bought in dry powder form or as liquid concentrates; dry powders are safer and easier to transport. Before use they have to be mixed into stock solutions that are then stored in the plastic bottles. The developer is further diluted, usually, for actual use and then thrown out at the end of the printing session. Fixer is reused. For field printing it is probably wise to purchase "resin coated" (RC) photographic paper, which requires

only a few minutes of washing and dries quickly. With practice it is possible to process thousands of negatives and efficiently contact print all your material. We had a darkroom in the Andes and processed six thousand negatives, with the aid of a local helper who quickly learned to develop professional-quality negatives.

THE PHOTOGRAPHIC FILE

Though gathering data with photography is in many ways a means of simplifying your field effort, it is also an exhaustive chain of effort, beginning with the first-hand observation and ending months or years later in a systematically organized file. Direct observation without the camera can be at least partially retained in the mind regardless of the loss of notes, but the photographic memory resides in the negatives and prints alone. Should this data stray, become buried under other material or destroyed by vermin or carelessness, then the memory storage is lost for good. Hence the care of negatives, contact prints, and identifying data is critical. Filing negatives becomes the final technical link between field observation and research analysis and conclusion. A failure in this final process can destroy much of your nonverbal research experience.

Negatives are extremely perishable. They always have been: glass plates could shatter, nitrate film could deteriorate and even explode through improper storage. All the priceless motion picture film footage shot by Kroeber of Ishi, the last "wild" California Indian, was lost, to be found decades later stored over the steam pipes of the University of California Anthropology Museum. When the can was opened nothing was left but flakes of nitrate film. Modern "safety" films are tougher and will not explode, but negatives can still be rendered useless through abrasion, moisture, mold, and neglect.

The greatest threat, however, is outright loss. Negatives have a way of disappearing unless they are stored with maximum security and filed systematically. The Farm Security Administration file kept a control record of every negative. Every time it was handled, the operation was noted in the control book. Negatives are so perishable and so easily misplaced that there are agencies in New York that exist solely to act as custodians of photographers' negative files.

Methods that can ensure the maximum use of your camera observations literally begin when you make the exposure. Whenever possible keep an adequate film log that can later provide on-the-spot insights and identification for each photographic record. As time and distance cloud the memory this log will become increas-

ingly important; indeed it is the key to the integrity of your records. If you are too harassed to to make this record on location, write it up each night.

The second step comes immediately after you develop your negatives or have them processed. Each negative strip or frame should be given a chronological number so that the precise order of observation, roll for roll, exposure for exposure, can be irrefutably retained. Professionals number film as it is cut up and stored in glassine envelopes. This should be done before contact printing so that each print will have the negative number on it. Today all-35 mm film is frame numbered so that sequence within the roll is established. This means you can assign a single number to a whole strip of miniature film, and the individual frame is identified by this number plus the edgenumber. Some 120 film is also edge numbered, and this number may be incorporated in your system, but your distinguishing number should appear on each frame since negatives of this size are frequently cut up and printed alone. Negatives must be numbered with waterproof ink with a crow-quill drafting pen or with modern fine-point permanent makers designed for this purpose. Nothing else will hold on the slippery celluloid surface.

Roll film should be cut in strips and placed immediately in glassine or chemically inert plastic sleeves or envelopes. This is done for a number of reasons. It is a hazard to store film rolled up in film tins; stored this way it curls like a spring, and makes printing extremely difficult. Film should be stored flat, so that it can be handled without fingering and scratching. Also 35-mm film in cans cannot be examined easily, while cut-up film can be inspected safely through the glassine envelopes. Ideally 35-mm film should be cut in six-frame strips, $2^{1}/_{4}$ by $2^{1}/_{4}$ in. in four-frame strips, $2^{1}/_{4}$ by $3^{1}/_{4}$ in film in three-frame strips, so that they may all be printed roll-for-roll on one sheet of 8 by 10 in. paper. Four sheets of 4 by 5 in. film fits the same size. If you prefer, 35-mm film can be cut in five frame strips, in which case you should limit yourself to thirty-five shots on each roll. Thus, a print file from these various negative sizes can be filed uniformly on cards or sheets. Later you may want to select individual negatives for special use, in which case negatives $2^{1}/_{4}$ by $2^{1}/_{4}$ in. or larger may be cut from their strips and placed in small envelopes; this is more convenient and there is less risk in enlarging. But 35-mm strips should never be cut into individual frames.

There is a real advantage to having negatives strip-printed in their authentic order. It allows you to see your field studies in organized blocks, which is usually the way you should consider your photographic data. Cutting up your contact sheets, unless you have duplicate sets, exposes photo-records to premature editing and even

misplacement of some valuable frame that might become lost to study. We do not, and realistically should not, know what scrap of evidence may form a significant link later, maybe years later in our research. This is why you should resist the temptation of cutting up your contact sheets, lest you lose a genuine control circumstance that lies in the undisturbed relationship of the sequential camera observation. For the times when it *is* methodologically important to work with each frame separately, *make a duplicate set* instead of dismembering your only contact sheets.

For analytic purposes it can be useful to have 35-mm negatives enlarged *enmasse* so that the print looks like a huge contact sheet. Photographic labs can do this for you so that a whole roll appears on a single 11 by 14 in. or 16 by 20 in. sheet. Alernatively, you can do it yourself if you have a large format enlarger. We have profitably done this with a 5 by 7 in. enlarger, enlarging twelve frames at a time, with a 4 by 5 in. enlarger (which are more common) you could enlarge nine frames at a time using a glass negative carrier.

Black-and-white negatives can be used to produce black-and-white slides for viewing and analysis, using special films made for the purpose or by using Kodak's Technical Pan film and experimenting with exposure and development times until a satisfactory contrast is achieved. Slides can also be made from color negatives; again special film has to be used and some experimentation is necessary to obtain correct exposure and color balance. Labs can do this for you, but the expense may be high.

The most critical step in ensuring dynamic research opportunity for your records is the photographic print file. One challenge of a file is to facilitate efficient tracking of selected visual criteria through all of the photographic record. An average file covering a year's work might contain from two to six thousand separate observations, and unless all these views are available to rapid examination, carrying out research within a photographic file becomes time defeating.

Efficient filing can be an equal challenge for the raw data of interview notes. Even if a file is duplicated a mere five times for cross referencing, raw data covering a few year's fieldwork might fill a large storeroom. Such an effort would be prohibitively costly. Fortunately modern business methods came to the rescue of the cumbersome cross-reference file with the development of the McBee punch card filing system, and more recently, small but powerful computers. The computer is phasing out the use of punch cards for verbal data, but they often remain a necessity when working with visual records. Programs are in development that allow storage of visual images in computer data base files; these should increase the

usefulness of computers in visual analysis, but only with cards can you sort for a series of images and then lay them out to be viewed as a set.

Punch cards of various sizes are manufactured with separate categories represented on each card by a border of numbered holes. This allows for an almost unlimited pattern of cross referencing by clipping out the border of selected categorical numbers. Selection of a reference is accomplished by running a needle through the master card so that all the cards holding the reference you are seeking automatically drop out. This method is ideally suited for cross-selecting the imagery of photography, as contact prints or groups of prints can be mounted directly on the McBee punch cards. It is also possible to make good photocopies of prints and mount them on the cards instead of printing an additional set of photographs for this purpose. Despite the computer revolution, representatives of the manufacturer of these cards report that they expect them to continue to be available.

Of course this ultra efficient system has variations. With the smaller file, or one that is to be used in a general multipurpose way, single frames can be mounted on a 5 by 7 in. card which gives ample room for typing in all the identifying data. These cards can then be filed by some basic system of topical divisions with as many subdivisions as might be needed: farming, fishing, lumbering, millwork, fiestas. This variety offers special study opportunities. File cards can be removed for select study or shuffled into comparative categories.

Even though a considerable amount of direct research can take place on contact prints, in many cases of complex process and detail enlargements clarify and extend the research opportunity. A selected file of 8 by 10 in. *mounted* enlargements of representative material from the master file can function as a key that greatly extends our ability to read detail reliably from small contact prints.

Photographic prints should generally be mounted to prevent curling and cracking. A mounted print is infinitely easier to study. The time and expense of mounting is repaid by an efficient use of the file. Mount prints made on fiber-base papers with dry mounting tissue. Rubber cement contains sulphur and will stain photographic material in a short time. Dry mounting, even with a household iron, is faster and considerably more permanent. Resin-coated (RC) photographic papers, however, are highly susceptible to heat and should not be mounted using a hand iron. Such photographs can be dry mounted with low-temperature mounting presses, but other methods of mounting may be easier for the researcher. These include a variety of photo adhesives, all of which are more expensive than

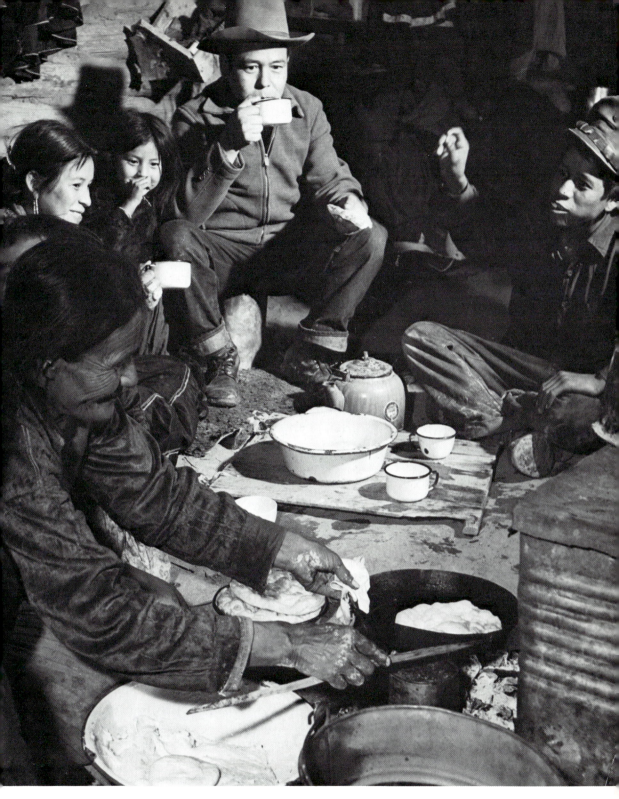

Navajo family meal. The camera provides us with access to both infinite detail and infinite qualitative depth, both the hardware of culture and the full dimension of human character.

dry mounting. RC papers are a bit thicker and more resistant to curling so it may not always be necessary to mount them for analysis purposes.

An important caution: whenever possible, store negatives in a different location from your print files—even in a separate building—so that in the case of disaster you will be left with one or the other. Fire or water can destroy a photographic file in minutes.

Professional anthropology is meticulous about filing and cross-referencing written data and interview materials, but it is the rare research center that contains an organized visual file. In the early years of developing photography for anthropology one of the authors, John Collier, installed such a file for the Cornell Department of Anthropology. To his shock, *no one* looked at this file! In response to his questions he was told, "John, we don't know how to look at these photographs." In a seminar, when graduate students were asked to describe the people who had provided the interview data, not one was able to do so. Were the files improperly organized? Could there have been ways to organize that would have led students spontaneously to relate the photographic evidence to other aspects of their research? The answer remains unclear, but certainly it should help to have the visual information integrated with other data files. This integration must begin in the field; do not wait until you return. Do it *now*, when the integrated view is so important.

We conclude this technical writing at the far end of the photographic process with a word of warning—the most deadly end to all our efforts is the photographic file that sits unused. Every attempt should be made to defeat this eventuality by interrelating the file in as many ways as possible with the project's verbal data. The richness of an integrated file is suggested by the observation of anthropologist John Hitchcock, "The more you see the more you know, and the more you know the more you see" (personal communication). Consider that knowledge in our scientific culture is basically verbal, or at least is communicated in words. Words are more abstract than pictures and less complicated. Much of the photographic view is open-ended, challenging you on each inspection to reaffirm opinion. Our filing problem is to tie photography's open door to reality to the verbal abstractions of written data, whether these be the observations of the fieldworker or the words of the native. A real function of the photographic file is to keep alive the cultural moment so that we can consider written field notes with a full sense of the imagery of real circumstances and use the right visual references to vitalize the meaning of the written words.

References

Bateson, Gregory. 1963. "Exchange of Information About Patterns of Human Behavior." In *Information Storage and Neural Control,* William Fields and Walter Abbott, eds. Springfield, Ill.: Charles C. Thomas.

Bateson, Gregory, and Margaret Mead. 1942. *Balinese Character: A Photographic Analysis.* New York: New York Academy of Sciences Special Publication.

Benedict, Ruth. 1934. *Patterns of Culture.* Boston: Houghton Mifflin.

Birdwhistell, Ray L. 1952. *Introduction to Kinesics.* Louisville, Ky.: University of Louisville Press.

———. 1970. *Kinesics and Context.* Philadelphia: University of Pennsylvania Press.

Byers, Paul. 1964. "Still Photography in the Systematic Recording and Analysis of Behavioral Data." *Human Organization* 23: 78–84.

———. 1966. "Cameras Don't Take Pictures." *Columbia University Forum* IX 1: 27–31.

Byers, Paul, and Happie Byers. 1972. "Noverbal Communication and the Education of Children." In *Functions of Language in the Classroom,* C. Cazden, V. John, D. Hymes, eds. New York: Teachers' College Press.

Cathey, Alyce. 1965. "A Study of Low-Fifth Girl Grouping at Noon: 12:00 Lunch Group and 12:15–12:50 Game Group." Unpublished manuscript.

Collier, George, and Evon Z. Vogt. 1965. "Aerial Photographs and Computers in the Analysis of Zinacanteco Demography and Land Tenure." Paper presented at the Sixty-fourth Annual Meeting of the American Anthropological Association, Denver (mimeographed).

Collier, John, Jr. 1957. "Photography in Anthropology: A Report on Two Experiments." *American Anthropologist.* 59: 843–859.

———. 1967. *Visual Anthropology: Photography as a Research Method.* New York: Holt Rinehart and Winston.

———. 1973. *Alaskan Eskimo Education: A Film Analysis of Cultural Confrontation in the Schools.* New York: Holt, Rinehart and Winston.

Collier, John, Jr., and Anibal Buitron. 1949. *The Awakening Valley.* Chicago: University of Chicago Press.

Collier, John, Jr., and Marilyn Laatsch. 1975. *Film Analysis of the Rough Rock Community School.* San Francisco: manuscript with limited private reproduction and circulation.

———. 1983. *Education for Ethnic Diversity: An Ethnography of Multi-Cultural Classrooms.* Unpublished manuscript.

Collier, Malcolm. 1979. *A Film Study of Classrooms in Western Alaska.* Fairbanks: Center for Cross Cultural Studies, Univeristy of Alaska.

———. 1983. *Nonverbal Factors in the Education of Chinese American Children: A Film Study.* San Francisco: Asian American Studies San Francisco State University (also available from ERIC).

Egli, Emil. 1960. *Europe from the Air,* Hans Richard Muller. New York: Funk and Wagnalls.

Erickson, Frederick. 1979. "Talking Down: Some Cultural Sources of Miscommunication in Inter-Racial Interviews." In *Research in Non-Verbal Communication,* Aaron Wolfgang, ed. New York: Academic Press.

Erickson, Frederick, and G. Mohatt. 1982. "Cultural Organization of Participant Structures in Two Classrooms of Indian Students." In *Doing the Ethnography of Schooling: Educational Anthropology in Action,* G. Spindler, ed. New York: Holt, Rinehart and Winston.

Gesell, Arnold. 1945. "Cinemanalysis: A Method of Behavior Study." *Journal of General Psychology* 47: p. 3.

Gesell, Arnold, and Frances L. Ilg. 1934. *An Atlas of Infant Behavior.* New Haven, Conn.: Yale University Press.

Goldschmidt, Walter, and Robert B. Edgerton. 1961. "A Picture Technique for the Study of Values." *American Anthropologist* 63(1): 26–47.

Hall, Edward T. 1959. *The Silent Language.* New York: Doubleday.

———. 1966. *The Hidden Dimension.* New York: Doubleday.

———. 1974. *Handbook of Proxemic Research.* Washington, D.C.: Society for the Anthropology of Visual Communication.

———. 1976. *Beyond Culture.* Garden City: Anchor Books.

———. 1983. *The Dance of Life: The Other Dimension of Time.* Garden City: Anchor Press/Doubleday.

Heider, Karl. 1972. *The Dani of West Irian: An Ethnographic Companion to the Film, Dead Birds* (with narration and a filmmaker's essay by Robert Gardner). Andover, Mass.: Module #2, Warner Modular Publications.

Honigmann, John Joseph. 1954. *Culture and Personality.* New York: Harper & Row.

Leighton, Alexander H., Edward A. Mason, Joseph C. Kern, and Frederick A. Leighton. 1972. "Moving Pictures as an Aid in Community Development." *Human Organization* 31(1): 11–21.

Lewis, Oscar. 1951. *Life in a Mexican Village: Tepotzlan Revisited.* Urbana: University of Illinois Press.

Lewis, Oscar. 1961. *The Children of Sanchez: Autobiography of a Mexican Family.* New York: Random House.

Mead, Margaret. 1963. "Anthroplogy and the Camera." In *The Encyclopedia of Photography*, vol. 1, Willard D. Morgan, ed. New York: Greystone Press.

Mead, Margaret, and Paul Byers. 1967. *The Small Conference.* The Hague: Mouton & Co. N.V.

Mead, Margaret, and Frances Cooke MacGregor. 1951. *Growth and Culture: A Photographic Study of Balinese Childhood.* (Based upon photographs by Gregory Bateson analyzed in Gesell categories.) New York: Putnam.

Michaelis, Anthony R. 1955. *Research Films in Biology, Anthropology, Psychology, and Medicine.* New York: Academic Press.

Newhall, Beaumont. 1949. *The History of Photography from 1839 to the Present Day.* New York: Museum of Modern Art.

Nichols, Bill. 1981. *Ideology and the Image.* Bloomington: Indiana University Press.

Profiles 2, 5 (December/January 1985).

Redfield, Robert. 1930. *Tepotzlan, A Mexican Village: A Study of Folk Life.* Chicago: Univeristy of Chicago Press.

———. 1955. *The Little Community: Viewpoints for the Study of a Human Whole.* Chicago: University of Chicago Press.

Roberts, John M. 1951. *Three Navajo Households: A Comparative Study of Small Group Culture.* Papers of the Peabody Museum of American Archeology and Ethnology vol. 40, no. 3. Cambridge, Mass.: Harvard University Press.

Rotman, Arthur. 1964. "The Value of Photographic Technique in Plotting Sociometric Interaction." Paper presented at the annual meeting of the Southwest Anthropological Association, San Francisco.

Ruby, Jay, and Barbara Myerhoff, organizers and chairpersons. 1978. "Portrayal of Self, Profession, and Culture: Reflexive Perspectives in Anthropology." Symposium at the annual meeting of the American Anthropological Association, Los Angeles.

Ruesch, Jurgen, and Weldon Kees. 1956. *Nonverbal Communication: Notes on the Visual Perception of Human Relations.* Berkeley and Los Angeles: University of California Press.

Smith, W. Eugene. 1958. "Drama Beneath a City Window: Sixth Avenue Photographs." *Life* 44 (March 10, 1958): 107–14.

Sorenson, Richard. 1976. *The Edge of the Forest: Land Childhood and Change in a New Guinea Protoagricultural Society.* Washington, D.C.: Smithsonian Institution.

Spindler, George, and Louise Spindler. 1965. "The Instrumental Activities Inventory: A Technique for the Study of the Psychology of Acculturation." *Southwestern Journal of Anthropology* 21: 1–23.

Togashi, Naomi. 1983. *Japanese Home Styles in San Francisco.* Unpublished manuscript and photographic project.

Twain, Mark. 1917. *Life on the Mississippi.* New York: Harper and Brothers Publishers.

Whyte, William H. 1980. *The Social Life of Small Urban Spaces.* Washington, D.C.: The Conservation Foundation.

Worth, Sol. 1981. *Studying Visual Communication.* Philadelphia: University of Pennsylvania Press.

Worth, Sol, and John Adair. 1972. *Through Navajo Eyes: An Exploration in Film Communication and Anthropology.* Bloomington: Indiana University Press.

Vogt Evon Z., ed. 1974. *Aerial Photography in Anthropological Research.* Cambridge, Mass.: Harvard University Press.

Films Cited

Bitter Melons. 1971. John Marshall. Color, 30 minutes. Distributor: DER (Documentary Educational Resources).

Dead Birds. 1963. Robert Gardner and Karl Heider. Color, 85 minutes. Dist: Contemporary Films.

From The First People. 1977. Leonard Kammerling and Sarah Elder. Color, 45 minutes. Dist: DER.

It Happened on Wilson Street. (no reference available)

Kenya Bora. 1973. David MacDougall and James Blue. Color, 66 minutes. Dist: Wheelock Educational Resources.

Living Maya. 1983. Hubert Smith.

Man Of Aran. 1934. Robert Flaherty. Black and white, 77 minutes. Dist: Contemporary/McGraw Hill.

Men Bathing. 1973. John Marshall. Color, 14 minutes. Dist: DER.

On Spring Ice. 1975. Leonard Kammerling and Sarah Elder. Color, 45 minutes. Dist: DER.

The Dream Blowers. c. 1965. Richmond, Ca., YMCA. Color, approx. 30 minutes.

The Feast. 1968. Timothy Asch and Napoleon Chagon. Color, 15 minutes. Dist: DER.

The Path. 1971. Donald Rundstrom, Ronald Rundstrom and Clint Bergum. Color, 34 minutes. Dist: Sumai Film Company.

To Live With Herds. 1972. David MocDougall and Jane MacDougall. Black and white, 70 minutes. Dist: Media Center, Rice University.

Index

Plenns, the, 101–4
politics, **85,** 91, 192
portraiture, 223
projective interviewing, 39, 77, 90, 100, 118, 119, 123–26; in illustration, 111, 120, 121, 130, 131
proxemics, 12, 77, 94, 96, **97,** 143, 187, 191, 199

qualitative data, 27, 140–44, 176
quantitative data, 177, 190, 193, 208

rapport, 23, 25, 102, 105, 133–37, 214, 224. *See also* feedback
reality, 8–9, 88, 90, 106, 126–32, 144, 153, 154, 169
Redfield, Robert, 16, 65, 108, 154, 158, 161, 167
reflectivity, 152, 153, 180
reflexivity, 153
religion, 79, 133, 135
research, 3; approaches and basics, 158, 162–68, 169, 171, 233–38; developing categories, 38–39, 163, 172, 177, 178, 190, 191; first impressions, 16, 168, 172, 182; selectivity, 9, 20, 62, 146–48, 162–66, 176, 178. *See also* analysis
Riis, Jacob, 9
Roberts, John, 45, 51
robot cameras, 145, 218
role of filmer, 156; self-filming, 122, 156, 157
role of interviewer/photographer, 20–25, **21,** 102, 105, 133–37. *See also* feedback *and* rapport
role of subject, 23, 73, 87, 102, 106, 118–23, 156–57. *See also* decoding: local/native interpretation
Rorschach cards, 123, 125
Rosa, Pat, 123
Ross, William A., 109
Rotkin, Charles, 30
Rotman, Arthur, 86
Rouch, Jean, 214

Ruby, Jay, 154
Ruesch, Jurgen, 46
Rundstrom, Don, 157
Rundstrom, Ron, 123, 157
rural studies, 38, 39, **80–81,** 83, 186

San Francisco, 118, 181
selectivity, 9, 20, 62, 146–48, 162–66, 176, 178
self-filming, 122, 156–57
sequence, 158, 163, 166, 171, 173, 186, 187; analysis of, 179–81, 184, 192, 234; camera technology and, 211, 217. *See also* time
Siegel, Bernard J., 127
Smith, Hubert, 156, 160
Smith, W. Eugene, 79
social relations, 19, 27, 62, 76–97, 100, 109, 117, 126–27, 140–44, **164, 174,** 187, 192, **196,** 210, 226; dynamics of, 85, 91, 93–96, 226; sources of information for, 82–83. *See also* behavior; community studies; rapport
sociograms, 91
sociometrics, 186
Sorenson, Richard, 12
sort cards, 193, 200, 235
sound, 193, 220, 225
space. *See* use of space
Spindler, George, 124
Spindler, Louise, 124
spinning, in illustrations, 4, 64, 68, 70, 71
Stanford, Leland, 139
subjectivity, 153; reflectivity, 152, 153, 180
survey and orientation. *See* environment; orientation
synthesis, 15

TAT (Thematic Apperception Test), 123, 125, 126, 127
Taos, 35
team analysis, 177, 182, 194
technology, 2, **4,** 59, **64,** 65–74, **68, 70, 71, 72, 74,** 208; guides

to filming, 67, 225; social aspect
of, 69
technology of photography. *See*
camera
Thematic Apperception Test
(TAT), 123, 125, 126, 127
Through Navajo Eyes, 157
time, 3, 11, 13, 77, 82, 84, 87, 92,
144, 159, 185; logic versus
chronology, 180, 191, 192;
movie film time lapse, 220. *See*
also sequence
timing, 213
Togashi, Naomi, 199
tracking, 20, 84, 87, 92, 175, 186
208
Twain, Mark, 165

unstructured viewing, 159, 167,
171, 176, 178–81, 191, 193, 203
urban studies, 9, 39–42, **40,** 61,
79, 123, 145

use of space: inventory for, 2,
44–50, **52–55,** 58–60, 145, 172;
proxemics, 12, 77, 94, 96, **97,**
143, 187, 191, 199

video, 69, 84, 139, 145, 176
video editing, 197
video equipment, 221
Vikings, 30
Vogt, Evon Z., 30, 113

weaving, **72**
whole context, 158, 162, 178, 179,
187
whole vision, 7, 65
Whyte, William H., 145, 220
Wisconsin, 126
Worth, Sol, 13, 122, 152, 157, 160

yacht club, 90, 135–36
Yaple, Peter, 222
youth, 123